Medical Art Therapy with Children

of related interest

Medical Art Therapy with Adults
Edited by Cathy A. Malchiodi
ISBN 1 85302 677 8 pb
ISBN 1 85302 676X hb

Using Interactive Imagework with Children
Walking on the Magic Mountain
Deborah Plummer
ISBN 1 85302 671 9

Art-Based Research
Shaun McNiff
ISBN 1 85302 621 2 pb
ISBN 1 85302 620 4 hb

Arts Therapies and Clients with Eating Disorders
Fragile Board
Edited by Ditty Dokter
ISBN 1 85302 256 X

Play Therapy with Abused Children
Ann Cattanach
ISBN 1 85302 193 8

The Arts in Health Care
A Palette of Possibilities
Edited by Charles Kaye and Tony Blee
ISBN 1 85302 360 4

Growing Up with a Chronic Disease
The Impact on Children and Their Families
Christine Eiser
ISBN 1 85302 168 7

Medical Art Therapy with Children

Edited by Cathy A. Malchiodi

Foreword by Judith A. Rubin

Jessica Kingsley Publishers
London and Philadelphia

First published in the United Kingdom in 1999 by
Jessica Kingsley Publishers Ltd
116 Pentonville Road
London N1 9JB, England
and
325 Chestnut Street
Philadelphia, PA 19106, U S A

www.jkp.com

Library of Congress Cataloging in Publication Data
A CIP catalogue record for this book is available from the Library of Congress

British Library Cataloguing in Publication Data
Medical art therapy with children
1. Art therapy for children
I. Malchiodi, Cathy
615.8'5156'083

ISBN 1 85302677 8 pb
ISBN 1 85302 676 X hb

Printed and Bound in Great Britain by
Athenaeum Press, Gateshead, Tyne and Wear

Contents

96778

9. Understanding Somatic and Spiritual Aspects of Children's Art Expressions 173
Cathy A. Malchiodi, Director of the Institute for the Arts and Health, Utah

List of Figures

To my husband David, who teaches me about science

Acknowledgements

This book would not have come into being without the help of many people along the way. First and foremost, I thank the authors, a group of eminent art therapists whose wide range of experiences with medical populations made this book possible. Their expertise and commitment made this project a pleasure to envision, shape, structure, edit, polish, and put into its final form.

Thank you to the following people and organizations for consultation and for lending material and illustrations: Judy Rollins for information on hospital art programing; Eastern Virginia Medical School for lending illustrations from their research collection; the American Art Therapy Association for granting permission to publish previous material and illustrations; and the Guilford Press for granting permission to publish illustrations from my previous book, *Understanding Children's Drawings*. Thank you to my husband, David Barker, for providing advice on medical literature, particularly genetically inherited illnesses.

A special thank you is extended to Judy Rubin for reading the initial proposal, offering critical advice and suggestions for improvement, and supporting and encouraging my work as a writer. Her seminal work with children through art therapy provided a foundation and an inspiration for this book. It is truly a privilege to have her write the Foreword.

Last, but definitely not least, thank you to Jessica Kingsley for recognizing the importance of this book and her staff for making the process of editing, revising, and proofing so seamless and pleasurable.

Foreword

When my tonsils were removed almost sixty years ago, even a routine operation was a terrifying experience. The pediatrician advised my parents not to tell me about it in advance, so I learned in the car on the way to the hospital that something scary was going to happen to me. My most vivid memory is of an ether mask being shoved over my nose and mouth, stifling a scream. I also remember waking up in a strange place among strange people with my throat burning, wondering if I would ever see my family again.

The hospital stay seemed an eternity. Visiting hours were sharply limited. There was no play equipment and, since television hadn't happened yet, I had nothing to do but wait until my release from this mysterious, frightening prison. When I got home, I am told I refused to eat or talk, only slowly coming back to normal.

Since drawing was one of my favorite activities, I wish my parents had thought to bring me some paper and crayons. Distressed by their own inability to be more than helpless observers of my pain and panic, neither they nor I thought of making art. Needless to say, no one in the hospital offered art materials either.

By the time I brought my own children to hospitals for treatment in the sixties and seventies, there was greater sensitivity to the impact of medical procedures on children and families. Visiting hours were more flexible, and a parent could stay overnight in a child's room. Some play equipment was available, and there were also volunteers who came around offering art supplies as well as toys.

Hospitals have come a long way since then, as described in this book, which is the first of its kind. Cathy Malchiodi's introductory chapter provides a useful outline of the history and present state of medical art therapy with children and families. As with the field of art therapy as a whole, the roots of pediatric art therapy are old and deep, despite the fact that this area of specialization is quite new.

Although neither I nor my parents thought to provide me with art materials at the time of my tonsillectomy, children have always used art and play spontaneously, to cope with stresses over which they have no control. Many a preschooler returns from a visit to the doctor and then plays the role of nurse or doctor, taking care of a doll or a playmate. Making a picture about

what has happened also allows the child to turn passivity into activity, helping him or her to master an experience that would otherwise be difficult to digest.

Ophir, a five-year-old boy, hadn't been especially interested in art, but after an accident which left him 'temporarily handicapped', drawing became his chief form of 'self-rehabilitation'. (Schwarcz and Schapir 1985) Rachel, an eight-year-old dying of leukemia, spontaneously began to write and to draw, her own creativity helping her to face illness and eventually death (Bertoia 1993).

A trauma is, by definition, an experience which is too overwhelming for a child's ego to assimilate. Even with excellent preparation, clear information, and a responsive environment, many kinds of medical events can still overwhelm children's coping capacities. Since drawing, painting, modelling and constructing come naturally to children, especially during times of stress, art therapy for youngsters dealing with medical traumas makes very good sense.

And, as noted many times in this book, making art is not only therapeutic for the creator, it also provides diagnostic information for the treatment team. Although this dual aspect of art therapy has always existed, it has not been stressed in the literature, perhaps because we take it for granted. It is particularly relevant in medical settings. Whether time is of the essence – as in an emergency – or hangs heavy, as in long periods of recovery and rehabilitation – an activity which is at the same time both diagnostic and therapeutic is especially helpful.

Some of the chapters in this book focus on the use of art in assessment, while others stress the use of art in treatment. But both functions are always served, regardless of the primary reason for the art activity. In other words, any art intervention with a sick child or adolescent promotes healing at the same time that it provides information, and vice-versa. It is therefore both economical and extraordinarily rich in potential.

This dual impact (both diagnostic and therapeutic) is especially true when the art activity is conducted by a qualified art therapist. Of course, not only art therapists can make the healing capacity of art available to others; many people can – and should – offer children art materials in situations of medical stress.

The experience of being able to take charge, even in the small sphere of a piece of drawing paper, is vital when a youngster is not able to control either the medical condition or the interventions of others. I hope that this book

will inspire parents, nurses, doctors, social workers, and all who deal with sick children to see that they have the opportunity for art expression.

I also hope that readers of this book will come away with an appreciation for the special expertise of a trained art therapist, who can truly make the most of such opportunities. The contributors to this volume offer many examples of what is possible when sophisticated art therapy is made available to children in medical settings. Each of the chapter authors has become familiar with the particular medical conditions they treat, so that they can then integrate what they already know about child art therapy with the needs of those they seek to help.

Medical art therapists actually follow a long line of medicine men, who often use artistic imagery – like masks and sand painting – in healing rituals. Thus the old-but-new field of art therapy, as it has developed during the last half century, has spawned an old-but-new area of specialization – medical art therapy. And, within that realm, there is a sub-specialty of medical art therapy with children, with which the reader can now become familiar.

Cathy Malchiodi has made an important contribution by bringing together the work of many individuals in a new and rapidly-growing area. Happily, this volume about children is to be joined by another, on medical art therapy with adults. In clinics and rehabilitation centers, in hospitals and hospices, in emergency rooms and waiting rooms, medical art therapy has an exciting future, full of potential. We get an inviting glimpse of what lies ahead in this welcome addition to the literature of art therapy.

Judith A. Rubin

References

Bertoia, J. (1993) *Drawings from a Dying Child.* New York: Routledge.

Schwarcz, J.H. and Schapir, E. (1985) 'Spontaneous artwork as an aid in self-rehabilitation: the case of a temporarily handicapped boy.' *The Arts in Psychotherapy 12*, 81–87.

Introduction to Medical Art Therapy with Children

Cathy A. Malchiodi

Art expression has been widely used in therapy with children in medical environments by art therapists, play therapists, psychologists, medical social workers, clinical counselors, nurses, and other health care professionals. Because it encompasses both the creative process and self-expression, art is recognized for its therapeutic role in helping children cope with stresses and short- and long-term sequelae associated with physical illness, impairment, or injury, medical procedures such as surgery or pharmacological interventions, and hospitalization. However, despite art's potential to alleviate trauma, encourage emotional reparation, and enhance mental and physical health in pediatric patients, relatively very little has been written about the specialized application of art therapy to medical populations.

Medical art therapy is a term which has been applied to 'the use of art expression and imagery with individuals who are physically ill, experiencing trauma to the body, or who are undergoing aggressive medical treatment such as surgery or chemotherapy' (Malchiodi 1993). The practice of art therapy in medical settings has been an important thread of art therapy's collective history since its beginnings. As early as 1945, the British artist Adrian Hill noted that art making was helpful in his recovery and that of other patients hospitalized for tuberculosis (1945, 1951). For this reason, Hill could very well be called one of the first 'medical art therapists', setting the stage for the application and expansion of art therapy in medical milieus.

Since the time of Hill's work, art therapists and other health care professionals have been active in introducing, developing, and applying medical art therapy in a variety of settings with both child and adult populations. In the last two decades, medical art therapists have documented

their work with children's health care environments and with a variety of pediatric populations (Appleton 1993; Councill 1993; Gabriels 1988; Goodman 1991; Levinson and Ousterhout 1980; Long *et al.* 1988; Malchiodi 1998a; Perkins 1977; Prager 1995; Schikler and Turner-Schikler 1992; Teufel 1995). Allied health care professionals such as play therapists, child life specialists, recreation therapists, and activity therapists have also recognized the importance of art expression in work with physically ill children and have included it as part arts programming (Rollins 1990) and child life programming (Rode 1995).

More recently, the hospital arts movement has enhanced the promotion and development of art programs in health care settings with children (Kaye and Blee 1997; Palmer and Nash 1991). In response to the interest and need for clinical skills in working with physically ill children, courses within art therapy, child life, and counselor training programs have been developed, to address the growing need to understand how art expression is specifically used with pediatric populations (Malchiodi 1996). Additionally, medical students are beginning to experience first-hand, the value of art making in meeting the psychosocial needs of hospitalized children (Rollins 1993).

This first chapter introduces the reader to the use of medical art therapy with children, the interface between art therapy and play therapy in medical environments, and the role of art expression in meeting the psychosocial needs of physically ill children. Special attention is given to the unique potentials of medical art therapy in work with pediatric patients and the importance of standards of practice and ethical uses of art expression with hospitalized children.

The psychsocial impact of illness, medical intervention and hospitalization

In order to understand the role of medical art therapy with children, first it is important to consider the psychosocial impact of illness, medical intervention, and hospitalization. The term *psychosocial* is commonly used in medical settings to describe the interdependence of psychological and social factors and there is large body of knowledge describing the psychosocial needs of pediatric patients, particularly in the fields of medicine, nursing, and health psychology. All health care professionals who work with physically ill children agree that the experiences of illness, medical treatment, and hospitalization are extremely stressful, and depending on the extent of the illness, treatment, and hospitalization, can have a major influence on

children's development and emotional growth. Thus, pediatric patients' psychosocial needs are paramount in treatment and are the major concern in using art expression as therapy.

Each of the chapters in this book provides specific details about the psychosocial needs of children who are seriously or chronically ill, hospitalized, or undergoing medical treatment. However, it is important to mention a few of the more common reactions pediatric patients experience. First and foremost, emotional distress is frequently prevalent during and after hospitalization, and long-term sequelae may also occur. Reactions to illness and hospitalization, however, differ according to individual children and depend on various factors. For example, the initial environment in which the patient is seen (e.g. an emergency room, intensive care unit, or a doctor's office) affects the child's response. The patient's condition or illness may be acute or chronic or the child may have had traumatic experiences or emotional distress, in addition to the one that brought the child to the hospital. The quality and amount of social support is also critical and inadequate care from parents or caregivers can compound the psychosocial stress a child experiences.

Three primary sources of stress have been identified in pediatric patients:

(1) separation from parents or caretakers through hospitalization (relocation to a new environment)

(2) loss of independence and control which accompanies illness and hospitalization

(3) fears and anxieties about medical procedures which may cause harm or pain, and worry about death (Golden 1984).

These stresses may affect children in various ways because of developmental factors. For example, very young children (infants, toddlers and pre-schoolers) are particularly vulnerable to separation from parents or caretakers. Children between the ages of five to eight years, while still vulnerable to the effects of separation from family, may be more fearful of procedures and pain and also upset by the loss of control and independence, while older children may become more concerned about dying and the meaning of death. Studies indicate that younger children exhibit more emotional distress than older ones (Jay, Ozolins and Elliott 1983), but older children may be more able to effectively disguise their feelings.

In response to the variety and extent of psychosocial stress children experience, research indicates that there are specific factors which can help

children adjust to illness and hospitalization (Gaynard *et al.* 1990; Prugh *et al.* 1953). These factors include preparation activities and information, frequent visitation by parents, and opportunities for creative activities such as art and play during and after hospitalization.

Medical art therapy: how art helps the pediatric patient

Much of what is known about how medical art therapy can help children, comes from experience about how children use art for self-expression, conflict resolution, and emotional reparation. Art is believed to be a visual language for children and a developmentally appropriate form of communication, especially for young children who may not have the cognitive abilities to express themselves with words. The creative process of art making is not only an integral part of human growth and development, but is particularly important as a means of problem-solving, improvisation, and spontaneous expression for children. These qualities of the creative process are thought to be innate, universal, biological traits of the human species (Dissanayake 1992), as well as inherently therapeutic (Maslow 1983). For children, art expression is a way of knowing the world around them and of communicating and exploring their inner worlds of feelings and perceptions (Kramer 1971; Rubin 1984).

Art therapy is one of few therapies where the individual becomes actively involved in treatment through the process of art making and through the creation a tangible product. For ill or hospitalized children, the active qualities of making, doing, cutting, arranging, molding, gluing, and constructing are valuable in alleviating feelings of helplessness and lack of control often associated with physical debilitation and hospitalization. While surgery, chemotherapy, dialysis, and other medical interventions place children in a passive role in their treatment, art making requires that they become active participants in their health care.

Art expression also provides, with the guidance of the therapist, a way to rehearse and prepare for medical procedures such as surgery, chemotherapy, radiation treatment, and dialysis. Providing the pediatric patient with the opportunity to depict a procedure, not only gives the therapists clues to how the child perceives medical intervention, but also facilitates self-assurance and a sense of mastery. As Piccirillo (see Chapter 6, p.122) observes in her work with children living with AIDS (CLWAs), creative activity naturally enhances mastery, and the essence of 'the art making process involves "doing and undoing" which directly counteracts feelings of helplessness'. She notes

that mastery encourages problem-solving skills, helps to develop confidence in abilities to make choices and enhances one's sense of control over life's events.

Art expression is a 'normalizing activity' (Malchiodi 1998b), one which capitalizes on the essential work of childhood (Rollins 1997). Undeniably, when a child becomes seriously ill, undergoes invasive medical procedures, surgery or other interventions, or is hospitalized for acute or chronic illness, there is a profound effect on the child's sense of self. Being ill may mean wearing hospital clothes, experiencing unfamiliar surroundings, smells and sights, and fear and confusion about what is happening. Hospitalization and serious illness disrupt usual routines and replace them with medical interventions, tests, and medications. In contrast, the creative process of art making focuses on something else besides the illness, disability, or dysfunction.

Of all the expressive modalities used with children, art is one of few which leaves a tangible product, a lasting mark on the world. The resulting image becomes important, not only for communication of feelings and experiences, but also as a visible and external record of the self. As many of the medical art therapists in this book note, art serves an important function as a form of 'visual legacy', a quality which can be particularly important during life-threatening circumstances such as HIV/AIDS, cancer, or other serious illnesses. In cases of terminal illness the art product survives as permanent proof of the child's existence.

While the characteristics of art expression make it a modality of choice in any therapeutic work with pediatric patients, there are several circumstances in which it has been specifically helpful to children in medical settings. These include art-based assessment of the pediatric patient; addressing body image and physical symptoms; enhancing mind-body; encouraging resilience; and complementing the use of medical play with pediatric populations.

Art-based assessments and the pediatric patient

Admission to the hospital, whether an initial hospitalization, a return visit, or an unexpected trip to the emergency room, is a critical period and a stressful time when art interventions can help children cope with traumatic experiences. Art as therapy can also be particularly helpful at this time in establishing rapport and promoting trust with the child and making contact with child and family. Because the child is often in crisis due to the trauma of illness or injury, art-based assessments are useful tools to allow the child to

express feelings and to provide the therapist with information on the pediatric patient's level of psychosocial functioning, symptoms, and perceptions of medical procedures and hospitalization.

Throughout the following chapters, the authors discuss specific art-based assessments they have found valuable in their work with pediatric populations. Art-based assessments are particularly helpful during admission and initial hospitalization, to not only help the therapist understand the child's psychosocial needs, but also contribute data to the medical treatment team. For example, Gabriels (1988; also see Chapter 5) in her work with children with asthma, uses a series of three drawing tasks to evaluate the perceptions of their condition and help them to identify personal and social supports and what triggers symptoms. Councill who works with pediatric cancer patients, notes the usefulness of the Bridge Drawing Activity (see Chapter 4) in helping her understand psychosocial needs through allowing children to express thoughts and feelings about their illness and themselves.

Other medical art therapists who work with children have highlighted the importance of art activities in evaluation, particularly in determining further treatment. Prager (1995) emphasizes the importance of assessment rounds in evaluating the psychosocial needs of hospitalized children, underscoring its value in deciding what additional art interventions will be necessary. In addition to looking at initial drawings for clues to psychosocial circumstances, she also looks for visual indications in the patient's room such as toys, cards, and other belongings to help her determine a plan for medical art therapy.

Art activities in general can be versatile tools in understanding pediatric patients in several areas, such as: developmentally appropriate behavior, emotional maturity, skill level and/or handicaps, cognitive abilities, and presence of stress factors (e.g. degree of family support or pre-existing trauma). For example, upon admission a child with kidney problems may be given a cloth doll with no features and be encouraged to color it with felt pens, creating a face and clothes for the doll. The therapist may capitalize on the activity by interviewing the child and her doll about physical symptoms, helping the patient to explore and clarify why she is being hospitalized and learning what she understands about her illness through her comments and art expression. The therapist may also engage in medical play (for more information about medical play, see below) and 'admit' the doll to the hospital, using the doll to prepare the patient for hospitalization and medical procedures. In this way, art expression is not only extremely useful in helping

the therapist understand what the child perceives about medical treatment, hospitalization, and illness, but also serves a dual purpose as a preparation activity for the child.

Encouraging resilience: enhancing health and well-being in physically ill children

Resilience has been a recent focus in health psychology literature and the importance of enhancing resilience in physically ill children is a primary psychosocial concern of helping professionals in medical settings. Resilience is defined as the successful adjustment and adaptation to life after experiencing an adverse, hostile, or negative event (Garmezy 1993). Children (and adults) who are considered resilient are able to quickly return to pre-crisis state following trauma and who seem to be impervious to negative life experiences. Children who are resilient and who have experienced serious illness, traumatic experiences such as accidents, severe burns, or physical abuse, or invasive medical treatments are thought to have higher self-regard, better interpersonal skills, and tolerate stress to a greater degree than non-resilient children.

For children who have long-term physical disabilities, recurring illnesses or chronic medical conditions, resiliency may involve a continuous effort to cope with traumatic events. In this sense, illness or disability becomes routine part of life, rather than an end or resolution. These children may experience physical and emotional problems, but manage to limit the degree to which these problems disrupt their lives. As a result, resiliency in children leads to a better quality of life, greater self-esteem, a greater sense of optimism, and increased sense of inner control of one's life.

Some aspects of resilience are directly related to early child development and nurture from parents and other caretakers. Other aspects, however, can be cultivated and we now know a great deal about how resilience can be encouraged in 'high-risk' children. For example, social support from family and community, a sense of inner locus of control, and psychological resources are now recognized as key to children's abilities to be resilient in the face of trauma (Rak and Patterson 1996).

Art expression when used as intervention and support, is particularly effective with pediatric patients in supporting and cultivating psychological resources related to resiliency. In particular, creative imagery is a recommended intervention to reinforce children's innate resilience or to teach them to self-manage and cope with stress (Rak and Patterson 1996). As

previously mentioned, art therapy can help children struggling with illness or invasive medical procedures, to develop a sense of control and personal mastery over the traumatic events in their lives. It is also obvious that art expression can be helpful to health care professionals interested in identifying and developing psychological resources necessary to resiliency in children.

Addressing body image and identifying symptoms

Body image is a term frequently used to describe how an individual mentally represents or perceives his or her body. It can also include an individual's attitudes and feelings about physical, emotional, and interpersonal views of oneself. Health care professionals recognize that the integrity of a child's developing body image can be especially threatened by illness, pain and other symptoms, disfigurement, invasive medical procedures, or surgery. It is natural that a child's attention is directed to an ill body part or disability or generalized feelings of illness. Therefore, medical caregivers are often concerned with addressing children's body image and helping them to identify and clarify physical symptoms.

Art expression has been extremely useful in helping caregivers understand more about how children conceptualize and perceive their body images and is particularly valuable in clarifying and addressing their physical symptoms. Some have noted how art expression is helpful in understanding how children experience pain, with conditions such as headaches (Lewis *et al.* 1996) and traumatic burns (Levinson 1986). Erika Cleveland's cogent observations on her work with children and adolescents with eating disorders (see Chapter 3), underscore the importance of addressing body image in pediatric work. Eating disorders have serious physical ramifications which are often intertwined with psychosocial factors. Cleveland finds art expression particularly helpful not only to address the psychosocial complexities of the illness, but also to allow children and adolescents to express how they perceive their illness and how they see it affecting their bodies.

A simple body outline is one of the more common activities used by medical art therapists and other health care professionals with pediatric patients to help them identify areas of pain or discomfort. For example, in Barton's research with juvenile rheumatoid arthritis patients (Chapter 8), the use of the Body Outline Form (BOF) illustrates how art expression can be applied to help children express and clarify pain through color, shapes, and

images. Similar body outline activities can also be particularly helpful in identifying psychosomatic pain and stress in children who have experienced body trauma and psychological crisis from physical or sexual abuse (Malchiodi 1998a; Steele 1997).

Somatic aspects of children's art expressions are intriguing and there is a growing body of information on how children use art to express physical symptoms, sensations, and trends in health or illness. Because somatic aspects are an important topic in the psychosocial treatment of pediatric patients, a separate chapter (see Chapter 9) is devoted to this subject.

Medical art therapy as a mind-body intervention

It has been noted that art making can be a complement to medical treatment and the creative process may be an important aspect of health and well-being (Malchiodi 1998b). Medicine has recognized the value of creative modalities in health and wellness and subsequently, art therapy has been declared a 'mind-body intervention' by the National Institutes of Health Office of Alternative Medicine (National Institutes of Health 1994). Mind-body interventions are techniques used to enhance the power of the mind to influence the body in ways which encourage and stimulate health and well-being. More commonly known mind-body interventions include meditation, yoga, tai chi, and biofeedback, techniques which have been proven to facilitate the mind's capacity to affect the body.

Although there has been very little research on the use of art expression as a mind-body intervention with children, some art therapists have begun to explore just how art expression functions in this capacity. In Chapter 2, Carol DeLue describes her research on the use of mandala drawings with children to explore the physiological effects of this art task on relaxation. DeLue used biofeedback devices to measure children's responses to mandala drawing to determine the efficacy of using a specific drawing task to enhance and encourage relaxation and stress reduction.

Art expression can also be useful in helping children address symptom management and identify what triggers symptoms. In Gabriels' work with children with asthma (see Chapter 5), one of the most common chronic physical disorders in childhood, symptom management is an important goal in treatment. While there may be a familial history and allergic reactions may play an important part in asthma attacks, according to Gabriels, children can learn through art activities to clarify and identify specific factors which trigger their asthmatic attacks.

Therapists who work with pediatric patients often use techniques such as self-hypnosis and guided imagery with pediatric populations. Siegel (1986) reports that guided imagery in particular is valuable in the treatment of cancer patients and may improve some patients' outcomes. Councill (see Chapter 4) notes that these techniques, both with and without visual art components, are helpful in reducing children's anxieties over specific medical procedures and encourage relaxation. Art expression can also be helpful in assisting children in exploring and preparing for medical procedures such as surgery, intravenous injections, or catherization, particularly when combined with play activities. Pediatric patients who are mentally and psychologically prepared for medical procedures are reported to be less anxious, need less medication, and cope more effectively with medical interventions (Peterson and Mori 1988).

Art and play: powerful partners in healing

An introduction to medical art therapy is incomplete without a discussion of the role of therapeutic play in work with pediatric populations. Play therapy is 'a psychotherapeutic method…intended to help relieve the emotional stress of young children through a variety of imaginative and expressive play materials' (Webb 1991, p. 27). It has been suggested that play is one of the most powerful and effective means of stress reduction for children (Petrillo and Sanger 1981).

In clinical work with children, art and play have always been closely intertwined and frequently used to address their psychosocial needs, including emotional reparation, resolution of trauma, and restoration of social functioning. Art therapy and play therapy share a common bond through their natural appeal to children and their healing qualities of creativity, spontaneous expression, make-believe, and non-threatening, developmentally appropriate communication. Integrating art and play is intrinsic to any successful clinical work with children because together they provide an enticing means of creative expression and are consistently appealing during the process of treatment.

Gibbons and Boren (1985) describe three types of play beneficial for stress reduction which correspond to ways that art is used in therapy with pediatric patients:

(1) Recreational play

This type of play occurs naturally, is spontaneous and unstructured, is directed by the child, and is influenced by the child's developmental level. In this sense, play activities may serve as tasks to combat boredom, provide distraction, or occupy long hours of hospitalization or recovery.

(2) Therapeutic play

This type of play activity is structured for a specific purpose by an adult and can be preparatory or cathartic. Child life specialists and activity therapists often use therapeutic play with pediatric patients.

(3) Play therapy

This type of play is considered psychotherapeutic in nature and is often provided by a qualified play therapist, medical social worker, clinical counselor, psychologist, or psychiatric nurse. It can be directive or non-directive, depending on the style and philosophy of the therapist and the specific needs of the child.

In medical settings, therapeutic uses of art are very similar to three types of therapeutic play described by Gibbons and Boron. First, many children may naturally use art as a pastime, a creative activity for self-expression, personal gratification, and recreation. This spontaneous art making is similar to recreational play in that it originates from the child's initiative and is self-directed. Art expression may also be therapeutic and often becomes so, when a helping professional or supportive individual is available to provide an art activity and to be present during the child's art making activity. For example, a child life specialist may offer pediatric patients structured activities to help them prepare for medical procedures or surgery, or to assist in the release of emotions and to alleviate stress.

Lastly, art therapy in a medical setting, like play therapy, involves more than children's spontaneous play or a helping professional offering art activities to pediatric patients. Medical art therapy does not automatically happen when physically ill children are offered the chance to express themselves through art. It is inaccurate to say that by simply introducing hospitalized or seriously ill children to art making, emotions are communicated and safely released, while children automatically master traumatic events and feelings. Knowledge of the specific practice, theory, and

methodology of medical art therapy and how play therapy complements and interfaces with art making, is necessary for successful therapeutic exchange, conflict resolution, and emotional reparation to occur.

The term 'medical play' (McCue 1988) has been used to specifically describe play therapy with pediatric patients, defining it as a form of play that involves medical themes or medical equipment and is distinct from generalized play activities. McCue identifies four types of medical play: role rehearsal/role reversal medical play, medical fantasy play, indirect medical play, and medical art, which is defined as the creative use of art materials and medical equipment. Although medical art is a specific category of medical play, in reality art expression is used to complement all four types of medical play described.

In medical play, children are typically encouraged to use medical equipment to express concerns about procedures and medications. For example, a child may be invited to explore and play with a hypodermic syringe or a Hickman catheter (a device inserted into the patient's chest to receive drug intervention), to help familiarize the child with equipment and procedures. For example, in one unit where I worked, a stuffed animal with a Hickman catheter was used as a prop for introducing and rehearsing how chemotherapy was administered. In many of the chapters in this book, authors note how art and play are interlinked throughout treatment and the importance of including medical play in conjunction with medical art therapy is emphasized. This enhances children's preparation activities, their exploration of illness and hospitalization, and reparation and resolution of physical and psychological trauma.

Medical art therapy and family work

Although this book addresses the application of medical art therapy with children, art therapy with pediatric patients inevitably reaches beyond the patient to the family system. Many of the authors in this book note the importance of assessing the child's perceptions of family dynamics, particularly family interactional patterns and the quality of support received from family members. The pediatric patient's concerns do not affect the child in isolation; the experience of illness pervades the whole family system. While art therapy with families with a pediatric patient could easily fill an entire book, it is nevertheless important to highlight the importance of family art therapy in this volume.

First and foremost, information obtained from families and caregivers plays an important part in designing subsequent interventions for the pediatric patient. Family members serve as a primary source of support for the child, as intermediaries with members of the health care team, advocates for the child's needs, and individuals who help the child adapt and cope with illness. Through art activities with the family, the therapist can explore many interpersonal aspects of the pediatric patient and the family system: how family members perceive the child patient; the amount, type, and quality of support the family can offer the child in hospital or at home during recovery; special concerns of siblings or parents; and parents' feelings and concerns about their child's health care, hospitalization, and medical procedures. Because some pediatric patients may be too ill to participate in art therapy themselves, the parents and siblings may be those in most need of art therapy and in the form of family work. For example, when a child is seriously ill, a great amount of stress is placed on the healthy siblings who have been observed to be the most unattended, isolated, and perhaps the most unhappy of all family members during the crisis of a seriously ill child (Chesler and Barbain 1987; Tritt and Esses 1988). Family art therapy can be key to enhancing the communication of information not always found in medical charts or conveyed by siblings or parents, and can play a vital role in establishing and strengthening supportive relationships between the family and therapist.

For example, as Councill notes in Chapter 4, a parent who does not talk about the child's illness may send a message to the child that such things must not be talked about within the family or with health care professionals. Or the parent who displays a great deal of anxiety and pessimism may inspire a sense of hopelessness in the child, undermining the child's capacity for resiliency. In Councill's experience, art therapy can support communication between the patient, family, and health care team, assisting families in clarifying feelings and strengthening the relationship between the pediatric patient, medical team, and family members.

Barton (see Chapter 8) underscores the importance of evaluating and understanding both children's and parents' or caregivers' perceptions of pediatric patients' symptoms such as pain. Because physicians must often rely on parents' or caregiver's observations of children's pain and symptoms, it is important to have an accurate description of children's pain from their primary caregivers. Drawing is certainly an effective way for children to express symptoms such as pain through colors, shapes, and images. However,

Barton asked not only children to draw their pain, but also asked primary caregivers to draw how they perceived their children's pain. Her study highlights the importance of obtaining information from significant family members, to help the therapist more clearly understand how well caretakers perceive the patients' symptoms. This application of 'caregiver-and-child' art therapy would be undoubtedly valuable for any seriously or chronically ill pediatric population and their families.

Medical art therapy with parents, siblings, and/or extended family members can helps the therapist to identify family strengths, coping skills, and beliefs. In my experience in working with physically ill children's families, it is also particularly important to explore with families their cultural beliefs about illness (i.e. how is illness viewed), as well as religious or spiritual beliefs (i.e. how do spiritual or religious beliefs influence the family and the child). Additionally, a parent's religious beliefs may provide a window as to how the family functions and what strengths they find through their beliefs. Children are often influenced by the family's religious beliefs; for example, a child who has a particular religious upbringing may perceive illness as a punishment for sins. How seriously ill and life-threatened children express the spiritual beliefs of their families, is the subject of the final chapter of this book (see Chapter 9).

Standards and practice of medical art therapy

It is conceivable that in addition to art therapists, a variety of other health care professionals use or are interested in using art as therapy with children who are ill or hospitalized. Social workers, psychologists, play therapists, occupational therapists, child life specialists, clinical counselors, nurses, and even a few pediatricians use drawing or other art activities with children. Children often demand that some sort of action-oriented activity be part of therapy; in order to successfully engage in therapeutic exchange, art expression is a natural modality and a developmentally appropriate means to include in treatment. For this reason, it is important for anyone using art activities for therapeutic goals with children who are ill or hospitalized, to be fully aware of how art making functions in assessment and treatment.

While there are no specific formal guidelines for health care professionals using art as intervention with children in medical environments, there are some publications to consider before one embarks on using art therapy with medical populations. For example, the American Art Therapy Association has established standards of practice (AATA 1989) and ethical guidelines (AATA

1995) for art therapists, which cover the use of art activities in therapeutic settings and the disposition of art expressions made in therapy. While each health care professional has standards of practice and ethical codes governing their specific work with patients, any professional unfamiliar with art therapy guidelines for practice and ethical handling of art expression, planning to use art in therapy with pediatric patients, would be wise to consult them. Likewise, health care professionals unfamiliar with the treatment of children in hospitals may want to familiarize themselves with the Association for the Care of Children in Hospitals (ACCH; see Resources for more information), which has established guidelines for the care and treatment of children in hospitals. These guidelines provide an outline for standards of practice with physically compromised children and their families.

First and foremost, it is important for the health care professional using art as therapy with children with medical problems, to engage only in activities in which one has had training. As the reader will see from the contents of this book and accompanying references, there is much to understand about children's art making, how art functions as a therapeutic modality, and how art encourages self-expression, conflict resolution, emotional reparation, and personal transformation. Each chapter suggests activities and ways of working with pediatric patients or children with serious medical conditions. The interventions provided throughout this book are presented to give the reader an idea of how medical art therapy is practiced by various a t therapists, and how art serves as therapy for diverse pediatric populations. However, to apply these activities without adequate knowledge of both the art process and the clinical skills of working with physically ill, traumatized, or hospitalized children, would be unethical and not in the best interests of pediatric patients.

Because most children who experience physical illness, injury, or hospitalization are traumatized in some way by their experiences, it is particularly important that the therapist understand how children perceive and express traumatic events. For the therapist using art expression with pediatric patients, this means having at least a working knowledge of how children express traumatic experiences through art. Although there has not been a great deal of research on children's expressions of serious illness and hospitalization, there has been quite a bit of research on the art expressions of children who have had traumatic experiences (Malchiodi 1997, 1998a; Tibbetts 1989; Stronach-Bushel 1990). Post-traumatic play and children's

short- and long-term reactions to trauma (Terr 1990) and how children communicate trauma through art making and play, are also important areas of understanding. A brief introduction to this material is presented in Chapter 9 to guide the practitioner.

It is also important that therapists have some degree of knowledge of medical procedures and illnesses and their effects on children. Tracy Councill (see Chapter 4) notes that one can learn a lot about the experience of illness and medical procedures from pediatric patients and their families, and by reading about pediatric illnesses and psychosocial aspects of hospitalization. Knowledge about how illness affects the patient is integral to how art therapy is presented in medical settings. In some cases, the child may be fragile and susceptible to infections, and the therapist must be cognizant of maintaining the sterile environment through appropriate use of media and tools. In other situations, a patient may be unable to participate without physical adjustments, such as arrangements for medical art therapy at the bedside or creation of special devices to help the patient draw or paint. For example, Cotton (1985), in her work with pediatric cancer patients, describes her patient Sabrina as unable to hold a brush at one point, because of the deterioration of her health and the intravenous injections' damage to her hands.

In my own work as a medical art therapist, I feel that it important to have a working knowledge of medical illness, but more importantly to have a level of comfort with illness, medical procedures, and health care systems. In some cases, it is necessary to have a working knowledge of the issues of medical ethics, because families are often struggling with treatment options, concerns about symptom or pain management, and possibly questions about life support or issues of death and dying. A sensitivity to the variety of cultural beliefs about illness, health care, and death are also clearly important to medical art therapy. As previously mentioned, both children's and families' views of illness, death, religion, and spirituality are important and children may use art expression to explore beliefs and questions they have about illness or dying.

Using art as therapy within medical environments poses some specific ethical problems for the therapist to consider. For example, Councill (1993) notes that art therapy with pediatric cancer patients may be offered in the hospital waiting room where children await chemotherapy, radiation treatments, or check-ups. The family, including siblings, may be present and may become part of the art therapy. Confidentiality is not easily maintained

in this open environment where patients come and go at will, and where art therapy essentially takes place in a public arena, such as a waiting room or at the bedside.

While most therapeutic and health care disciplines have standards of practice and codes of ethics, none of these except for art therapists, specifically consider in-depth the use of art expression in therapy and assessment. For this reason, health care professionals using art activities with pediatric patients for the purpose of therapy or assessment should become familiar with the ethical issues involved in the display and disposition of children's art expressions. Because children's art expressions, especially those made by children in distress, are so visually compelling, hospitals and clinics often want to exhibit them to draw attention to the needs and issues of hospitalized children. Although these public exhibitions of children's work may have the best intentions, this practice may not be in the best interests of children.

Therapists who decide to render children's more sensational art expressions public through exhibition, have to consider if this practice is in the children's best interest or promotes interests other than those of the children. First and foremost, therapists and health care facilities must respect pediatric patients' overall safety and well-being, and be concerned primarily with the protection of the child clients they seek to help. It seems somewhat ironic that children who may have emotional problems, are in crisis, or are recovering from physical trauma or illness, are also sometimes inadvertently abused through misuse of their art expressions by the same adults who want to intervene on their behalf.

There are many other ethical issues involved in using art as therapy with pediatric patients. For a more in-depth examination of ethical issues related to the use of art expression with children, Malchiodi (1998a) and the AATA ethical standards for art therapists (1995) may be consulted.

Conclusion

In the chapters which follow, the reader will learn more about how medical art therapy helps children to emerge from their illnesses as emotionally whole, to preserve many areas of normal functioning, to regain a sense of control and mastery, and to reconstruct and restore the self. The authors, each practising medical art therapists, demonstrate through clinical experiences and case material how art therapy within medical settings encourages

pediatric patients to confront and overcome trauma, transform suffering, and create a vision for the future.

Although I have received the support and encouragement of many health care professionals for my work as a medical art therapist, I have always found that children are the most extraordinary advocates and inspiration for the necessity of art making in health maintenance. Their capacity and affinity for using art to attract that which is well within them is proof of art's power to transform and repair. Their unwavering belief in art's power to tap inner resources that reduce stress and channel distress, and restore, normalize, and humanize what are often inhuman circumstances, demonstrates why medical art therapy is a powerful tool in ameliorating illness and sustaining children's health and well-being.

References

American Art Therapy Association, Inc. (1989) *General Standards of Practice Document.* Mundelein, IL: Author.

American Art Therapy Association, Inc. (1995) *Ethical Standards for Art Therapists.* Mundelein, IL: Author.

Appleton, V. (1993) 'An art therapy protocol for the medical trauma setting.' *Art Therapy: Journal of the American Art Therapy Association, 10,* 2, 71–77.

Bach, S. (1990) *Life Paints its Own Span.* Zurich: Daimon Verlag.

Chesler, M. and Barbain, O. (1987) *Childhood Cancer and the Family: Meeting the Challenge of Stress and Support.* New York: Brunner/Mazel.

Cotton, M. (1985) 'Creative art expression from a leukemic child.' *Art Therapy: Journal of the American Art Therapy Association, 2,* 2, 55–65.

Councill, T. (1993) 'Art therapy with pediatric cancer patients: helping normal children cope with abnormal circumstances.' *Art Therapy: Journal of the American Art Therapy Association, 10,* 2, 78–87.

Dissanayake, E. (1992) *Homo Aestheticus: Where Art Comes From and Why.* New York: The Free Press.

Eiser, C. (1985) *The Psychology of Childhood Illness.* New York: Springer-Verlag.

Gabriels, R. (1988) 'Art therapy assessment of coping styles of severe asthmatics.' *Art Therapy: Journal of the American Art Therapy Association, 5,* 2, 59–68.

Garmezy, N. (1993) 'Children in poverty: resilience despite risk.' *Psychiatry, 36,* 127–136.

Gaynard, L., Wolfer, J., Goldberger, J., Thompson, R., Redburn, L. and Laidley, L. (1990) *Psychosocial Care of Children in Hospitals.* Washington, DC: ACCH.

Gibbons, M. and Boren, H. (1985) 'Stress reduction.' *Nursing Clinics of North America, 20,* 1, 83–103.

Goodman, R. (1991) 'Diagnosis of childhood cancer: case of Tim, age 6.' In N. Webb (ed) *Play Therapy with Children in Crisis.* New York: The Guilford Press.

Hill, A. (1945) *Art Versus Illness.* London: George Allen and Unwin.

Hill, A. (1951) *Painting Out Illness.* London: Williams and Norgate.

Jay, S., Ozolins, M. and Elliott, C. (1983) 'Assessment of children's distress during painful medical procedures.' *Health Psychology, 2,* 133–147.

Kaye, C. and Blee, T. (1997) *The Arts in Health Care: A Palette of Possibilities.* London: Jessica Kingsley Publishers.

Kramer, E. (1971) *Art as Therapy with Children.* New York: Schocken.

Levinson, P. (1986). 'Identification of child abuse in the art and play products of pediatric burn patients.' *Art Therapy: Journal of the American Art Therapy Association, 3,* 2, 61–66.

Levinson, P. and Ousterhout, D. (1980) 'Art and play therapy with pediatric burn patients.' *Journal of Burn Care and Rehabilitation, 1,* 42–26.

Lewis, D., Middlebrook, M., Mehallick, L., Rauch, T., Deline, C. and Thomas, E. (1996) 'Headaches: what do children want?' *Headache Journal, 36,* 4, 224–230.

Long, J., Appleton, V., Abrams, E., Palmer, S. and Chapman, L. (1989) 'Innovations in medical art therapy: defining the field.' *Proceedings of the American Art Therapy Association 20th Annual Conference.* Mundelein, IL: AATA, Inc.

Malchiodi, C. A. (1993) 'Introduction to special issue: art and medicine.' *Art Therapy: Journal of the American Art Therapy Association, 10,* 2, 66–69.

Malchiodi, C. A. (1996) 'Artmaking as complementary medicine: art: partners in psychoneuroimmunology and integral health care.' *Proceedings of the 27th Annual Conference of the American Art Therapy Association.* Mundelein, IL: AATA.

Malchiodi, C.A. (1997) *Breaking the Silence: Art Therapy with Children from Violent Homes* (2nd edition). New York: Brunner/Mazel.

Malchiodi, C.A. (1998a) *Understanding Children's Drawings.* New York: The Guilford Press.

Malchiodi, C.A. (1998b) *The Art Therapy Sourcebook.* Los Angeles: Lowell House.

Maslow, A. (1983) *The Farther Reaches of Human Nature.* New York: Penguin.

McCue, K. (1988) 'Medical play: an expanded perspective.' *Children's Health Care, 16,* 3, 157–161.

National Institutes of Health (1994) *Alternative Medicine: Expanding Medical Horizons.* NIH publication #94–066, Washington, DC: Author.

Palmer, J. and Nash, F. (1991) 'The hospital arts movement.' *International Journal of Arts Medicine, 1,* 1, 34–38.

Perkins, C. (1977) 'The art of life-threatened children: a preliminary study.' In R. Shoemaker and S. Gonick-Barris (eds) *Creativity and the Art Therapist's Identity:*

The Proceedings of the Seventh Annual Conference of the American Art Therapy Association. Baltimore, MD: AATA.

Peterson, L. and Mori, L. (1988) 'Preparation for hospitalization.' In D. Routh (ed) *Handbook of Pediatric Psychology.* New York: The Guilford Press.

Petrillo, M. and Sanger, S. (1981) *Emotional Care of Hospitalized Children.* Philadelphia: J.B. Lippincott.

Prager, A. (1995) 'Pediatric art therapy: strategies and applications.' *Art Therapy: Journal of the American Art Therapy Association, 12,* 1, 32–38.

Prugh, D., Straub, E., Sands, H., Kirschbaum, R. and Leniham, E. (1953) 'A study of the emotional reactions of children and families to hospitalization and illness.' *American Journal of Orthopsychiatry, 23,* 70–106.

Rak, C. and Patterson, L. (1996) 'Promoting resilience in at-risk children.' *Journal of Counseling and Development, 74,* 4, 368–373.

Rode, D. (1995) 'Building bridges within the culture of pediatric medicine: the interface of art therapy and child life programming.' *Art Therapy: Journal of the American Art Therapy Association, 12,* 2, 104–110.

Rollins, J. (1990) 'The arts: helping children cope with hospitalization.' *NSNA Imprint,* 79–83.

Rollins, J. (1993) 'Medical students as facilitators of the arts for children in hospitals.' *International Journal of Arts Medicine, 2,* 1, 7–13.

Rollins, J. (1997) 'The artists of studio G.' *Action for Sick Children / Cascade, 25,* 8–9.

Rubin, J. (1984) *Child Art Therapy* (2nd edition). New York: Van Nostrand Reinhold.

Schikler, K. and Turner-Schikler, L. (1992) 'Expressive therapy in pediatric and adolescent gynecology.' *Obstetrics and Gynecology Clinics of America, 19,* 1, 151–161.

Siegel, B. (1986) *Love, Medicine, and Miracles.* New York: Harper and Row.

Steele, B. (1997) *Trauma Response Kit: Short Term Intervention Model.* Grosse Pointe Woods, MI: The Institute for Trauma and Loss in Children.

Stronach-Bushel, B. (1990) 'Trauma, children and art.' *American Journal of Art Therapy, 29,* 48–52.

Terr, L. (1990) *Too Scared to Cry.* New York: Basic Books.

Teufel, E. S. (1995) 'Terminal stage leukemia: integrating art therapy and family process.' *Art Therapy: Journal of the American Art Therapy Association, 12,* 1, 56–61.

Tibbetts, T. (1989) 'Characteristics of artwork in children with post-traumatic stress disorder in Northern Ireland.' *Art Therapy: Journal of the American Art Therapy Association, 6,* 3, 92–98.

Tritt, S. and Esses, L. (1988) 'Psychosocial adaptation of siblings of children with chronic medical illness.' *American Journal of Orthopsychiatry, 58,* 2, 211–220.

Webb, N. (1991 'Play therapy crisis intervention with children.' In N. B. Webb (ed) *Play Therapy with Children in Crisis.* New York: The Guildford Press.

Physiological Effects of Creating Mandalas

Carol H. DeLue

Introduction

Children face many cognitive, physiological and emotional stress-inducing experiences and any skills to help them identify and cope with these stressors are beneficial. It is imperative that children who are under stress are able to express their feelings in a way that is comfortable, safe, and natural to them. Creative expression, specifically art, is one of these ways. Art is the child's universal language, a form of communicating and a way of learning by synthesizing experiences (Levick 1986).

This study described in this chapter investigated whether or not a simple art task, drawing a mandala, could be helpful in reducing stress and inducing relaxation in children. To study the physiological effects of this art task, a group of school-age children's peripheral skin temperatures and heart rates were monitored during a brief twelve to fifteen minute art experience which involved creating a mandala drawing. The results demonstrate a statistically significant physiological effect and indicate that a mandala drawing task may be a simple tool that can be offered to children in order to help them deal with stress and anxiety by encouraging a relaxation response.

Stress and stress reactions

'Stress is the non-specific response of the body to any demand made upon it, whether it is caused by or results in pleasant or unpleasant conditions' (Selye 1974, p.27). Hans Selye, an Australian physiologist and the first major researcher on stress, noted that stress is not only caused by harmful and unpleasant condition, called *distress,* it is also caused by pleasant agents or

situations, called *eustress*. The body undergoes the same non-specific responses to distress and eustress. Eustress may in fact cause less damage than distress; however, the outcome is dependent on how a person responds to it.

An innate stress response, known as the *flight* or *fight* response (Cannon 1932), is often brought on by situations that require behavioral adjustments and can be one of the more damaging stress responses if the stress is prolonged and unabated. Constant stimulation of the sympathetic nervous system because of the fight or flight response is largely responsible for many stress-related illnesses such as headaches, hypertension, gastrointestinal disorders, and some types of pain. Generally, during a situation that elicits the flight or fight reaction, fighting or running from the stress is inappropriate and, in and of itself, becomes a source of stress. Cumulative effects may occur in the body, resulting in chronic stress.

Childhood stress may begin in the womb and studies suggest that the fetus' heart rate may respond to the mothers own stress level (Brazelton 1991; Humphrey 1993). In each stage of development there are stressors which children experience as they grow. Humphrey (1993) states that 'children at all the early age levels, beginning at birth (and possibly before as well) are likely to encounter a considerable amount of stress in our complex modern society' (p.17). Varma (1996) asserts that 'stress is likely to be most evident during periods of rapid change, and since childhood is the period during which we develop most rapidly, a strong argument can be made that stress is likely to be prevalent in children' (p.XIX). Arnold (1990) defines childhood stress as: 'any intrusion into children's normal physical or psychosocial life experiences that acutely or chronically unbalances physiological or psychological equilibrium, threatens security or safety, or distorts physical or psychological growth/development and the psycho-physiological consequences of such intrusion or distortion' (p.2).

Young people face a variety of stressors and are not immune to the physically and psychologically debilitating effects of stress. Stroebel and Stroebel (1984) contend that: 'Evidence of physiological stress generally begins to appear as children experience the pressures of structured educational settings and the competitive milieu of their peer world' (p.252). According to Schultz (1980), 'psychological stress for children is a real or imagined threat that a child experiences with regard to survival and self esteem' (p.13). Children today are experiencing inordinate amounts of stress at increasing levels. In 1993, Humphrey referenced a survey in which more than four thousand Kansas elementary school children revealed that almost

half experienced severe stress behaviors, including headaches, sleep difficulties, biting fingernails, worrying about school performance, stomach-aches, and irritability. Setterlind, Unestahl, and Kaill (1986) noted that: 'Modern life with its constantly increasing change of pace induces both physical and psychological stress reactions in a growing number of individuals at a steadily decreasing age' (p.5). Undoubtedly, the children with severe physical illnesses described throughout this book undergo both physiological and emotional stress reactions because of the course of their conditions, trauma, medical interventions, and disruption of childhood and normal family life.

Elkind (1988) found that 'the way children respond to chronic stress depends upon several different factors, including the child's perception of the stressful situation, the amount of stress he or she is under, and the availability of effective coping mechanisms' (p.166). How people deal with stress in their adult life is determined to a large extent, on their coping in early years (Pellitier 1979). Paras (1985) states: 'Like adults, children experience the physical, mental, and emotional effects of stress. Their fears and anxieties are just as stress-provoking and threatening as those of adults' (p.7). Children often do not have the skills or resources to deal and cope with stress effectively (Chandler 1985). 'Children are being subjected to more stress at an earlier age. As a result children are manifesting signs of stress disease at an earlier age or are at increased risk for developing stress disease later in life.' (Hart 1992, p.17). Childhood stress often leads to both medical and psychiatric risk in adulthood (Gotlib and Wheaton 1997; Hart 1992).

Benson (1975) found that: 'We react in predictable ways to acute and chronic stressful situations, which trigger an inborn response that has been part of our physiological makeup for perhaps millions of years' (p.23). He further discovered that there is a tool that both adults and children can learn to use to deal with their anxieties, feelings of stress and some of the harmful psychological and physiological effects of society. Benson called this tool the relaxation response and stated that it could be evoked to quiet down the autonomic nervous system and bring upon a feeling of relaxation (p.178).

Mandala drawing and stress reduction

Many art therapists and others have noted that art making can be a relaxing activity, one which can reduce tension and anxiety. It is has been observed that when people engage in art making, they are usually focused and attentive to the creation they are producing. Most art therapists also believe that art

making leads to expression of inner thoughts and emotions, providing a way to understand and release uncomfortable feelings. Levick (1986), based on her many years of work with children asserts that they 'need to organize their feelings and thoughts as they develop, and one way to do this is through creative expression' (p.35). Rubin (1984) similarly states that 'children respond rapidly, perhaps unconsciously to the invitation to reveal themselves through a creative modality' (p.63). Jeffers (1990) quoted Freedman as saying, 'the activity of creating art provides an emotional outlet for the release of tension' (p.18).

Rhoda Kellogg (1970), who is widely known for her collection of mandala drawings by children, notes that 'when children work with art materials under favorable conditions, they are calm, self-controlled, and satisfied' (p.69). Kellogg believes that mandalas are a universal form, one which is an important part of sequence that leads from abstract to pictorial images. Fincher (1991), an art therapist who has studied mandala symbolism, refers to Rhonda Kellogg's work, quoting: 'The art of children from all over the world contains mandala forms: circles, crosses inside circles, suns, circles with faces, and so on' (p.20). When children reach three to four years old, the mandala form is created out of random scribbling, and from this point on all other children's art forms subsequently develop.

The term mandala is derived from the Sanskrit word meaning *magic circle* and *center*. The circle itself is universal in nature, found throughout all cultures and civilizations appearing in artistic forms, dreams, meditative rituals, religious traditions, architecture, and nature itself. Jung was the first psychotherapist to study the mandala both personally and professionally. His personal work with mandalas began by sketching every morning a circular drawing that reflected his inner situation at the time. Jung claimed that the mandala had a calming and centering effect upon its maker:

> Without going into therapeutic details, I would only like to say that a rearranging of the personality is involved, a kind of new centering. That is why mandalas mostly appear in connection with chaotic psychic states of disorientation or panic. They then have the purpose of reducing the confusion to order…patients themselves often emphasize the beneficial or soothing effect of such pictures. (Jung 1959, pp.360–361)

Fincher (1991), based on her study of the work of Joan Kellogg, also refers to the therapeutic experience of creating a mandala:

The circle we draw contains – even invites – conflicting parts of our nature to appear. Yet even when conflict surfaces, there is an undeniable release of tension when making a mandala... By making a mandala we create our own sacred space, a place of protection, a focus for the concentration of our energies. (p.24)

Helen Bonny and Joan Kellogg (Kellogg, Mac Rae, Bonny and Di Leo, 1977) found that concentrating on the making of a circular design immediately following intense experiences gave clients a needed opportunity to unwind (p.126). Joan Kellogg (1978) states that because of the intense focusing that occurs during the making of a mandala, an altered state of consciousness and an almost hypnotic state may ensue (p.36). It appears that the body's physiology responds by quieting when the mind is focused on the circular form. Keyes (1974) also notes that: 'The construction of a mandala involves and satisfies a need for order. It is both a process and a product of meditation' (p.58).

Slegelis (1987) specifically set out to determine if drawing within a circle is calming and relaxing. Slegelis' research measured the difference in the number of angles drawn within circles versus squares, to test if drawing within a circle is calming and relaxing. She based her work on the assumption that: 'Angles are interpreted by many psychotherapists as depiction's of frustration and anger (or associated feelings), whereas curvilinear expressions often indicate a state of relaxation' (p.305). Her hypothesis, that there would be fewer angles drawn in circles than in squares, was shown to be true with statistical significance. The study inferred that fewer angles drawn within circles support Jung's claim that creating artwork within a circle has a calming and soothing effect. Smitheman-Brown and Church (1996) also investigated the impact of mandala drawing, examining it as a tool for children diagnosed with attention deficit disorder with or without hyperactivity, and accompanied by impulsivity. They found 'the mandala exercise had the effect of increasing attentional abilities and decreasing impulsive behaviors over time, allowing for better decision making, completion of task, expression of growth in developmental level, and an interest in personal aesthetics' (p.256).

Intent of this study

The intent of this study was to add to the understanding of how art making (in this case, mandala drawings) may be useful in inducing relaxation and

reducing stress responses. Based on the literature that indicates mandalas are calming, it was the purpose of the study to determine through physiological measurements of peripheral temperature and heart rate if the creation of mandalas may be used to encourage relaxation in elementary school aged children. It was assumed that these physiological indices were an indication of relaxation and a determinant of physiological change secondary to being involved in the art process.

The children's heart rate by the means of pulse rate and peripheral temperature were used as measures of relaxation. Measuring the pulse rate is a simple way to count a person's heartbeats and can provide information on levels of stress and tension in the body. Basmajian (1983) referring to heart rate states the following:

> Changes in heart rate may provide valuable information about the present physiological state of the cardiovascular system. Heart rate is influenced by stress, exercise or muscle tension, personality, motivation, emotion, and organic pathology. Heightened levels of arousal, anticipation and muscular tension are intimately linked to increased heart rate activities. (p.30)

Peripheral skin temperature is also a measure of levels of stress and tension and temperature biofeedback instruments were used in this study to measure changing skin temperature. Schwartz (1987) states, 'sympathetic nervous system arousal leads to increased vasoconstriction, which leads to a reduction in blood volume and hence to a cooling effect at the skin' (p.98). Conversely, a decrease in the sympathetic nervous system leads to vasodilation and peripheral warming. Fuller (1977) indicates that 'psychological factors which influence skin temperature include emotional stress, anxiety, and environmental stimuli. An autonomic or sympathetic response to such stimuli results in changes in cardiac output, arterial blood pressure, and peripheral vasomotor activity' (p. 47).

Subjects

The research described in this chapter took place in a suburban city in Northern California. Subjects for this study were drawn from an upper middle-class elementary school day-care program. Subjects consisted of thirty-three children within the age range from five to ten years old. The sample was predominantly Caucasian (twenty-eight subjects); five children were Hispanic, African-American, or Hawaiian. Subjects were randomly

assigned into groups. The experimental group was comprised of seventeen children, seven males and ten females. The control group was comprised of sixteen children, eight females and eight males.

Equipment and materials

Physiological monitoring equipment included a Human Systems Biofeedback 302 thermal instrument to measure the subjects peripheral skin temperature, and a Marshall F-89 automatic oscillometric blood pressure and pulse monitor. The thermistor was placed on the inner wrist of the subjects non-dominant arm with paper tape during the entire session, and temperature was recorded every minute. The wrist location was selected as it was amenable to the study task. The examiner recorded the pulse rate by placing the child's left index finger into a hand held oscillometric monitor after demonstrating on herself. This instrument was chosen due to its simplicity in use and its ability to involve the child.

2.1 Mandala Drawing

Age range
Five years and older

Objective
A simple drawing task that can be offered to a child to help deal with stress and anxiety by eliciting a calming and relaxation response.

Materials
A standard box of oil pastels and one or two 12 x 18 inch sheets of white drawing paper with a 10.5 inch diameter circle drawn in pencil in the center of the sheet.

Task
The child is asked to draw inside the circle and is told that he or she can draw whatever he or she would like. The child may draw symbols, shapes, lines and use any colors. The child draws for twelve or fourteen minutes completing the picture. After completion he or she is asked to give the picture a title and to describe it.

Figure 2.1 Mandala drawn by an 8-year-old female: 'Recycling'. In describing it she said: 'There is a rainbow because there were clouds, because after the rain there is usually sun and then there is rainbows. It was in the rain forest because it does not get much light, so they had a party with balloons, floweres and animals.' Her heart rate decreased six beats per minute from 95 to 88.

Figure 2.2 Mandala drawn by a 7-year-old male: 'The Ocean Picture'. He stated: 'There is an oil can, somebody's pouring it into the ocean. There is a yellow surf board and a shark and right next to it there is a fish and there is three birds and a whale jumping. The shark already ate something so it does not want to eat anything else, so the fish is going to go past it. The fish thinks it did not notice him but it did. It is a nice shark and the whale is a friend of the shark and fish.' During the drawing his pulse decreased 16 beats per minute from 91 to 72.

The experimental group of children who performed the drawing task used a standard box of 36 Pentel oil pastels and one or two 12 x 18 inch sheets of white drawing paper with a 10.5 inch diameter circle drawn in pencil in the center of the sheet.

The children in the control group participated in problem solving activities such as dot-to-dot, matching, and hidden picture puzzles. These activities were chosen because they were believed to be neutral tasks that most closely simulated the treatment task without requiring creative input. These tasks were also selected on the basis that they were familiar to children, would not provoke emotionally stimulating content, and were appropriate for the age variance and differing ability levels of the children.

Research design

This research study used an experimental pre-test, post-test control group design. The treatment of human participants was in accordance with the ethical standards of the American Psychological Association (APA) and American Art Therapy Association (AATA) guidelines for human subject research. Subjects were randomly selected and assigned to the experimental or control group. Each group was pre-tested on the dependent variables. An unpaired two-tailed t-test was the procedure used for statistical data analysis.

Procedure

Each subject was seen individually for approximately thirty minutes during the month of February 1994 between the hours of three and six p.m. Testing was performed in a classroom different from the child's regular room. Room temperature varied between 68°F and 74°F. The examiner and subject were seated side by side at a rectangular table, and their chairs were faced away from distractions in order to decrease stimuli. During the task the examiner responded minimally to questions, so the focus was on the task. The examiner did not initiate any conversation during the task itself, but observed the child and took brief notes.

Using peripheral temperature and heart rate as physiological indices, autonomic arousal was measured by the following procedure:

(1) Introduction and briefing (three minutes)

The researcher met with the child and explained and demonstrated on self how the thermometer, placed on the inside of the wrist of the non-dominant

hand was used. The child's temperature was monitored minute by minute during the entire session. The oscillometric pulse monitor was explained next and then the child's pulse rate was measured.

(2) Warm-up (two minutes)

The child was asked a series of general 'kid's questions' (e.g. How old are you? What is your favorite food? What is your favorite color?). These were asked to put the child at ease.

(3) Activity (twelve to fourteen minutes)

The child was either asked to color in a circle or engage in puzzles. The time slightly varied for each child on this task and was not asked to stop before the completion of the task. This was to control for the corresponding physiological effects of satisfaction rather than frustration. If a child in the experimental group finished prior to an appropriate time they were given the choice to either work a little longer on their picture or begin a new one. The control group children had an abundant number of puzzles to work on during the task time.

(4) HR Measure and closure (five minutes)

The child's heart rate was once again recorded. The child was asked about the drawing or about the puzzles (e.g. Can you tell me about your drawing? Did you like doing the puzzles?). He or she was then asked to answer the initial list of 'kid's questions' again. At the end of this time the thermometer was removed from the child's wrist.

Table 2.1 Heart rate information

	Experimental (n=17)		Control (n=16)	
	Mean	SD	Mean	SD
HR Pre	92.7	15.3	86.4	12.4
HR Post	85.4	11.7	86.8	9.3

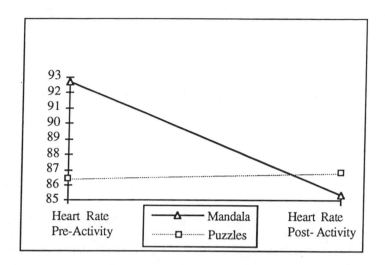

Figure 2.3 Heart rate by condition

Results

For the children in this study, creating mandalas proved to be physiologically relaxing. The results shown in Tables 2.1 and 2.2 indicate that there were significant relaxation effects from the creation of the mandalas.

Results (Table 2.2) of the two-tailed t-test were significant for heart rate change by condition (t=-2.28, p<.05*). The subjects in the experimental group had an average heart rate reduction of seven beats per minute whereas the control groups average heart rate increased less then one beat per minute (Figure 2.3). There was no statistically significant heart rate change by sex (t=.30, p=N.S.) (Table 2.2). There was no difference (t=.67, p=N.S.) in temperature change by condition (Table 2.3).

A marginal significance (t=2.06, p<.05) by gender was indicated between males and females post-temperature change (Table 2.4). The fifteen males averaged peripheral temperature increased 2.2°F. The eighteen females averaged peripheral temperature raised 0.4°F.

The results of this study verified that children who engaged in the creation of mandalas experienced a reduction in autonomic arousal as evidenced by a slowing in heart rate.

Table 2.2 Heart rate change by condition and sex

Experimental (n−17)	
Mean	-7.2
SD	9.1
Control (n=16)	
Mean	0.31
SD	9.9
t-Value	-2.28
P-Value	0.3*
Male (=15)	
Mean	-3.0
SD	10.0
Female (n=18)	
Mean	-4.1
SD	10.4
t-Value	0.30
P-Value	N.S.

Key: SD = standard deviation; N.S. = not significant
*<.05 significance level

Table 2.3 Means and standard deviation for temperature change by condition

	Experimental (n=17)		Control (n=16)	
	Mean	SD	Mean	SD
Temp. Pre	89.6	4.6	91.6	3.1
Temp. Task	90.2	4.2	92.2	2.6
Temp. Post	91.1	3.2	92.5	2.1

Key: SD = standard deviation; N.S. = not significant
*<.05 significance level

Table 2.4 Means and standard deviation for temperature and heart rate change by sex

	Male (n=15)		Female (n=18)	
	Mean	SD	Mean	SD
Temp. Pre	90.5	4.8	90.6	3.4
Temp. Task	91.5	3.9	90.8	3.4
Temp. Post	92.7	2.5	91.0	2.8
t-Value	2.06			
p-Value	.05*			
HR Pre	88.1	13.9	90.9	14.6
HR Post	85.1	10.1	86.8	11.0

Key: SD = standard deviation; N.S. = Not significant
* <.05 significance level

Discussion

Analysis of heart rate change by experimental or control condition indicated that children who engaged in the creation of mandalas experienced a statistically significant reduction in autonomic arousal. There were essentially no gender differences except that males had a greater increase in skin temperature than the females from the initial baseline through the end. There was no significant change in peripheral skin temperature between the control or experimental group. The children in the experimental group had an overall elevated heart rate upon the start of the session compared to the control group. This variable is unaccounted for because the groups were randomized appropriately and there were no differences seen in heart rate between males and females. Both males and females had a reduction in heart rate with no significant difference at either the beginning or end of the session (see Table 2.4).

In using the wrist placement to examine temperature, the researcher was aware that the wrist temperature would be less sensitive than a finger tip placement would have been. The wrist location was selected regardless, because it was less distracting and more comfortable than the finger tip placement. Therefore, it was suspected that heart rate would be the primary physiological measure.

As with all research, this study tried to minimize limitations. Threats to internal validity were accounted for by the random selection of subjects, assignment to groups and use of a control group. Threats to external validity were difficult to control, however. These threats were slightly reduced due to the inclusion of a control group into the study design. A validity threat of regression to the mean was possible due to the experimental group having a higher base heart rate. Threats due to ecology included the possible pre-test sensitization in that the initial pre-test of pulse rate may have reduced the novelty of the instrument or any fears the children had about them. The children were a representative sample of upper middle-class public school aged children in the United States who are in day care because both parents work.

Implications for further research raised by this study include:

(1) To further determine if different art materials and art therapy tasks produce a reduction in autonomic arousal.

(2) To implement the use of a variety of monitoring equipment to measure physiologic responses. Examples include an electromyograph to measure reductions in muscle activity, electroencephalograph to determine the changes in brain waves and measurements of electrodermal activity to observe the correlates with the emotional states.

(3) To compare creating mandalas with other art processes.

(4) To further determine if these results can be generalized to different populations (e.g. adolescents, adults, psychiatric groups).

(5) To lengthen the time of the experiential task in order to determine how physiology changes over a longer period, and to follow up for some time after the task to see if autonomic arousal stays lowered or increases to the pre-baseline measurements.

(6) To assess the application of data to high stress situations (e.g. physically ill children who are anxious about medical interventions,

children who are chronically stressed due to abuse, and other highly stressed populations).

Conclusion

This research uses physiological indices to substantiate Carl Jung's assertion that mandalas have 'a calming and centering effect upon its maker'. The results show how the creativity of art making can initiate a reduction in autonomic arousal and bring upon the relaxation response. This study suggests that children tend to have a reduction in heart rate, regardless of the theme and/or content of the artwork produced. Mandala drawing may be an important activity to offer children who are anxious or experiencing stress because it can help to calm them while offering a developmentally appropriate task for self-expression. This could be particularly important for hospitalized, traumatized, or physically ill children who are undergoing many changes and new experiences because of illness or crises.

The findings of this study contribute to the validity of art therapy by using statistical measures which quantify the physiological effects of engaging in an art task, specifically creating a mandala drawing. This research is viewed as a beginning, and as a way to statistically verify what has been clinically observed in a variety of settings where art therapy has been used.

References

Arnold, E. (1990) *Childhood Stress.* New York: John Wiley and Sons.

Basmajian, J. (1983) *Biofeedback Principles and Practice for Clinicians.* Baltimore: Williams and Wilkins.

Benson, H. (1975) *The Relaxation Response.* New York: William Morrow and Company.

Brazelton, T. (1991, July 30) 'How tension affects the baby.' *San Francisco Chronicle.*

Cannon, W.B. (1932) *The Wisdom of the Body.* New York: W.N. Norton and Company.

Chandler, L. (1985) *Children Under Stress: Understanding Emotional Adjustment Reactions.* Springfield, IL.: Charles C. Thomas.

Elkind, D. (1988) *The Hurried Child: Growing up too Fast too Soon.* Reading, MA: Addison-Wesley Publishing Company.

Fincher, S. (1991) *Creating Mandalas for Insight, Healing, and Self Expression.* Boston and London: Shambhala.

Fuller, G. (1977) *Biofeedback: Methods and Procedures in Clinical Practice.* San Francisco, CA: Biofeedback Press, Consolidated Printers.

Gotlib, I. and Wheaton, B. (1997) *Stress and Adversity over the Life Course.* Cambridge, United Kingdom: Cambridge University Press.

Hart, A. (1992) *Stress and Your Child: Know the Signs and Prevent the Harm.* Dallas, TX: Word Publishing.

Humphrey, J . (1993) *Stress Management for Elementary Schools.* Springfield, IL: Charles C. Thomas.

Jeffers, C. (1990) 'Client-centered and discipline-based art education: metaphors and meanings.' *Art Education 43,* 2, 17–21.

Jung, C.G. (1959) *The Archetypes and the Collective Unconscious.* New York: Pantheon.

Kellogg, J. (1978) *Mandala: Path of Beauty.* Townson, MD: Mandala Assessment and Research Institute.

Kellogg, J., Mac Rae, M., Bonny, H. and Di Leo, F. (1977) 'The use of the mandala in psychological evaluation and treatment.' *American Journal of Art Therapy, 16,* 4, 123–134.

Kellogg, R. (1970) *Analyzing Children's Art.* California: Mayfield Publishing Company.

Kemper, D., McIntosh, K. and Roberts, T. (1991) *Healthwise Handbook.* Boise, ID: Healthwise.

Keyes, M. (1974) *The Inward Journey: Art as Therapy For You.* California: Celestial Arts.

Levick, M. (1986) *Mommy, Daddy, Look What I'm Saying What Children are Telling You Through Their Art.* New York: M. Evans and Company.

Paras, D. (1985) 'Stress Management, Relaxation Techniques and Free Drawings with Elementary School Children.' Unpublished master's thesis, College of Notre Dame, Belmont, CA.

Pelletier, K. (1979) *Mind as Healer, Mind as Slayer.* New York: Delacorte Press/Seymour Lawrence.

Rubin, J. (1984) *Child Art Therapy: Understanding and Helping Children Grow Through Art* (2nd edition). New York: Van Nostrand Reinhold.

Schultz, E (1980) 'Teaching coping skills for stress and anxiety.' *Teaching Exceptional Children 13,* 12–15.

Schwartz, M. (1987) *Biofeedback: A Practitioner's Guide.* New York: The Guilford Press.

Selye, H. (1974) *Stress Without Distress.* Philadelphia: J.B. Lippincott Company.

Setterlind, S, Unestahl, L. and Kaill, B. (1986) *Relaxation Training for Youth.* Sweden: Stress Management Center.

Slegelis, M. (1987) 'A study of Jung's mandala and its relationship to art psychotherapy.' *The Arts in Psychotherapy 14*, 301–311.

Smitheman-Brown, V. and Church, R. (1996) 'Mandala drawing: facilitating creative growth in children with ADD or ADHD.' *Art Therapy: Journal of the American Art Therapy Association 13*, 252–259.

Storr, A. (1983) *The Essential Jung.* Princeton, NJ: Princeton University Press.

Stroebel, E. and Stroebel, C. (1984) 'The quieting reflex: a psychophysiologic approach for helping children deal with healthy and unhealthy stress.' In J. Humphrey (ed) *Stress in Childhood.* New York: AMS Press Inc.

Varma, V. (1996) *Coping with Children in Stress.* Vermont: Ashgate Publishing Company.

Addressing Psychological Complications of Eating Disorders in Children and Adolescents Through Art Therapy

Erika Cleveland

This chapter addresses the use of art therapy with children and adolescents with eating disorders on a short-term crisis psychiatric unit in a medical hospital. In this setting the patients' conditions have stabilized and acute medical care is no longer needed. The focus of the interdisciplinary treatment, including art therapy, is on psychological complications of eating disorders, such as the child's reaction to the trauma of chronic illness and to the related medical procedures. Although the general focus of the treatment team is helping the child and family cope with and manage the eating disorder, art therapy offers the child an opportunity to explore psychological meanings in an effort to begin addressing contributing factors on a deeper level.

This chapter is based on extensive experience with patients with eating disorders and presents observations on developing effective art therapy goals, interventions, and treatment planning to address these complications. Two case studies represent the less common occurrence of eating disorders in males and school-aged children, in that eating disorders more often occur among adolescent girls and women.

Literature review

Literature on the use of art therapy with individuals with eating disorders is somewhat limited. An article by Wolf, Willmuth and Watkins (1986) reviews literature from twenty years ago, on the role of art therapy in the treatment of anorexia. Wolf describes the use of art therapy to treat adolescents and young women with eating disorders in a psychiatric inpatient setting similar to that described in this chapter. The importance of an integrated team approach is stressed, as well as coordination of therapeutic and physical aspects of the disease, including the need for refeeding. More recently, edited texts on eating disorders have addressed the use of art therapy with anorectic and bulimic patients in a variety of settings (Hornyak and Baker 1989) and arts therapies, including art and dance/movement therapies, and psychodrama with eating disorders populations (Doktor 1994). Several authors have focused on the more common occurrence of eating disorders in adolescent girls and women (Gillespie 1996; Levens 1995; Wolf, Willmuth and Watkins 1986). Gillespie (1996) addressed the body-image distortions of young women with both anorexia and obesity, making a connection between the objectification of and splitting from the body that occurs in both illnesses. Levens (1995) makes an interesting connection between primitive, magical beliefs in incorporation and even cannibalization, and the distortion of body boundaries in eating disorders. She shows how art therapy can help provide eating disorder patients with concrete boundaries, within which to explore frightening feelings while maintaining control.

Two art therapists in England have described their work with male eating disorder patients (Luzzatto 1994a, b; Schaverien 1995). Luzzatto formulates the presence of a 'double-trap' image in the work of patients with eating disorders. This image appears to incorporate aspects of the patient's sense of victimization, of identification with the 'trap' which both protects and imprisons the individual and a dangerous 'bad object' outside of the trap. Schaverien (1995), in an extensive case study with a young anorectic man, focuses on the three-part relationship between the art therapist, the patient, and the art work as a healing force. She formulates the concept of the art work as a 'transactional object' which allows the patient to distance from the illness while gaining a sense of self.

Recently, eating disorders have been identified more often in younger children. However, the writer was not able to find references in the art therapy literature on the topic of pre-pubertal children experiencing eating disorders.

Impact of eating disorders on physical and psychosocial areas

Physical manifestations

Anorexia can be seen as a form of self starvation, with symptoms of 'emaciation; poor circulation leading to circulatory failure, shown by pallor, slow and weak pulse, low blood pressure, cold hands and feet, discolored skin and mucosa, occasionally with ulceration; and lanugo hair (a fine downy hair) found particularly on the back' (Bryant-Waugh and Lask 1995, p.14). In anorexia, the diagnosis is made when there is refusal to eat, weight loss, or failure to gain and weight being 15 per cent below expected. In females, amenorrhea is also present (Harper 1994). In bulimia, physical complications may be caused by episodes of binge eating and some purging; or calorie consuming activity, such as laxative abuse or vomiting, or vigorous exercise (Harper 1994). According to Hall *et al.* (1989), medical complications occur in about 40 per cent of people with anorexia and 34 per cent of those with bulimia nervosa, the majority remaining undiagnosed for significant periods. Some of the complications are irreversible and some life-threatening, making hospitalization necessary. Hall *et al.* point out the risks related to the secretiveness of eating disorders, noting that many patients remained unidentified for long periods of time and were only diagnosed upon outpatient visits for related medical complications.

Some studies have shown that eating disorders seem to be occurring with increasing frequency (Lucas *et al.* 1991; Szmuckler *et al.* 1986). In younger children, eating disorders are less clearly defined and more difficult to diagnose accurately. Because the child is at an earlier stage of physical development, aspects of growth and physical development are more seriously affected than in older children, at times causing permanent damage. Bryant-Waugh and Lask (1995a) report that in childhood-onset eating disorders, defined as onset before age 15, there are several variations in the presentation of symptoms and complications, including about 25 per cent referred to their clinic who do not fit traditional eating disorders criteria. They describe the difficulties in using standard criteria developed primarily for adolescent girls to determine the presence of an eating disorder in a younger child. Instead they note 'determined food avoidance, failure to maintain the steady weight gain expected for age, or actual weight loss and over concern with weight and shape' as typical symptoms. The authors have also seen features such as self-induced vomiting, laxative abuse, excessive exercising, distorted body image, and a morbid preoccupation with energy intake in this age group (Bryant-Waugh and Lask 1995a, p.192).

In adolescents and young adults, statistics suggest an incidence of 5 to 10 per cent of eating disorders occurring among males (Barry and Lippmann 1990). The diagnosis of male anorexia is more complex because it is more difficult to identify without the cessation of menstruation as a symptom and, for this reason, may be underidentified (Crisp 1980). Presentation in males includes the 'refusal to maintain minimal normal weight, loss of more than 15 per cent of original body weight, disturbance of body image, intense fear of becoming fat and no known illness leading to weight loss' (Barry and Lippmann 1990, p.161).

Psychosocial factors

A wide range of psychosocial factors affect children and adolescents with eating disorders. There are psychosocial explanations for eating disorders, including early conflicts related to nutritional and interpersonal needs and a difficulty in identifying feelings (Bruch 1974) and a wish to avoid growth, sexuality, and independence (Crisp 1980). Family dysfunction is seen as a contributing factor according to theorists such as Bruch (1974) who suggest that parents of children with eating disorders do not encourage adequate creative expression in their children. Broader cultural factors are also seen as possible contributors to the problem. Eating disorders appear be more common in cultures that emphasize thinness as an ideal of beauty (Bruch 1974), and also in professions that value thinness highly such as modeling and dancing (Szmuckler *et al.* 1986).

Literature with a feminist perspective focuses on the mother-child relationship in attempting to understand the etiology and dynamics of eating disorders, particularly when discussing women with eating disorders (Chernin 1985). This literature links eating disorders in females with the strong bond formed by mothers and their daughters to avoid separation. Schaverien (1995) describes in detail a case in which a young man with anorexia struggles with dependency needs towards his mother and developmental regression. She asserts that there is little difference in the etiology and treatment of males as opposed to females with eating disorders, because both genders with this disease appear to be fearful of becoming adults and to wish for merging with the mother. Schaverien does point out a developmental difference between males and females; the female, in merging with the mother is drawn to the same sex, while in males, the gender difference can lead to confusing feelings, such as a wish for sexual union or gender confusion. Other differences between male and female anorectics

include males' delusion that their body weight is just right, in contrast to females who desire even greater thinness (Barry and Lippmann 1990), and the male focus on muscle mass, leading to abuse of enhancers such as anabolic steroids, which can cause psychosis and depression (Mickalide 1990). In their study of males with eating disorders, Kearney-Cooke and Steichen-Asch (1990) found themes of a lack of cohesive sense of self, and separation issues, including concerns about the separateness of one's own body image from those of others and concerns about control.

Understanding and treating children with eating disorders presents additional problems. Bryant-Waugh and Lask note some of the psychosocial factors related to childhood-onset eating disorders (1995a), describing categories such as food avoidance emotional disorder (FAED), selective eating, and pervasive refusal syndrome. In the first category (FAED), depression, school avoidance, and obsessive behavior are often present. In the second (selective eating), children appear to eat only select foods, but may appear otherwise healthy. In the third (pervasive refusal syndrome), reported in girls between the ages of 8 and 14, there is a pervasive refusal to eat, drink, walk, talk, or indulge in any forms of self care. The intense, frightened avoidance behavior suggests that this may be a form of post traumatic stress disorder in which child victims of physical and sexual violence have been silenced by repeated threats (Bryant-Waugh and Lask 1995a). Many other accounts of childhood-onset eating disorders occur throughout literature with little consensus. The case of Miranda described in this chapter fits some of the characteristics of pervasive refusal syndrome and elements in her art and behavior suggested she had experienced trauma. However, it was difficult to confirm this, given the possibility that Miranda had also been traumatized by some of the invasive medical procedures involved in the treatment of her disease. This points out the difficulties inherent to treating patients with eating disorders and the importance of addressing individual needs as they present themselves.

It is also important to note that children and adolescents with eating disorders can experience traumatic effects from medical interventions such as the insertion of a feeding tube in the nose or stomach. Gavin and Roesler (1997) found that the insertion of a breathing tube can often have a lasting effect on both children and families and stress the importance of appropriate preparation and therapy to treat the symptoms. Shopper (1995) also describes several cases in which various medical procedures caused traumatic reactions. He stresses the need for awareness of these concerns and suggests

that children may become angry at their parents when children see them as colluding with the doctors to provide these invasive treatments.

Setting and population

Art therapy described in this chapter took place in a short-term, locked psychiatric unit of a major children's medical hospital, where the average length of stay is 10 to 14 days. The art therapy program is part of an interdisciplinary team approach, with art-based assessments contributing information about the child's coping style, defenses, and strengths during the initial intake phase of treatment. Art-based assessments can assist the therapist in developing a treatment plan for the patient, while also contributing information that helps the treatment team determine diagnosis and treatment. While the length of hospitalization is becoming increasingly shorter, hospitalizations occasionally last up to several months due to medical or diagnostic complications. The individuals whose cases are described in this chapter had lengths of stay considerably longer than the average for this type of setting.

Children and adolescents are referred to the psychiatric unit by pediatricians, therapists, school staff, or families, and are scheduled for admissions or admitted from the emergency room or from medical units. Many already have extensive outpatient teams, especially those with complicated chronic medical conditions. In these cases, the role of the psychiatric admission is often to assist outpatient treaters and the family to agree on treatment goals or diagnoses. The psychiatric treatment team consists of a psychiatric fellow or psychologist who coordinates the team and provides individual treatment, a social worker, nursing staff, a pediatrician, an art therapist, a nutritionist, recreation therapist, and various specialists in areas such as neurology, cardiology, endocrinology, behavioral medicine, and gastroenterology.

In the case of eating disorders, the child or adolescent and his or her family has often been in the medical system for an extended period of time. Typically the family has sought multiple consultations, with lack of consensus about diagnosis and treatment. The child or adolescent has become accustomed to multiple consultations, often with groups of medical treaters, and has experienced multiple medical interventions. In many cases, admission to the inpatient unit is the first time the family has considered psychiatric treatment for their child.

In the inpatient setting, patients are referred for individual art therapy for several reasons:

(1) They are non-verbal (i.e. electively mute) or have limited access to feelings through words (i.e. serious depression, cognitive-neurological impairment).

(2) They require additional assessment and evaluation.

(3) They do not progress with verbal therapy.

(4) They are unusually responsive to artistic media.

All patients receive group art therapy three to four times a week. Focal inpatient treatment planning (Harper 1989) is used on the unit and helps the clinical team streamline treatment goals based on a step-by-step sequence of:

(1) problem definition

(2) definition of factors contributing to the problem and strengths

(3) selecting factors and defining objectives

(4) developing interventions, evaluation and discharge plan, with the realization that it is important to anticipate discharge needs from the onset of treatment.

In children with eating disorders, psychosocial factors are closely intertwined with medical symptoms. Many children with eating disorders who are eventually admitted to the psychiatric crisis unit are initially seen on a specialized medical floor until their medical condition is stabilized. Treatment on the psychiatric unit includes close monitoring of medical symptoms, such as vital signs, pulse, and weight. Once acute physical symptoms are managed, treatment also includes a program of gradual refeeding (Harper 1986).

Case examples

The following case illustrates a directive art therapy approach to treating the physical and psychosocial impact of an eating disorder on a severely ill adolescent male.

John

John, a 16-year-old with a one and a half year history of anorexia nervosa, was admitted from the medical unit with a weakened immune system and impaired cognition. Preoccupation with weight, dietary restriction, and excessive exercising had worsened two months prior to admission. Despite outpatient intervention and a prior medical admission, John's weight loss continued. He described a need to maintain his current weight in order to perform well in his chosen sport. His parents noticed that he was withdrawing from friends and described him as short-tempered and irritable, with a loss of his 'wonderful sense of humor'. Initially on no medication, he eventually agreed to begin to take medications to treat his depression and disordered thinking. His hospitalization lasted for approximately two and a half months.

John attended weekly art therapy sessions. During his first session, he completed the Diagnostic Drawing Series (DDS) (Cohen, Hammer and Singer 1988), an art-based assessment. The DDS provides information about the patient's emotional and cognitive functioning, based on information gathered from each individual task in a series of three pastel drawings and the patient's response to the sequence of tasks. The first directive 'Make a picture using these materials' may be regarded as 'a graphic representation of the client's defense system' (Cohen, Mills and Kijak 1994, p.106). John's response to the initial directive was to draw a tree 'probably a maple, with rolling hills... I drew this before in elementary school. I call it lonesome tree because it's alone... '

The second directive in the DDS, 'Draw a tree', often results in 'defenses...quickly lower(ing) as a result of shifting to a directive task immediately following the free picture, and so a less guarded response may occur' (Cohen, Mills and Kijak 1994, p.107). John's response to this structured task was to draw a 'very tall Maine spruce...they look really natural, exposed to the elements, weathered'.

In observing John and his art work, I noted the contrast between the tall, thin trunk, and its lack of groundedness, fragmented branch structure, and empty core of the second drawing, and the full, rounded and more grounded tree of the first, free drawing task. According to Cohen *et al.* (1994, p.107), the tree drawing 'can be viewed as a symbolic self portrait, displaying one's vegetative and/or psychic state'. The differences between John's response to the two tasks gave me information about his defensive style. If viewed as self images, John's trees may reflect an initial guarded self-image of groundedness

and fullness, and suggest an underlying fragmentation and lack of groundedness. Both images reflect contrasting, yet equally authentic elements of his personality.

John responded to the final directive, 'Make a picture of how you're feeling using lines, shapes, and colors', with a wish to 'get all his feelings out', and a self-described feeling of 'expansiveness' as he drew an abstract image of concentric circles expanding outward. This seemed to reflect a willingness and ability to think abstractly and begin to address concerns more directly in the art therapy.

The second art therapy session was scheduled directly after a difficult team meeting in which John was confronted by the treatment team, of which I was a part, about a need to increase the medication for his depression. The team felt that John, in this initial stage of treatment, was not able to think clearly due to the way in which the disease had affected his brain. John refused to cooperate in the second art therapy session, turning his back to me. His response suggested that he needed more time to integrate the information presented in the team meeting and perhaps, he also needed more time in order to see me as an ally.

As art therapy treatment progressed, John appeared to develop trust in me, sharing his concerns about his illness, his awareness of its power over him, and his ambivalence about getting better. During a session in the mid-treatment phase, I decided that he was now ready to explore his disease more directly. I suggested that he draw the disease in a visual form. For his second drawing (Figure 3.1), I asked John to draw himself in relation to the disease. This direct approach was chosen to help John to organize and manage his confusing feelings related to the illness and his tendency to become overwhelmed and feel constricted by a more open-ended structure.

John's first drawing, done in pencil, depicts 'the disease of eating disorder…it's a parasite with many bones with mouths, with spines, jagged teeth…it sucks the life out of me.' In response to the second directive, he drew 'the parasite…it is larger than me…sucks the life out of me…my identity…who I am… I do things that I know are wrong…it controls me…it sucks the life, the personality out of my brain and heart.' While drawing these images, John seemed to be close to the emotional experience of his relationship to the 'disease' as he began to weep and speak in a soft, but audible tone.

While the first image is drawn in pencil and is quite small on the page, the second image (Figure 3.1) claims more space. When asked to describe 'what

Figure 3.1 John's drawing of himself in relation to his disease

Figure 3.2 John's image of anorexia

supports you?', he added in colored pencil, 'two of my most favorite colors, blue and green, representing wide open spaces and nature' and added his heart which he colored red. He then added some hands behind his self-representation, describing these as: 'my family, I'll draw the hands supporting me and ready to catch me if I fall – made me realize I'm not so alone.' I explored with John my observation that the anorexia 'parasite' was much bigger than him, as he had drawn it on the page. He seemed surprised at this observation, but also pleased that he had been able to draw his disease and thus make it somewhat less frightening and overwhelming to him.

In the next art therapy session, John was asked to address how the inpatient work related to his life outside the hospital. He described his image as 'Anorexia…it's a prison…it keeps me from the relationships I want to have. This is my mother…we're reaching out to each other but the anorexia keeps us apart. It feels like the anorexia is much bigger than me…it's in my head – it controls my thoughts.' He had depicted the anorexia in a form similar to the previous image (Figure 3.2). However, here he had attached it to his head instead of to his head and heart.

The figure of himself on the left side of the page faces the figure of his mother, who is larger and lower. Neither is grounded and color is not used. I noticed that both figures had open mouths and appeared angry, though he had described them as loving. The lack of correspondence between his comments about the image and its appearance suggested that he might have had underlying feelings of anger towards his mother which he was not able to confront. I knew from team discussions that his mother had become intensely involved in details of his self-care since his illness. I did not comment on these observations, given John's apparent inability to acknowledge these feelings.

I followed up on the imagery instead, by suggesting that John might explore what he could do to change the situation. He drew himself 'beating back the illness', below the first image on the same page (Figure 3.2), and stated that he was now bigger than the anorexia 'parasite, I am punching at it and I broke its bones with my fist. That makes me feel better, to know that I am stronger and can fight back. I look angry.' In this image, he appeared to be exploring the depth of his own feelings, including anger, and using his inner resources to confront the anorexia 'parasite'.

In a later session, John reported that 'at least now I know what the enemy looks like'. He expressed surprise in looking back at the image of the anorexia that was bigger than him (Figure 3.1) and stated: 'I still feel that way

sometimes, but not like it was then.' I pointed out that his figures are drawn in profile, except for one he had entitled 'The Wish', which was the only figure that was not extremely thin. He was able to say: 'I can face myself when I am like that – when I'm too skinny I can't face myself in the same way.' I encouraged him to share his art work with his outpatient therapist and to continue to use art as a means of exploring his feelings related to his illness.

Miranda

The second case involves a young girl with a chronic eating disorder. This case illustrates an art therapy approach that integrates art making with sand play to encourage the patient to explore her concerns. The girl's non-verbal communication was guided by the art therapist, using the patient's unique symbolic language to address her severe physical, psychosocial, and developmental concerns.

Miranda, an eight-year-old young girl admitted for severe food restriction with long-standing malnutrition and growth failure, had had significant delays in social and emotional development throughout her life. She had been refusing to eat solid foods and had concerns about choking on the food. Her mother's drug use, intermittently explosive behavior, and removal from the home, exacerbated Miranda's difficulties. Her mother's recent pregnancy with a three-month-old child also seemed to preoccupy Miranda, although Miranda was not in direct contact with her mother.

During the first month and a half of individual and group art therapy, Miranda drew animals portraying themes of protection and nurturing. She frequently depicted a mother and a baby bird, showing how the mother tries or fails to provide the baby bird with food. For example, she described one drawing as: 'mom is looking for food for baby – she will pop the balloon, there is a worm in it – there is no room for both of them in the big tree.' In this picture, the 'baby bird' sits in the tree by itself. On the reverse side of this image (Figure 3.3), Miranda drew 'a carrot person, so skinny that he doesn't have any clothes on underneath – he's going to a show'. This 'carrot person' is depicted between two birds, similar to those in the first drawing. Three birds surround the 'carrot person': one flying in the sky from left to right, one in the tree to the right of the 'carrot person' and a large bird to the left of the carrot person in a tree that is cut off of part of the page.

In a preceding individual art therapy session Miranda created an image she called 'bird and rabbit country'. This large, extremely detailed pencil

Figure 3.3 Miranda's drawing, 'carrot person' and birds

drawing appears to portray many of the concerns of Miranda's hospitalization. The following is an abbreviated version of her story for this image:

> Rabbit's on a trip. Rabbit forgot to turn the stove off in his house. His wife turns it off. They go to the woods. There they see the duck family – duck and her boy (husband or boyfriend? this was unclear), duck mom (she originally had glasses which were then erased), babies. There's another bird, family-mother is big and dangerous, she has big claws. She protects her little babies. They're cuter. There's a fight between the two (bird and duck) families about whose babies are cuter. Then mother (bird) gets hit in the head by the bad guys. She falls into their net. Bad guys have big noses and that makes them meaner. The chickies (baby birds) save their mother by eating through the net. Bad guys get scribbled (with the pencil) and pecked to death by the chickies. The chickies grow up and fly away.

Miranda expressed pride in this story and asked to show the picture to others on her team in the hospital. The image communicated Miranda's struggles with conflicting, chaotic feelings in dealing with her eating difficulties, and it also portrayed some of the conflicts related to family members, particularly her newly pregnant mother. When she made this image, she was still refusing to eat any solid foods and had not yet begun to talk about her fears related to eating. It is possible that the 'duck mom' referred to the art therapist (who had glasses) as a possible provider of food.

With this single image, Miranda seemed to combine conflicting and contradictory feelings. The 'bird and rabbit country' drawing may reflect ambivalence towards nurturing figures, possibly including the art therapist. The mother bird, 'big and dangerous and with big claws', gets captured and almost killed by the 'bad guys with big noses', but is then saved by the baby 'chickies'. Both bad guys and chickies seem to represent different aspects of Miranda's ambivalence towards nurturance figures in her own life. The image may also represent her ambivalence about recovering (little babies are cuter and perhaps better), although she does represent the 'chickies' as eventually growing up and flying away.

For the first time, Miranda began to openly to discuss her fears with the psychiatrist and other members of the team. She also attempted to eat solid foods, agreeing to hold them briefly in her mouth. During these sessions, Miranda's art work changed. She used paint for the first time, creating a 'sun, cloud, tree, caterpillar, kite and bird'. Miranda changed a 'mistake' of spilled brown paint into a kite, showing a new ability to deal more creatively with problems as they present themselves by integrating mistakes. She said about this image: 'the caterpillar escapes the bird. The caterpillar becomes a gold butterfly.' I noticed that the caterpillar, in escaping the devouring bird, is transformed into a gold butterfly, also suggesting Miranda's willingness to consider alternative resolutions to her fears.

At this point in her treatment Miranda became interested in repetitive sand play. In one session she 'dug up and saved' several small toy figures, saving a small toy 'baby' thirteen times. At other times, the sand became 'bad food' given to Miranda and to me (who was assigned the role of her sister) by the mother. After symbolically representing her own aggression in the form of the bird who seeks to eat the caterpillar, Miranda seemed to need to explore the different meanings of food, including its associations with nurturance as well as with danger.

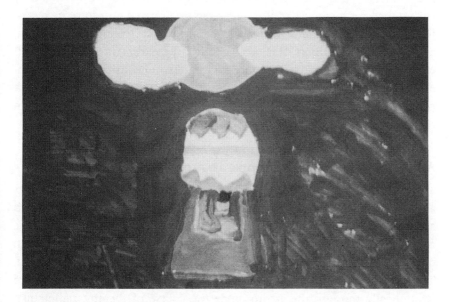

Figure 3.4 Miranda's painting of a 'hot air balloon'

During these final sessions Miranda showed an ability to shift from regressive sand play to more integrated work. In describing a final painting (3.4), Miranda said, 'it's a hot air balloon tied to the ground, no one's in it but when it's dry I'll put someone in it.' She painted the blue background of the sky systematically, painting 'puffs' with paint and then covering them with blue. The blue sky also covers the bottom of the balloon, and there is no apparent connection between the balloon and the ground. The contradiction between her comment about the balloon being tied to the ground and the image in which it is not attached, possibly represented ambivalence about her upcoming discharge.

Miranda's art seemed to reflect her developing ability to tolerate a greater range of affect and to consider alternate approaches to difficult situations. She showed facility in choosing and working with images that represented her most painful fears, such as the bird, over a long period of time. Her stories about the bird's 'adventures' were useful as a source of meaning, in addition to her comments about different images. These images and stories helped me to understand Miranda and to develop treatment interventions.

Miranda seemed to explore issues about her condition through art before she was ready to talk about them or to act on them. However, it was only during the later sessions that this understanding carried over into the rest of her treatment. Her ability to express contradictory feelings through art, along with the support she received in other areas in her treatment, encouraged her to begin to eat more solid foods and consider what it might mean to recover from her illness. She began a difficult task of healing which continued after her discharge from the hospital to a residential treatment center.

Art therapy goals, interventions, and treatment planning

The use of art to understand the patients' symbolic communications provides a means for the therapist to formulate goals and treatment plans which address the highly complex nature of the disease. Though a directive approach is often effective, children and adolescents can benefit from an open-ended approach in which the therapist takes her cues from the patient. The art therapist uses these cues, whether spoken or communicated symbolically through the art, to guide the course of therapy, rather than imposing directives. Children's symbolic communication reveals a complex interweaving of fears, concerns, and hopes related to their medical illness. The non-threatening nature of the art therapy approach is highlighted in the following list of goals and interventions. The discussion of the treatment plan underscores the importance of discharge planning during all aspects of the treatment.

Goals

Goals are determined by the patient's developmental level, emotional readiness, defenses and responsiveness to the art process, among other factors. They must remain flexible because they may need to be adjusted as therapy progresses. Specific goals for using art therapy with children and adolescents with eating disorders include:

(1) Adjustment to primary medical illness through development of coping skills

Art expression can help patients to realize their strengths and coping skills, to develop a sense of mastery over their conditions, and to begin to accept areas of functioning limited by illness. The therapist can reinforce coping skills by supporting the child's art process, such as Miranda's increasing ability to

tolerate her 'mistakes' in art and to create new solutions (as in her first painting).

(2) Expression of trauma related to painful medical procedures and issues related to body functioning and illness

Painful or invasive procedures such as intubations and medications, as well as concerns about issues related to the illness can be expressed and explored through art. Art therapy gives children permission to take control of the direction of the therapy, making choices among the art materials provided to them, and deciding how much or how little to reveal about themselves in their images and verbal communications.

(3) Articulation and expression of fears and concerns related to illness

Art expression is a way for the patients to articulate concerns related to their illnesses, based on their developmental level and readiness. Examples of this include Miranda's use of the bird metaphor to address concerns about eating and swallowing, and John's use of the 'parasite' representation to conceptualize his fears of being destroyed by his eating disorder.

(4) Development of self esteem

Art reflects patients' self images in a concrete way, allowing them distance from their negative self impressions, and enabling a gradual shift to a more positive self perception.

(5) Expression and exploration of body image

Art expression is valuable in describing and exploring body image with individuals who have eating disorders. John's body image shifted from the tall thin, fragmented tree image, to an image of himself as capable of fighting his illness. Miranda's exaggerated concerns with mouths and with swallowing recurred throughout her art in the images of birds. Through her art she also commented on her fantasies about the advantages of remaining small and 'cute'. Art therapy allowed her to visually work through these concerns and to accept alternative images of her body.

(6) Exploration of alternative views about illness

Art expression is valuable in helping patients think about alternative conceptualizations about their illness. John's relationship to the anorexia 'parasite' shifted as it became less overwhelming and less connected with his identity. Miranda's birds seemed to represent both her fears and desires about eating. Through art and play she was able to begin to integrate her identification with the devouring bird or the thing (worm or caterpillar) being devoured.

(7) Expanding one's concept of self in the world and relationships

Both patients described in this chapter, used art therapy to expand on their concepts of the world. The experience of exploration with art materials itself can be seen as an exploration with patients' inner and outer worlds. As patients begin to make choices and develop themes in their art, they similarly makes choices about themselves in the world. The therapist can help make this connection for the patient through interpretations and observations, attuned to the readiness of the patient and considering the therapeutic value of an interpretation in relation to the stage of treatment.

Interventions

Art therapy interventions described in the two cases were designed to address the impact of medical illness on physical and psychosocial functioning. While some generalizations can be made about the types of interventions most useful for this population, it is important to keep in mind the unique nature of each case and to adapt interventions with individual concerns in mind. Contrasting ages and developmental levels in the case vignettes were presented, to reflect the differences in approach with different developmental levels and ages.

In the case of Miranda I allowed her to guide the direction of therapy. Directives were not given and interventions were always based on close observation of the patient's actions and artistic expressions. This approach was based on the observation that Miranda often needed to regroup after making steps forward in her work elsewhere. This stance allowed Miranda to maintain a sense of control and to decide whether to confront problems directly through art and play, or to use expressive modalities more defensively. In Miranda's case, I acted as an ally throughout the therapeutic experience. I accepted Miranda's range of expressions, such as her regressive

play with the sand. Also, in this way, Miranda's experiences were validated and as a result, her fears began to dissipate.

In working with John, I was more directive, presenting him with specific tasks. Interventions included directives such as:

(1) Depict your illness through art

Visualizing his illness assisted John throughout his admission and also guided his transition when he left the hospital. As John commented towards the end of his admission: 'at least now I know what the enemy looks like'. This intervention is useful with patients with an eating disorder, especially adolescents (see Table 3.1).

(2) Depict yourself in relation to your illness

In response to the previous intervention, John was asked to depict himself in relation to his illness. In this way, he was given the opportunity to organize and manage his confusing feelings. The art provided distance from his inner confusion by objectifying his illness (see Table 3.1).

(3) Draw your supports, both external and internal

This intervention provided a way to gauge the effectiveness of John's coping strategies, as well as giving him a chance to explore what these strategies were. He appeared to gain a sense of reassurance from this task. Some elements in his drawing helped direct the future course of his treatment.

(4) Draw how to change the situation

This task allowed John to begin to practice behaviors that could help him manage his illness through art. In some cases, he was asked to explore these concerns directly through art.

(5) A final review of all the art work

This intervention played an important part in the termination process, and in preparing the patient for discharge. Together, the patient and I explored the progress he had made over the course of his treatment, by reviewing his art expressions. Connections were made between the different images, and recurring themes that could help John cope with inevitable difficulties, were explored. I encouraged him to take his art work with him when he left the

3.1 Depict your illness and depict yourself in relation to your illness

Age range
9 and above

Objective
To assist children and adolescents in visualizing, objectifying, and exploring their illness and to provide an opportunity to organize and manage feelings.

Materials
The child or adolescent will need drawing materials such as a set of markers, oil pastels, crayons, or colored pencils; collage materials and glue; and paper to draw on or attach collage.

Task
The child or adolescent is instructed to 'depict your illness through art', using any of the materials available. In response to the previous intervention and during the same or follow-up session, the child or adolescent may be asked to 'depict yourself in relation to your illness'. The therapist explores with the patient the content of the images, helping him or her to clarify feelings, explore beliefs and perceptions, and identify supports, as appropriate.

hospital, to explore it further with his outpatient therapist. I also urged him to continue using art to explore issues on his own.

Treatment planning

Any therapist treating children and adolescents with eating disorders must work closely with the treatment team in all aspects of treatment planning to develop interventions. Within the context of the team, art therapy is often most useful in providing information which communicates the 'voice of the child' expressed through art. It is important that the therapist remain flexible and able to adjust interventions and treatment plans in an ongoing manner,

throughout the course of the treatment, based on changes that occur in the patient and the family. Often changes first become evident in the patient's art and only later in the patient's behavior. This was evident in Miranda's willingness to explore concerns about eating sooner in art therapy than in the other forms of treatment.

In treating psychological concerns of children with eating disorders, it is important to be aware of discharge planning concerns at all stages of the hospitalization. For the therapist, this meant determining how to make use of material presented in the art and to explore how much to leave for treatment in the outpatient setting. Patients often experience their art as a link to the outside world and a record of progress during the hospitalization. The art acts as a transitional object, connecting the patient's work in the hospital to an outside setting.

Conclusion

Art therapy serves a unique function in the treatment of children and adolescents with eating disorders. It is a non-threatening way to gain diagnostic insight into the concerns of these patients. The use of simple, familiar art materials provides children and adolescents with a means to communicate, and to begin to work through the complexities of their illness and its psychological manifestations.

Artistic communications can create a bridge between the child's world and the treatment team, families, and others involved in their care. Art therapy can provide a sense of relief from, at times, frightening medical procedures and treatments. Art therapy also provides ongoing information to the team about a child or adolescent's internal experience of those treatments. The therapist who uses art effectively as therapy with patients who have eating disorders can become an advocate for the patient, helping him or her cope with the traumatic aspects of the medical treatments and communicate concerns to the team.

The child or adolescent gains self-understanding and insight through art therapy and the motivation to begin to heal. Children or adolescents are given a non-threatening arena for practising coping strategies they can use in their lives. Fearful experiences, overwhelming and confusing emotions, and concrete coping skills can be acted out in the art and thereby mastered. Art therapy can be an ally, helping therapists to understand patients and to guide them in a direction that best serves the healing process.

References

Barry, A. and Lippmann, S. (1990) 'Anorexia nervosa in males.' *Postgraduate Medicine, 87,* 8, 161–168.

Bruch, H. (1974) *Eating Disorders: Obesity, Anorexia Nervosa and the Person Within.* New York: Basic Books.

Bryant-Waugh, R. and Lask, B. (1995a) 'Eating disorders: an overview.' *Journal of Family Therapy, 17,* 1, 13–30.

Bryant-Waugh, R. and Lask, B. (1995b) 'Annotation: eating disorders in children.' *Journal of Child and Adolescent Psychiatry and Allied Disciplines, 36,* 2, 191–202.

Chernin, K. (1985) *The Hungry Self.* London: Virago Press.

Cohen, B., Hammer, J.S. and Singer, S. (1988) 'The Diagnostic Drawing Series: A systematic approach to art therapy evaluation and research.' *The Arts in Psychotherapy, 15,* 1, 11–21.

Cohen, B., Mills, A. and Kwapien Kijak, A. (1994) 'An introduction to the diagnostic drawing series: a standardized tool for diagnostic and clinical use.' Art Therapy: *Journal of the American Art Therapy Association, 11,* 2, 105–110.

Crisp, A. (1980) *Anorexia Nervosa: Let Me Be.* New York: Grune and Stratton.

Doktor, D. (ed) (1994) *Arts Therapies and Clients with Eating Disorders: Fragile Board.* London: Jessica Kingsley Publishers.

Gavin, L.A. and Roesler, T.A. (1997) 'PTSD distress in children and families after intubation.' *Pediatric Emergency Care, 13,* 3, 222–224.

Gillespie, J. (1996). 'Rejection of the body in women with eating disorders.' *The Arts in Psychotherapy, 23,* 2, 153–161.

Hall, R., Hoffman, R., Beresford, T., Wooley, B., Hall, A. and Kubasak, L. (1989) 'Physical illness encountered in patients with eating disorders.' *Psychosomatics, 30,* 174–191.

Harper, G. (1986) 'Anorexia nervosa.' In L. Sederer (ed) *Inpatient Psychiatry* (2nd edition). Baltimore, MD: Williams and Wilkins.

Harper, G. (1989) 'Focal inpatient treatment planning.' *Journal of the American Academy of Child and Adolescent Psychiatry, 28,* 1, 31–37.

Harper, G. (1994) 'Eating disorders in adolescence.' *Pediatrics in Review, 5,* 2, 72–77.

Hornyak, L. and Baker, E. (eds) (1989) *Experiential Therapies for Eating Disorders.* New York: The Guilford Press.

Kearney-Cooke, A. and Steichen-Asch, P. (1990) 'Men, body image and eating disorders.' In A. Anderson (ed) *Males with Eating Disorders.* New York: Brunner/Mazel.

Levens, M. (1995) *Eating Disorders and Magical Control of the Body: Treatment through Art Therapy.* London: Routledge.

Lucas, A., Beard, C., O'Fallon, W. and Kolind, L. (1991) '50-year trends in the incidence of anorexia nervosa in Rochester, MN: a population based study.' *American Journal of Psychiatry, 148*, 7, 917–922.

Luzzatto, P. (1994a) 'Anorexia nervosa and art therapy: the 'double trap' of the anorexic patient.' *The Arts in Psychotherapy, 21*, 2, 139–143.

Luzzatto, P. (1994b) 'Art therapy and anorexia: the mental double trap of the anorexic patient. The use of art therapy to facilitate psychic change.' In D. Doktor (ed) *Arts Therapies and Clients with Eating Disorders: Fragile Board.* London: Jessica Kingsley Publishers.

Mickalaide, A. (1990) 'Sociocultural factors influencing weight among males.' In A. Anderson (ed) *Males with Eating Disorders.* New York: Brunner/Mazel.

Schaverien, J. (1995) *Desire and the Female Therapist: Engendered Gazes in Psychotherapy and in Art Therapy.* London: Routledge.

Shopper, M. (1995) 'Medical procedures as a source of trauma.' *Bulletin of the Menninger Clinic, 59*, 2, 191–204.

Szmukler, G., McCance, C., McCrone, L. and Hunter, D. (1986). 'Anorexia nervosa: a psychiatric case-registered study from Aberdeen.' *Psychological Medicine, 16*, 49–58.

Wolf, J., Willmuth, M. and Watkins, A. (1986) 'Art therapy's role in the treatment of anorexia nervosa.' *American Journal of Art Therapy, 25*, 2, 39–46.

Art Therapy with Pediatric Cancer Patients

Tracy Councill

For children with cancer, entering the complex world of long term medical care has been compared to being transplanted into an alien culture (Spinetta and Spinetta 1981). Unfamiliar smells, sights, sounds, words, and medical interventions replace the comfortable rhythms of everyday life, and the diagnosis of a life-threatening illness shatters children's and their families' sense of trust and security. Luckily, these children can find stability through art expression in a time of confusion and upheaval for themselves and their families. Creating art offers the comfort of touch, the freedom of nonverbal expression, reduction of stress, and the opportunity to exercise a measure of control. When art therapy is partnered with medical treatment, children can begin to develop ways to meet the challenges of serious illness.

This chapter will examine the challenges pediatric cancer patients face, the use of art therapy in assessing the child and family's adaptation and coping styles, and the use of art therapy throughout to support children during medical treatment. Art therapy's role in monitoring psychological sequelae of medical intervention will also be discussed and guidelines for establishing a pediatric oncology art therapy program will be offered.

Setting and population

Pediatric oncology clinics typically treat infants, children and young adults who suffer from a wide array of malignancies (cancers) and related disorders. Brain tumors, solid tumors, leukemias and lymphomas may occur in children and related disorders such as osteopetrosis as well as hematological problems such as sickle cell anemia and other anemias, hemophilia, ITP (idiopathic

thrombocytopenia purpura), and thalassemia may be present. Some of these disorders, though not cancers, are serious chronic illnesses, requiring ongoing treatment for many years.

Working in a medical setting such as pediatric oncology does not necessarily require the therapist to have special medical training or expertise. A willingness to learn from the patients and their families, as well as from the medical team is usually sufficient. A working knowledge of symptoms, medication side effects, safety, and issues that evolve during treatment will emerge through experience and familiarity with books and other materials that patients and families use (some of these books are listed at the end of this chapter).

While childhood cancers and many blood disorders are potentially fatal and debilitating illnesses, it is important to realize that childhood cancers overall are treatable, chronic illnesses from which most children will recover. Treatment is generally prolonged and intense, with many complex transitions, including home medical management where parents may perform various aspects of their children's care. Young patients may spend long periods of time in the hospital and in outpatient clinics or infusion centers where they receive intravenous chemotherapy and/or blood transfusions, so a therapist may be called upon to devise interventions that are feasible and helpful in a variety of settings.

Physical and psychosocial impact of childhood cancer

Physical

Though childhood cancers remain rare – somewhere around one per cent of all malignancies (Pizzo 1993) – the diagnosis of childhood cancer is both physically and psychologically devastating to young patients and their families. According to Pizzo (1993): 'In the 1990s, more than 50 per cent of children diagnosed with cancer may be cured. Still, many children diagnosed today face a potentially fatal outcome and nearly all experience side effects of therapy. These side effects can be acute, chronic, extremely incapacitating, and detrimental to growth and development…the current approaches to therapy, though highly successful, place tremendous demands on the patient, the family, and the medical team' (p.178).

Perhaps the most obvious, and for many the most dreaded side effect of chemotherapy is alopecia, or hair loss. Cancer drugs attack the body's most rapidly-growing cells, including hair as well as malignant cells, so this is a

common, though not a universal, side effect. Rapid weight gain or loss, increase or loss of appetite, and mood disturbance and lability may result from certain medications, or from the illness itself.

Many patients report that their sense of taste is altered during the period of chemotherapy, and sometimes for months after treatment has ended. Fatigue, anemia, sleeplessness, and vulnerability to infection are common in cancer patients receiving chemotherapy. Frequent absences from school due to doctor's visits, hospital stays, infections, fevers, nausea, and other side effects disrupt many young patients' lives. Painful mouth and throat ulcers may result from some chemotherapeutic agents, prolonging hospitalization for antibiotic therapy and strong pain medication. Solid tumors may require extensive and debilitating surgery.

Brain tumors and their removal may result in temporary or permanent cognitive and motor impairments. Daily care of an indwelling catheter must become part of the patient and parent's daily routine, and the presence of the catheter itself may preclude swimming and participation in contact sports. The therapist may be called upon to help assess the extent of cognitive impairments, or to help young patients find adaptive strategies to use when carrying out motor tasks. Simple interventions involving lightweight materials that are easily manipulated, or positioning materials within easy reach, can be very helpful to weak or bedridden patients.

Psychosocial

Understanding the psychosocial experience of childhood cancer demands a realistic understanding of the seriousness of the situation. It is not limited to addressing children's questions and perceptions about death and dying, because there are often multiple losses throughout the course of illness. Children and families must live with many layers of losses, among them the loss of the ubiquitous illusion that 'bad things happen to other people'. Koocher and O'Malley titled their landmark 1981 study of childhood cancer survivors, *The Damocles Syndrome,* referring to the myth in which Damocles must enjoy a feast with a deadly sword dangling over his head. Many families and some older patients have also been helped by reading the famous book *When Bad Things Happen to Good People* (Kushner 1981). Though it provides no definitive answer to the inevitable question 'why', the book honors the challenges with which many pediatric patients and their families struggle.

The child's age, cognitive and psychosocial development, and family style, together with the symptoms of the illness and the impact of its

treatment create a picture of the total child. Parents' reactions to the bad news of diagnosis are often the best predictor of how the child will react. For example, a parent who does not talk about or name the illness may send a message to the child that such things must not be talked about. In this case, the child may feel he or she must protect the parents from the bad news that he or she already knows (Bluebond-Langner 1978). Likewise, the parent who verbalizes a great deal of anxiety and pessimism may inspire a sense of hopelessness in the child. In all cases, art therapy can support communication between the patient, family, and medical team and assist families in finding a balance between talking about painful subjects and going on with life.

The principles of child development can help family members and the treatment team anticipate children's needs along the way. A toddler, who is beginning to assert some independence and identity, may react to treatment with anger, aggressiveness, withdrawal, and developmental regression. In early childhood, the challenge to the child's growing independence may produce demanding, irritable behavior, and extreme emotional lability. Generally, the older the child, the greater the emotional impact of the physical changes produced by cancer treatment. Loss of hair, changes in weight, skin, strength, and energy, as well as absence from school and separation from friends, assault the young person's sense of self.

There are distinct developmental differences in children's concepts of death which have a psychosocial impact on pediatric patients. Young children often believe that death is reversible and focus on the abandonment they might feel. School-age children may see death as a punishment, and be particularly fearful of bodily harm. Older children generally have a more sophisticated understanding of death than do younger children, yet it is normal for adolescents to believe themselves to be invincible. Being faced with the possibility of death may push some young people to emotionally mature beyond their chronological years, resulting in even greater ambivalence about peer relationships. It may be only after treatment has ended that such problems as school refusal, risk-taking behavior, difficulty in forming relationships, exaggerated fears, and misplaced anger emerge (Ross 1993). Many of these difficulties may be mitigated or prevented by supportive, age-appropriate intervention during the period of diagnosis and treatment (Stuber et al. 1996).

Art-based assessments in the evaluation of children with cancer

Assessment is an important aspect of art therapy with medical patients, both in the formal sense of administering art assessment tools and in the context of day-to-day work in art therapy. Artwork can be a window not only to the patient's feelings about his or her illness, but also to cognitive and developmental maturity, coping styles, and personality. Strengths and limitations of a child's personality and how the child is adapting to his or her illness often emerge in artwork.

Patient artwork can also assist the medical team in assessing the degree of impairment and progress or regression in cases where there is neurological involvement. For example, a simple task such as copying a diagram of a circle can be carried out in the context of art therapy, at times with greater cooperation from the patient than when it is part of a formal neurological exam. Organic indicators such as slanting figures and use of only one part of the page may be apparent in the drawings of brain tumor patients, especially when neurological damage has occurred due to surgery or radiotherapy.

Though it can be difficult to conduct a lengthy assessment due to limitations of the hospital environment and time, many art-based assessment tools can be useful at initial meetings and throughout treatment. The following art-based assessments and activities can generate important information:

- Free drawings, paintings, or other expressions (i.e. with no directive given by the therapist) are almost always informative, especially when children reflect their choices of subject and the meaning of artwork.

- A bridge drawing (Hays and Lyons 1981) is useful in understanding the child's expectations of the future, and the relative threat or security he or she feels (see Table 4.1 for more information).

- A drawing of a volcano may be useful in understanding how a child manages anxiety (Cox 1993).

- A Person Picking an Apple from a Tree (PPAT) drawing is especially useful in understanding coping ability and resourcefulness (Lowenfeld 1957; Gantt 1990).

- The Child Diagnostic Drawing Series (CDDS) (Sobol and Cox 1992), with its sensitivity to dissociative processes, may have

special relevance to medical populations. Readers are encouraged to familiarize themselves with these assessments since they are useful tools in evaluating children throughout treatment.

More lengthy art-based assessments such as the ones developed by Ulman (Ulman and Levy 1975), Kramer (Kramer and Schehr 1983), and Rubin (1973) can yield important information, especially if there is a question of psychopathology beyond adjustment to the present illness. Family art assessments, tailored to the needs of the family, are often extremely helpful, especially at turning points such as diagnosis, relapse, and completion of treatment. However, it can be extremely difficult to gather all the members of

4.1 Bridge drawing (adapted from Hays and Lyons 1981)

Age range
Approximately 6 years to adult. Appropriate with children who are able to understand task and draw recognizable representations.

Objective
To help the child express how he or she overcomes obstacles and links two periods of life. Children with cancer symbolically cross many bridges during the course of treatment: diagnosis, termination of treatment, relapse(s), surgery, hospital to home or vice versa, and, in some cases, from life into death. Materials: Hays and Lyons, who developed this task, do not specify materials; in clinical applications, any drawing medium and white paper may be employed.

Task
The child is instructed to 'draw a bridge going from one place to another'. With an older child, the therapist may also ask the child to depict going from past to future and placing oneself on the bridge, offering an opportunity for expressing concerns at times of transition. After the drawing is completed, the therapist may wish to consider any or all of the following characteristics: direction of travel, placement of self, places on each side of bridge, solidity of bridge attachments, emphasis by elaboration, bridge construction, type of bridge, matter under the bridge, vantage point of the viewer, axis of the paper, consistency of gestalt, and, of course, the child's associations to the drawing.

a family for the assessment. Parents may not want to disrupt siblings' school and extracurricular routines and medical treatment necessitates numerous interruptions. For these reasons, adding dedicated art sessions for family evaluation is often difficult.

Role of art therapy in the treatment of childhood cancer

Artistic production holds a special place in child development. A very young child's first scribbles on paper are the beginnings of his or her symbol-making capacity, opening the door to emotional expression and representation of images and ideas through graphic means. A grounding in child development and familiarity with the developmental stages of artistic expression form the foundation for understanding and interpreting children's artwork (Golomb 1990).

Creating art in the medical setting brings familiar and usually pleasurable materials into an unfamiliar and sometimes threatening environment. The child artist also gains an important measure of control, as he or she is the creator and foremost expert on his or her art. The displacement inherent in art production encourages emotional expression: feelings too troubling to be spoken directly may be poured out in paint onto paper, or a monster made of clay may represent fantasies too frightening for the child to claim directly (Kramer 1979).

The goals of art therapy with medical patients may include any or all of the following:

(1) inviting emotional expression

(2) encouraging symbolic representation of physical states

(3) expressing expectations of treatment outcome

(4) facilitating coping through diversion

(5) developing personal imagery

(6) encouraging interaction between patients, including opportunities for mutual support

(7) building a sense of competence and control.

Case vignettes

Julie

Julie was a naturally bright and articulate five-year-old from a stable and supportive family. When she began her cancer treatment, art materials were already familiar to her and she used them freely and easily amid the trauma of painful procedures, confinement to the hospital, and separation from her brother. Her first pieces in art therapy were two masks, one representing her brother and the other herself. While her parents were realistically concerned with her life-threatening illness and managing the demands of prolonged treatment, Julie's primary concern at this time was her separation from her brother.

Julie enthusiastically participated in group and individual art sessions, creating a series of abstract mandalas and exploring materials such as glitter, sequins, and collage. However, she began to express her worries by regressing and not cooperating with medical procedures. She became demanding and unreasonable, both with her parents and the medical team, in an attempt to assert some control over her situation. She used artwork as a way to demonstrate her mastery of many materials and tasks, and her imaginative and expressive abilities.

As she began to assimilate information about her medical condition from medical staff, the social worker, and the art therapist, Julie created two works of art demonstrating her knowledge. Having been shown a set of puppets illustrating how leukemia and its treatment affect her blood cells, she fashioned her own set of puppets. One was a smiling white blood cell decorated with silvery tinsel and a braid of brown hair, complete with a stop sign to hold/stop the cancer process. The second was a 'blast', or cancer cell in jagged-edged brown felt, piled with many colors of fabric paint, bits of cloth for teeth, grains of wild rice, and a brown plastic snail. The last one was a smiling red blood cell with a pink hair bow; three platelets, one smudged with brown, and the other two healthy, pink and smiling. Julie also chose two large plastic syringes to represent chemotherapy, giving them smiling faces and little skirts. She used her puppets to enact a short story similar to one the social worker had presented, demonstrating her knowledge of how the leukemia process works and how chemotherapy helps. Her puppets may represent a form of identification with the aggressor, becoming an ally of the medical team and allowing their message to become her own.

At around this time, Julie created a 'Kingdom of Cancer' game (Figure 4.1). She drew a winding board game on two large sheets of paper, dictating

the rules of the game and descriptions of different places to her mother. She made her own set of dice, each with very high numbers of dots. The game was designed to be played with these high-rolling dice, taking the player through the stages of diagnosis, treatment, and recovery, culminating in 'your seventh birthday party' when treatment is over. Here, verbatim, are the instructions she dictated for the game:

First, we're at home, having a great life [1]. Then we get cancer – or if you don't get stuck in the cancer swamp, then you get something else. You get a Broviac (indwelling catheter for administering medications) [2]. Or, you will get a broken arm, sprained ankle, or an acute kind of cancer [3]. When you make it to the castle (hospital), you will have happy times [4]. You are very happy when you get to the castle because it's the day before your birthday when you turn seven [5]. Oops – I forgot. We get shots on the way. We get shots in the back and we get bone marrows and we get yucky medicine. And last but not least, the doctors poke our tummies [6]. But tomorrow you get happy times because it's your birthday [7].

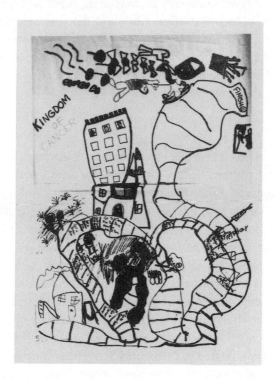

Figure 4.1 Julie's 'Kingdom of Cancer'

The 'Kingdom of Cancer' game was an impressive dramatization, through words, pictures, and play of one child's experience of cancer. Julie used her gameboard to plot out the many experiences she had had and to organize her experience in a visual form. She invited other patients along with myself to play the game with her many times. Each player endured many hardships, but eventually made it to the birthday party at the end.

Throughout her cancer treatment, Julie used artwork as an externalizing and integrating force. She eventually was able to express a great deal of anxiety and post-traumatic stress symptoms through her art expression, and at this writing has begun individual therapy in an attempt to heal the traumatic after-effects of her lifesaving therapy. One of the most potent ironies of the treatment of childhood cancer is that essential and often life-saving care involves painful procedures and debilitating side-effects. Many children with leukemia never feel ill until their chemotherapy begins; it is the life-saving therapy that causes their hair to fall out and their bodies to change, and it is a long time before they will begin to feel better.

In the case of Julie, art therapy became a safe outlet for expression, as well as a bridge between the medical team and the patient's healthy ego. By allying herself with Julie's verbal, cognitive, and creative strengths, I was able to encourage Julie to express herself on an age-appropriate level instead of limiting herself to the regressive, primitive defenses she used in her interactions with the medical team.

Mike

Mike's leukemia was diagnosed when he was ten years old; he completed his treatment at age thirteen. Although he resumed school and social activities, Mike experienced difficulties relating to peers, and problems with concentration and school attendance, resulting in poor grades. Two years after the end of treatment, while his cancer was still in remission, Mike began to have fainting spells and seizure-like episodes. I was asked to consult when a neurological evaluation was inconclusive, to try to discover whether he was 'faking' seizures to get attention, or whether there might be some other reason for his symptoms. Mike had used art to express himself throughout his cancer treatment. Previous to his cancer diagnosis, Mike had a complicated personal and familial history of depressive symptoms and bizarre behavior. His family had immigrated to the United States from another country, where he had been diagnosed with depression at age three. His mother reported that Mike engaged in self-destructive behaviors at that age, such as jumping

off the monkey bars on the playground and not catching himself when he fell. His father had been treated for depression, and the family had also been in therapy, but it was terminated due to logistical and financial difficulties. During his treatment, Mike demonstrated artistic talent, a sense of humor and warmth, and a rather morbid imagination. His mother reported that at times he would talk to her about his funeral plans, apparently, in part, to deliberately upset her.

Mike's first picture in art therapy was done during his initial hospitalization. As his hair began to fall out from the chemotherapy, he drew a tiny picture of a wolf hiding in a cave. He glued his own fallen hair to the wolf to give it fur, identifying with a powerful animal, sheltering it in a safe place, and using a part of himself he had lost in his picture. He and his mother found his use of his own hair very funny. It appeared he was using his idiosyncratic sense of humor to begin to integrate his losses and move towards hope.

Mike depicted dismal themes in his art: car crashes, wars, airplane crashes, and frightening mask-like faces. Occasionally, he would try his hand at more peaceful subjects such as portraits of family members, and one very articulate image of a flower. One of his most disturbing drawings came six months into his treatment on a clinic visit when he was to receive a bone marrow aspiration procedure. This is a painful procedure, performed under what is termed conscious sedation. Patients are anesthetized at the site of the procedure and sedated to reduce anxiety, but they must be alert enough to respond to direction during the procedure. The medical team reports that because of the sedative, patients do not remember the procedure. While most do not have a conscious memory of the procedure, it is my opinion that many young patients retain an unconscious memory of the trauma. Patients are observed to have greater difficulty with the procedure as treatment progresses, instead of adapting to it as one might expect.

Mike created a drawing (Figure 4.2) as he waited in the clinic for a bone marrow procedure. In it he depicts a figure with a very large head and a tiny body, being shot through the head with a bullet from a gun. The figure's eyes are huge and bloodshot and the facial expression one of shock. Blood splatters are drawn on the sides of the head, both where the bullet enters and where it leaves. The bullet is shown exiting on the left side of the page, with blood dripping from it.

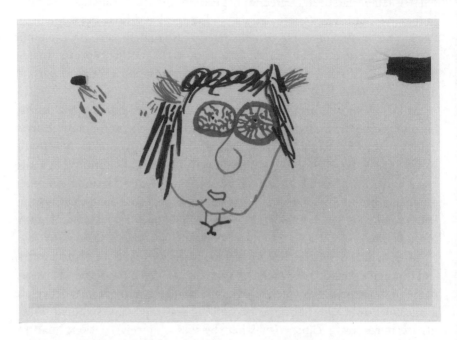

Figure 4.2 Mike's image of a human figure

Though Mike disagreed that the figure represented himself, we conducted assessments for suicidal ideation. Mike denied suicidal ideation or plan and he made no known self-destructive gesture following the drawing. Aside from the provocative content of Mike's drawing, the underlying message of his drawing is one of profound trauma and fear. He said the drawing was about his impending bone marrow procedure, suggesting that he felt the procedure to be an extreme threat.

Mike completed his treatment successfully, moving on to follow-up care which monitors for signs of relapse and long-term side effects of treatment. He continued to have difficulties in school and developed the seizure-like symptoms described above, two years after the end of his treatment. He and his mother both described not only seizures, but also what sounded like panic attacks, with shortness of breath, racing heartbeat, visual disturbances, and fainting with no apparent provocation. When no evidence of seizures could be demonstrated through a neurological evaluation, Mike entered individual art therapy, with the goal of helping him reflect on his experiences

in cancer treatment so that he could re-establish a sense of well-being. Post-traumatic stress disorder could have been related to his physical symptoms, and it was hoped that art therapy could both clarify the diagnosis and allow him an opportunity to work through the trauma he had experienced.

I asked Mike to make a bridge drawing early in this second phase of treatment, to help make the goal of therapy tangible. The task was selected to allow him to express how he bridged the gap between the period of his cancer treatment, his life at present, and his hopes for the future. Mike's well-articulated pencil drawing of a bridge (Figure 4.3) shows a past (during initial treatment), full of holes and broken boards, suggesting a very real possibility of falling off the bridge altogether. The middle section, representing the present, appears solid, but the bridge ends abruptly, leaving the right quarter of the page completely blank. No environment around the bridge is depicted at all. Mike did not offer a full explanation of his artwork, but he was positive that it was finished. His shaky past and relatively solid present make sense in the context of his medical history, but the absence of any future at all is an indication that his expectation of the future – continuing life – may not be possible.

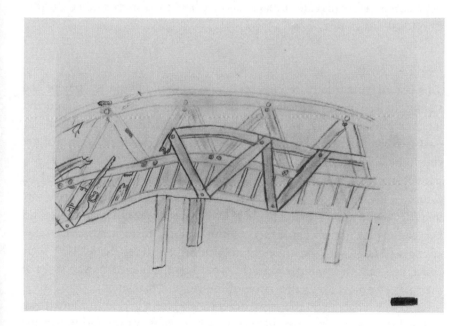

Figure 4.3 Mike's bridge drawing

A few weeks later, Mike created a small pencil drawing, for which he offered no explanation, but which may suggest both the presence of dissociation and a profound difficulty trusting others. The drawing, which he created spontaneously, depicts a tiny figure, wide-eyed and open-mouthed, running to catch an enormous heart-shaped balloon that is about to float away. As was his preference, he declined to talk about his artwork, but it seemed to contain powerful visual themes. Mike's heart-shaped balloons may represent feelings, especially love and happiness, but their floating away shows difficulty in trusting that it is safe to express such feelings. Perhaps Mike believed that if he did so, he would be carried away like the giant balloon, or he would lose all control of his feelings as they floated away beyond his grasp. There is a sense of anxiety in both the figure's facial expression and in the short pencil strokes shading the grass. The image of letting go versus holding on to the balloon may suggest that Mike is coping with a dissociative process – feeling a disconnection between himself and his emotions or actions. Stuber *et al.* (1996) reported that as many as 12 per cent of childhood cancer survivors may experience symptoms of post-traumatic stress disorder, including anxiety and dissociation. Though many preventive interventions were made with Mike during his medical treatment, his history of problems before his cancer diagnosis may have predisposed him to further emotional difficulties.

Family art session

This last vignette briefly describes a family art session with the parent and siblings of a child with cancer. A family art session can be a truly supportive intervention, especially for the siblings of a medical patient. Keri, an eleven-year-old, experienced an extremely dangerous reaction to her chemotherapy during the first days of her treatment for leukemia. She participated in a swim meet on Friday, was brought to the hospital on Saturday, and by Monday morning was on a respirator in the intensive care unit (ICU). She was to remain in the ICU for several weeks. During this time, her parents sought the guidance of the medical team in preparing her younger siblings, ages six and eight, to visit her in intensive care. They were concerned that the younger children would be frightened by the sight of their sister hooked up to a roomful of life-support machines.

Keri was sedated and therefore unresponsive for a period of time. It was decided that the siblings would visit after Keri came off the respirator, and could communicate with them. Prior to this visit, the father and the two

younger children came for an art session to prepare them for visiting their sister.

Among other art tasks, they worked together to make clay figures of their sister, depicting how they thought she might look. The father created a hospital bed and the two younger children, rudimentary clay figures. The eight-year-old brother struggled with his representation, as the arms continually fell off. Eventually, he began to cry, at first in frustration, and later while expressing his fears about how his sister might appear in the ICU. At that point, his father and I were able to offer a realistic description of what to expect on the ICU, and his fears seemed somewhat allayed.

The session ended with the family members and the art therapist joining to create artworks as gifts to decorate Keri's hospital room. Confronting the very frightening reality of the older sibling's situation through the tangible medium of art, offered family members the opportunity to replace the frightening images in their imaginations with accurate information and realistic expectations.

Art interventions

Many possible art interventions have been described in the previous sections of this chapter. In each case, art therapy was designed and guided with the individual child in mind. Some other art interventions, useful with pediatric cancer patients, should be mentioned in addition to those discussed within the case examples.

Clay is often a welcome and engrossing tactile medium for seriously ill children. The idea of making a 'mess' with clay within the sterile hospital confines can be appealing. Many types of clay might be included in the therapist's collection of materials, such as paper clays, play-dough, and the newer synthetic clays, each with its nuances of scent, pliability, and potential for permanence. Some children worry about getting their hands messy, and the smell of the clay is sometimes offensive, especially when chemotherapy distorts perceptions of taste and smell.

Though one might suppose otherwise, materials such as clay and dry sand are not suspect from an infection control perspective. Nonetheless, the therapist should consult the experts on infection control at a particular institution before employing such materials, and follow whatever precautions are suggested. In a bone marrow transplant setting, where patients are essentially devoid of an immune system for a period of time, sand might be autoclaved (heat sterilized) for extra safety and markers wiped with

disinfectant before being brought to the patient's room. For transplant patients, only new materials should be offered, and they should be left in the patient's room for the duration of treatment so that germs do not travel from one person to another via art materials. Similarly, if the child patient has some highly contagious disease, such as chicken pox, materials offered should be given to the child to keep rather than carried from room to room. Most art materials available for use with children are nontoxic, but any carrying a hazardous label (polymer clays, clays and glazes in powder form) should be used in accordance with the manufacturer's safety data sheet, available from the manufacturer.

Self-hypnosis and guided imagery exercises, both with and without visual art components, may be highly successful in reducing a child's anxiety over specific medical procedures. Simple interventions such as storytelling may distract young children effectively from blood drawing and intravenous placement. Older children may enjoy developing their own guided imagery exercises, in which the therapist leads the patient on an imaginary exploration of pleasant environment. The seashore, a meadow or woods, or the patient's own room are often chosen. Drawing a picture of a safe or favorite place can be a tangible reminder of the patient's relaxation cues. Blowing bubbles is an easy technique for encouraging deep breathing and relaxation. Many authors, including Bernie Siegel (1986), report using visual imagery to improve cancer treatment outcomes. I have not explored this possibility in any depth, though there is a great body of intriguing literature on mind-body medicine.

While individual art therapy is important, group art sessions can help patients support one another and reduce the sense of isolation that medical treatment often brings. Open art studio experiences in a clinic waiting room or hospital playroom can reduce anxiety and offer both an expressive outlet and the opportunity to assert control in a situation where many of the child's choices are taken away. In such settings, the therapist may introduce and lead an activity that continues for several hours with individual children moving in and out of it, in response to the demands of their medical care. A given child might interact with the therapist in several mini-sessions throughout the day, or spend several hours moving from project to project. Group boundaries in such a setting are necessarily loose. The therapist functions as gatekeeper, welcoming new arrivals, encouraging cooperation with treatment routines, and helping children articulate their feelings about the

many interruptions treatment causes in their lives. Siblings may accompany patients and participate in art therapy as well.

Art therapy can also be useful on visits to patients' school classrooms. Often a collaborative effort by medical personnel and the therapist can help educate the ill child's schoolmates and teachers about what to expect and how to approach the ill classmate. An art activity shared by all members of the class can help the child-patient and his or her classmates understand the child's illness and reestablish relationships. Learning that there are simple things that they can do to help their ill classmate, like washing their hands and being a friend, can be a relief to worried schoolmates. Perhaps the most important goal of any school visit is to establish that cancer is not contagious because many children and adults make this assumption.

Conclusion

One of the contributions of art therapy to cancer treatment is the possibility of helping young people emerge from their illnesses as emotionally whole and healthy as possible. Encouraging growth and development through art activities can help the ill child preserve many areas of normal functioning. The child who struggles with parents over administration of medicine and cooperation with medical procedures may regain a sense of control in art therapy and employ his most mature and age-appropriate behaviors around the art table, restoring to himself and to his parents the hope that he can be his 'old self' again. The therapist may also model appropriate limit-setting and redirection through art activities, and help young people with cancer find ways to express troubling feelings and care for themselves.

Art therapy can be an important tool for communication between the child and his or her family and the medical team. Art making offers the pediatric patient a unique opportunity to convey perceptions, experiences, and personal strengths and deficits through both process and product. Crayons and paper cannot replace the powerful drugs of modern cancer treatment, but they can go a long way toward helping young people see themselves as active partners in the process of getting well.

References

Bluebond-Langner, M. (1978) *The Private Worlds of Dying Children*. Princeton, NJ: Princeton University Press.

Cox, C.T. (Speaker) (1993) *The Volcano Drawing: A Technique for Assessing Levels of Affective Tension.* (Cassette Recording No. 16–143). Denver, CO: National Audio-Video.

Gantt, L. (1990) 'A Validity Study of the Formal Elements of an Art Therapy Scale for Diagnostic Information in Patients' Drawings.' Unpublished Doctoral Dissertation. Pittsburgh: University of Pittsburgh.

Golomb, C. (1990) *The Child's Creation of a Pictorial World.* Los Angeles: University of California Press.

Hays, R.E. and Lyons, S. (1981) 'The bridge drawing: a projective technique for assessment in art therapy.' *The Arts in Psychotherapy 8,* 207–217.

Koocher, G.P. and O'Malley, J.E. (1981) *The Damocles Syndrome: Psychosocial Consequences of Surviving Childhood Cancer.* New York: McGraw-Hill.

Kramer, E. (1979) *Childhood and Art Therapy.* New York: Schocken.

Kramer, E. and Schehr, J. (1983). 'An art therapy evaluation session for children.' *American Journal of Art Therapy 23,* 3–12.

Kushner, H. (1981) *When Bad Things Happen to Good People.* New York: Avon.

Lowenfeld, V. (1957) *Creative and Mental Growth* (3rd edition). New York: Macmillan.

Pizzo, P. (1993) 'The medical diagnosis and treatment of childhood cancer.' In N. Stearns (ed) *Oncology Social Work: A Clinician's Guide.* Atlanta, GA: American Cancer Society.

Ross, J. (1993) 'Understanding the family experience with childhood cancer.' In N. Stearns (ed) *Oncology Social Work: A Clinician's Guide.* Washington: American Cancer Society.

Rubin, J. (1984) *Child Art Therapy.* New York: Van Nostrand Reinhold.

Siegel, B. (1986) *Love, Medicine, and Miracles.* New York: Harper and Row.

Sobol, B. and Cox, C.T. (Speakers) (1992) *Art and Childhood Dissociation: Research with Sexually Abused Children.* (Cassette Recording No. 59–144). Denver, CO: National Audio-Video.

Spinetta, J. J. and Spinetta, D. (1981) *Living with Childhood Cancer.* St. Louis, MO: C.V. Mosby.

Stuber, M., Cristakis, D.A., Houskamp, B. and Kazak, A.E. (1996) 'Post-trauma symptoms in childhood leukemia survivors and their parents.' *Psychosomatics 37,* 3, 254–261.

Ulman, E. and Levy, B. (1975) 'An experimental approach to the judgment of psychopathology from paintings.' In E. Ulman and P. Dachinger (eds), *Art Therapy in Theory and Practice.* New York: Schocken.

Further reading

Adams, D. W. and Deveau, E. J. (1988) *Coping with Childhood Cancer.* Ontario: Kinbridge.

Baker, L.S. (1988) *You and Leukemia.* Philadelphia: W.B. Saunders.

Children's Brain Tumor Foundation (1995) *A Resource Guide for Parents of Children with Brain or Spinal Cord Tumors.* New York: Children's Brain Tumor Foundation.

Moyers, B. (1993) *Healing and the Mind.* New York: Doubleday.

Treating Children who have Asthma

A Creative Approach

Robin L. Gabriels

Asthma is currently considered one of the most common chronic respiratory diseases in the United States with 30 per cent of all asthmatics under the age of 18 years, and '...roughly half of all cases are diagnosed by 5 years of age' (Weiss 1994, p.154). There is evidence to suggest that there has been an increase in the prevalence of asthma in the United States over the past 10 years (1982 to 1992) by approximately 42 per cent and reported deaths from asthma have increased by 40 per cent (Todd 1995). The occurrence of death from asthma is highest in asthmatics between the ages of 5 to 35 (LeSon and Gershwin 1995). Also, current annual asthma-related health care costs in America exceed $6.2 billion and '...60 per cent of total asthma-related expenditures involve emergency room visits and/or hospitalizations (Todd 1995, p.3).

A retrospective study conducted by LeSon and Gershwin (1995) identified predictive conditions and risk factors related to asthma hospital admissions and incidence of intubation in asthmatics between the ages of 5 and 34. Statistically significant risk factors associated with intubation were: '...psychological and psychosocial problems, family dysfunction, low socioeconomic status, little formal education, intercurrent respiratory infection, crowding, a prior asthma emergency room visit in past year, a prior asthma hospitalization in past year, steroid dependency, parental history of allergy or asthma, a language barrier, cromolyn usage, atopy, prior intubation, active tobacco smoking, secondhand smoke exposure, duration of asthma for over 15 years, unemployment, and female gender' (p.237).

Asthma is currently defined by three characteristics:

(1) partially reversible airflow obstruction in the lungs

(2) inflammation of the airways

(3) hyper-responsiveness of the airways to a variety of stimuli. (Weiss 1994, p.155)

Although these are the common characteristics which define asthma, patients vary with regards to the frequency, intensity and reversibility of asthma attacks, along with the types of stimuli that affect the airways. In addition, a patient's frequency of asthma attacks may depend on the number of asthma triggers and/or degree of airway hypersensitivity. The patient's ability or willingness to recognize and treat their symptoms of asthma may affect attack frequency and the intensity of an asthma attack can influence their expectations of future attacks (Creer and Bender 1995). This heterogeneous presentation of asthma among patients requires that health care providers consider each patient's individual illness differences when defining appropriate treatment strategies.

Physical and psychosocial impact of asthma

Asthma affects many aspects of the individual's life, including their family and community support systems. It is important to consider how these systems are affected by asthma to assist in defining effective treatment interventions.

Chronic illness has been found to increase the risk for mental health problems in children. There are varied reasons for this increased risk and some involve exposure to stress and trauma associated with medical procedures, separations from family due to hospitalizations, illness management complications, and illness-related disability (Wamboldt and Levin 1995).

Creer, Stein, Rappaport and Lewis (1992) reviewed childhood asthma research and identified the impact of asthma on the child's physical, emotional, cognitive, and social development. Difficulty in breathing, possible weight gain from steroid medications, and unpredictable nature of asthma attacks in response to a variety of environmental triggers can limit physical, social, and play activities. In addition, research has revealed that asthmatics have higher rates of school absenteeism than non-asthmatics and this interferes with learning, social acceptance, and participation in

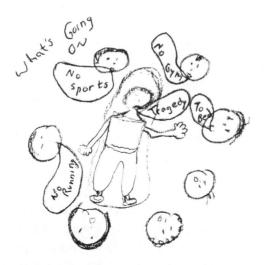

Figure 5.1 14-year-old's drawing of 'what asthma feels like'

extracurricular activities (Bender 1995). These limitations can contribute to a child's decreased self-esteem and self-efficacy as well as cause others to perceive the child as fragile and vulnerable (Creer *et al.* 1992). For example, one 14 -year-old boy drew a picture (Figure 5.1) to describe what it feels like to him when his asthma bothers him. He stated that he is in the middle and '…all around me are voices of reality…saying I can't do this, I can't do sports, I can't do the gym run, I can't do the things that I want to do. It's just too bad…I want to do these things, but I can't 'cause of the asthma. So, it just doesn't make me feel all that great…knowing that I'm limited, restricted because of my illness.'

Empirical research has examined the relationship between asthma and emotions. There has been some evidence to suggest that negative emotions (i.e. panic, fear, and anger) are not only caused from asthma, but may exacerbate asthma. However, conflicting findings indicate that this relationship is not strong and needs to be researched further (Lehrer, Isenberg and Hochron 1993). A study by Silverglade, Tosi, Wise and D'Costa (1994) involving 129 asthmatic adolescents and 74 non-adolescent asthmatics between the ages of 12 and 18 revealed that severe to moderate asthmatics differed significantly from mild asthmatics and non-asthmatics in their need for approval, inability to control emotions, and feelings of anxiety,

depression, and hostility. These findings support the idea that there may be a relationship between beliefs about personal control, mastery, and confidence with asthma severity.

Two drawings (Figures 5.2 and 5.3) and corresponding comments by a 13-year-old asthmatic girl reflect this sense of helplessness and lack of control over asthma and environmental triggers. For example, she described the first drawing (Figure 5.2) by stating: 'That's me (middle figure) and that's …supposed to be the asthma (referring to the two figures holding the rope) and it's squeezing my chest, because it's kind of how it feels when you're tight. I'm saying "it hurts" and they're happy that they're doing it.' About the second drawing (Figure 5.3) she said: 'That's me and there's a line in the middle 'cause half is cold and half is hot. It's like the fluctuation of the temperatures and how I'm in the middle and it's always fluctuating. I'm really allergic to rag weed. It seems like it never goes away and I'm saying that I wish it would stay cold or hot and for the rag weed to go away. She's mad about it. She's unhappy too. She's sad. She just wants it to be normal so that she can be well.'

Milgrom and Bender (1997) reviewed the pediatric asthma research regarding children's non-adherence to taking asthma medications. Findings indicate that teenage asthmatics have particular difficulty being compliant with taking their medications, largely because they are dealing with developmental issues of negotiating autonomy. Children may attempt to withdraw from their parents' involvement by being passive or rebellious, using medication noncompliance as a means of exercising control and/or their independence. This, in turn, can heighten parents' anxiety and they may respond by attempting to increase their involvement in their child's asthma medication management. This struggle can develop into a pattern of poor asthma management and dysfunctional patterns of family interaction. In addition, these maladaptive patterns have '…been identified in children and adolescents who died from asthma' (Milgrom and Bender 1997, p.5). Therefore, these authors stress the necessity of well-coordinated medical and psychological support services for these kinds of families.

Impact on the family

Asthma can trigger family stress due to the increase in medical expenses, interruption of family plans and daily routines, delay of other family members' needs in order to focus on the chronically ill member, and loss of privacy due to the increased involvement with health care professionals. As

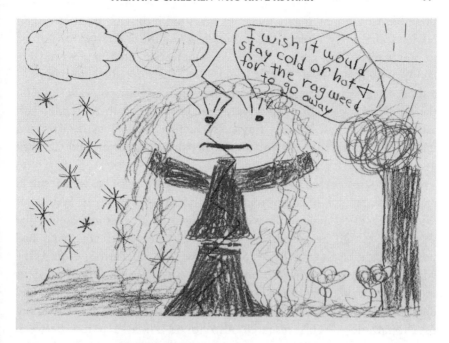

Figure 5.2 13-year-old girl's drawing

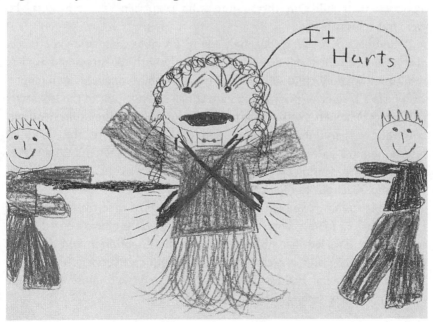

Figure 5.3 13-year-old girl's drawing

these burdens mount, family members may find it difficult to discuss their related feelings (e.g. resentment) to avoid causing the child who has asthma to feel guilty. This can eventually communication problems within the family (Wamboldt et al. 1995). In addition, the unpredictable nature of asthma can generate a sense of uncertainty which can be a constant strain on the family and can affect how family members relate to the child with asthma. All of these stresses can cause families to feel inadequate and incompetent in their ability to control their lives (Patterson and Garwick 1994).

Asthma stresses each family member in different ways which can result in maladaptive patterns of coping and interacting. A recent study by Wamboldt et al. (1995) of 62 adolescents with difficult-to-control asthma, found that there was a high proportion of parents of these adolescents, who had post-traumatic stress experiences of their own, most occurring prior to the adolescent's onset of asthma. In addition, parents with a history of previous trauma were more vulnerable to having their own emotional i.e. anxiety and depression) and medical problems, and their adolescents tended to have more psychopathology. This research also found an association between previously traumatized parents and their tendency to respond with more anxiety to their child's life-threatening asthma experiences than parents who were not traumatized.

Wamboldt et al. noted that the parents' previous traumatic experiences also influenced their ability to deal effectively with the stress and anxiety resulting from their child's illness. For example, they concluded that parents who have a history of prior trauma are at risk of engaging in the following parenting behaviors: withdrawing and under-treating the child's asthma, becoming hypervigilent, anxious, and over-protective of the child, or responding in a state of hyperarousal/hyperreactivity when the child is sick. Each of these parenting behavior patterns can affect a child's emotional and behavioral reactions to their asthma.

Various studies have documented that siblings of medically ill children tend to have academic, adjustment, and behavioral problems. In addition, studies have revealed that siblings of medically ill children tend to be the most neglected group in receiving mental health care services. Finally, the amount of parental distress has been correlated with more behavioral problems in these siblings (Wamboldt et al. 1995).

Art therapy treatment considerations

Art therapy can provide a means for children and their families to explore their feelings and concerns about asthma and the effect that it has on their lives. In addition, the art making process can assist in generating creative problem-solving strategies, reducing feelings of stress, enhancing communication patterns, and instilling a general sense of confidence and competence. Results from a study by Miles, Sawyer and Kennedy (1995) support the idea that in order to be an effective asthma self-management program there should be a focus on increasing children's sense of intrinsic motivation, competence, and independent decision making. Further, '...self-esteem, self-efficacy, and a sense of mastery have frequently been reported by investigators as important personal resources associated with better management and with better health outcomes for a variety of chronic illnesses' (Patterson *et al.* 1994, p.136). Rollins (1990) discussed specific ways in which creative expression can help children cope with hospitalizations. These include providing opportunities for children to: make decisions (e.g. making choices of art materials and creative themes) when their choices have been limited by their illness and hospital procedures; take an active rather than a passive role in making their own creations (unlike being in a passive patient role); communicate their range of feelings in a safe, fun, and non-verbal way; and use their imaginations to create art work about their physical limitations. Finally: 'The arts offer many tools to help children make sense out of their conditions and the hospital experience. Using art – the language of childhood – children can demonstrate an understanding of their conditions and treatment' (Rollins 1990, p. 82).

To date, relatively few studies have focused specifically on defining the benefits of using artwork with children who have asthma. A study by Quinn (1988) examined the illness drawings of children with asthma to understand their illness perceptions. He utilized a specific drawing task with 16 children ages 5 to 11 years and found that these children's illness drawings reflected their individual illness perceptions. He asserted that these drawings could be useful in providing physicians with initial information about a child's illness knowledge and fears to assist physicians in providing genuine reassurance to the child. A pilot study by Gabriels (1997) with 18 asthmatic children evaluated the utility of the Gabriels Asthma Perception Drawing Scale (GAPDS) as a screening tool to assess children's ability to perceive their asthma symptoms. Significant results indicated that girls identified more

affect in their drawings and were also better able to detect their airflow changes in their small airways.

Individual art therapy assessment and treatment

As previously mentioned, children with asthma may have a great deal of difficulty verbalizing their feelings about their asthma and related psychosocial concerns. Illness-specific art therapy tasks can provide the child with a non-threatening means of initially discussing how they perceive and are coping with their asthma. This initial assessment information can then be used to focus the child's treatment on specific psychosocial and illness concerns. Gabriels (1988) developed a series of three drawing tasks (see Table 5.1) and discussed their utility with pediatric asthmatic patients in providing information about patients' perceptions of their asthma and related feelings and concerns. In addition, these drawings provide an opportunity for children to begin to generate creative problem-solving ideas. For example, one 13-year-old boy created a good place for his asthma in his drawing of a football stadium with accommodations for smoking, non-smoking, and asthmatic people (see Figure 5.4). About this drawing, he stated: 'It's a football stadium and you have to make a place for people who

Figure 5.4 13-year-old boy's image of a good place for his asthma

5.1 Asthma drawings (adapted from Gabriels 1988)

Age range
7 and above

Objective
To asses a child's level of asthma awareness regarding their emotional experiences, physical symptoms, and emotional, environmental, and/or allergic triggers. These drawings can also provide information about the child's ability to cope, asthma self-care techniques, and perception of others in relation to their illness.

Materials
Provide a variety of art materials from which to choose (e.g. crayons, oil or chalk pastels, markers and colored pencils) along with white drawing paper.

Task
The child is asked to draw three pictures about their asthma.

1. Draw a picture of what it feels like to have an asthma attack or to wheeze.

2. Draw a good place that would be helpful for you or your asthma.

3. Draw a bad place that would not be helpful for you or your asthma.

Following the completion of each drawing, the therapist asks the patient to talk about their drawing.

smoke, non-smoking, and there's a place where asthma people sit so if they need a treatment they can still watch the game... The smoking people can't have their smoke travel over to your seats.'

The therapist may also want to include several other drawings as part of the initial art therapy assessment drawing battery. A task such as the Kinetic Family Drawing (KFD) Test, which asks the child to: 'Draw everyone in the family doing something, including you, doing something. Try to draw whole people, not cartoons or stick people. Remember, make every one doing something – some kind of action' (Burns and Kaufman 1972, p.5). This tool

has been used in several clinical studies to assess children's perceptions of their family dynamics, self-esteem, and overall family environment (Bossert and Martinson 1990). The therapist might also ask the child to complete the whole Draw-a-Person Task (DAP), a task which is thought to provide information about the child's developmental drawing levels (Lowenfeld and Brittain 1982) and self-perceptions (Hammer 1980).

5.2 Scribble journal

Age range
9 and above

Objective
Provides an opportunity for independent identification and expression of feelings and concerns outside the art therapy session. This can help to increase a sense of competence in the ability to cope with difficult feelings when alone.

Materials
Assist the child or adolescent in putting together a notebook of plain white drawing paper. The patient will need a set of markers, oil pastels, crayons, or colored pencils available to them outside the art therapy sessions.

Task
The child or adolescent is instructed to choose one color of marker, then to close his or her eyes and make a scribble on the paper without lifting the marker off the page. Following the completion of the scribble, he or she is encouraged to view the scribble from various angles, looking for an object or part of an object in the scribble. Next the child is allowed to use other drawing materials to develop this image into a complete picture, adding as many details as the child wishes. The child can then title the picture and write on the back of it how the spontaneous scribble image relates to experiences or feelings they are currently concerned about. He or she can bring the scribble journal to individual art therapy sessions to further explore the personal meanings of the scribble images.

Once the therapist has completed an assessment with a child, he or she can begin generating treatment goals and objectives based on the data obtained from this assessment, interview with the child's parents, review of medical and mental health records, and consultation with the multidisciplinary treatment team members. General individual art therapy treatment objectives should include providing the child with opportunities to identify feelings and concerns regarding asthma management/self-care issues, limitations due to illness, coping with medical procedures, or being hospitalized. The goal may be to increase the child's ability to directly identify concerns when the child begins to feel overwhelmed by the stress of asthma symptoms or medication management requirements. An art task to address this goal might be to introduce the latency age child or adolescent to keeping a scribble journal (see Table 5.2). This activity provides opportunity for independent identification and expression of feelings and concerns outside the art therapy session and can contribute to the child or adolescent's sense of competence outside the art therapy session.

Family art therapy

As discussed earlier, asthma can stress a family's ability to communicate effectively for a variety of reasons. For example, family members may feel guilty about harboring resentment regarding the burdens caused by the chronically ill member. This can present a challenge to the therapist who is faced with introducing the value of using art as a tool to express emotions with a family who may become anxious by the very mention of feelings, much less revealing them to each other! Potentially threatening experiences for families can be circumvented by introducing the family to a non-threatening way of expressing and sharing feelings. One way to accomplish this is to engage the family in a Feeling Vocabulary Drawing Task (see Table 5.3). With this task, the family is informed that they will be learning how to use colors, lines, and shapes to express a variety of general and specific feelings. Family members participate in identifying feelings which describe their own picture or design and later discuss their drawings with each other. This provides a non-threatening environment for family members to consider and respect each others' unique perspectives. The therapist can then generate a discussion with the family about the importance of open communication in the family and help them develop adaptive ways to cope with differing perspectives of family members within their home environment.

5.3 Family art/feeling vocabulary

Age range
6 years and above

Objective
Introduce family to a non-threatening means of expressing and sharing feelings and coping with individual members' differing perspectives.

Materials
Large drawing paper and chalk or oil pastels

Task
Family members are provided with their own sheet of drawing paper. They are asked to work together to identify a variety of feelings (about 6 feelings), then each describe these feelings using color, lines, shapes, or small pictures. Following the completion of these drawings, participants are encourages to discuss their unique interpretation of the feelings drawn. The therapist then generates a discussion with the family about the importance of open communication in the family and helps them to develop adaptive strategies to cope with individual family members' differing perspectives.

Multifamily group and peer group art therapy

Group art therapy experiences with this chronically ill population can provide time and cost-effective interventions which are helpful to a number of people at the same time. These types of groups can provide opportunities to increase communication and understanding about asthma and coping strategies, develop social skills, enhance competence, and decrease a sense of isolation. A clinical study of the usefulness of multifamily groups found that a significant number of families rated these groups as being helpful in providing an opportunity to share their experiences with others (Wamboldt *et al.* 1995).

One objective of peer group and multifamily group art therapy with an asthmatic population is to provide creative, challenging, enjoyable, and successful problem-solving and mastery experiences. The therapist can serve

5.4 Mystery bag group task

Age range
Latency age groups, adolescent groups, and multifamily groups

Objective
Increase creative problem-solving abilities and generate information exchange regarding various means of coping with asthma.

Materials
Odds and ends such as: string, paper with a variety of textures, shapes and colors, aluminum foil, one marker, buttons or beads, one pair of scissors (optional), and medical supplies (medical tape, tongue depressors, gauze, Band-Aids, etc.).

Task
The group is told to divide into small groups (3 to 5 individuals) or to sit together as a family. Each group is given one Mystery Bag and told that his activity is similar to a survival task in which they can only use what is available to them in their bags. In addition, they must work together to make a meaningful creation using all the supplied provided in the bag. Following the completion of the task, the teams are encouraged to show their creations, talk about what it was like to work together, and identify how they arrived at the completion of their creation. The therapist then encourages the group to apply the creative coping and problem-solving principals learned in this interaction tack to 'real life' management of the stress caused by asthma.

the role of structuring topic-specific art experiences and, at the same time, help group members generalize their successful creative problem-solving abilities to their management of asthma.

In addition, the opportunity for interaction with other families and individuals struggling to cope with asthma can generate an exchange of various strategies and perspectives. For example, the Mystery Bag Task (see Table 5.4) is appropriate for latency age, adolescent, and multifamily art therapy groups and can encourage communication between group members. Prior to the group, the art therapist collects a variety of odds and ends and

5.5 Medical play dough activity

Age range
3 to 7 years

Objective
Provide an opportunity for young children to explore and play with materials related to their asthma management and medical procedures within a non-threatening/enjoyable environment. This experience can provide an opportunity for young children to talk and play about their experiences and related feelings and enhance their sense of competency and self-efficacy.

Materials

Play dough recipe: 2 cups of flour, 1 cup of salt, and 1 tablespoon of oil (for softness). Add food coloring to water and then add water to dry mixture until desired play dough consistency is reached (about 1 cup). Medical supplies: syringes of various sizes without needles; use scissors to widen syringe openings for play dough. Tongue depressors and swabs can be used as poking and cutting tools. Medical gloves can also be provided for children to wear, especially for those children who may be reluctant to touch the play dough with their bare hands or have a skin condition that makes touching the salty dough uncomfortable.

Task directions

Allow each child in the group to participate in pouring one of the play dough ingredients into a large centrally located bowl. Also, encourage children to take turns mixing the play dough with their bare hands. Demonstrate how to squeeze play dough through the syringes, then allow them to explore the materials on their own. The therapist can provide reflective comments about the children's medical play to encourage them to further identify feelings (through play and verbalizations) about their medical experiences.

divides them evenly into several bags. The group is told to divide into small groups (3 to 5 individuals) or to sit together as a family. Each group is then given one Mystery Bag and told that this activity is similar to a survival task in which they can only use what is available to them in their bags. In addition, they must work together to make a meaningful creation using all the supplies provided in the bag. Following the completion of this task, the teams are encouraged to share their creations, talk about what it was like to work together, and identify how they arrived at the completion of their creation. The therapist then encourages the group to apply the creative coping and problem-solving principals learned through this interactive task to 'real life' management of the stress caused by asthma.

Preschool art therapy groups

Preschoolers can benefit from socially interactive opportunities to master experiences regarding their asthma and related medical procedures. Reading theme-specific books about asthma, doctors, going to the hospital, taking medications, medical procedures, and feelings, can provide opportunities for young children to draw and talk about their own feelings and experiences. These story themes can also be translated into medical art/play experiences for additional mastery opportunities (see Tables 5.5 and 5.6). For example, after reading a book about going to the doctor and getting shots, the therapist can assist children in making their own play dough and squeezing it through a variety of syringes. (Note: provide syringes without needles and use scissors to widen syringe openings for play dough). Use tongue depressors and swabs as poking and cutting tools. Allowing children to take an active part in creating their own play dough provides an additional opportunity for enhancing their sense of competency and self-efficacy.

Conclusion

Art therapy with pediatric asthma patients and their families provides opportunities to identify difficult feelings and concerns related to the emotional and physical effects of asthma and generate creative coping strategies. These opportunities can assist in reducing feelings of stress, enhancing family communication patterns, and increasing a sense of competence and confidence.

Because art therapy has great potential with patients with asthma, there is a need for continued research regarding its utility with children who have

5.6 Medical materials activity

Age range
3 to 7 years

Objective
Provide an opportunity for young children to enhance their sense of competency and self-efficacy by exploring and creating with materials related to their asthma management and medical procedures within a non-threatening environment. This activity can encourage young children to play and talk about their experiences and related feelings.

Materials
Provide each group member with a paper bear cut-out (approximately 3 feet tall) or have each child trace around a large teddy bear, then cut out their own paper bear. Have a variety of medical materials available (e.g. gauze, Band-Aids, syringes without needles, alcohol pads, tongue depressors and swabs). Also, provide glue and markers.

Task
Read to the group a theme-specific book about asthma, doctors, going to the hospital, taking medications, medical procedures, or feelings. Ask the group general questions about their similar experiences and/or feelings related to the story. Tell the group to decorate their bear with the materials provided and to draw any feeling they want on their bear's face. After the group has completed this task, have group members share their creations and say something about their bear.

asthma. Further studies could provide valuable information for health care systems as to the cost-effectiveness of art therapy programs. For example, the efficacy of art therapy programs could be measured by collecting data on the number of times patients present in emergency rooms and/or have to be hospitalized following their involvement in a specified length and type of art therapy experience. In addition, art therapy program outcomes could be measured by having children and adolescents complete a survey such as the Paediatric Asthma Quality of Life Questionnaire pre and post treatment. The

questionnaire evaluates children's perceptions of the impact of asthma on their quality of life (Juniper *et al.* 1996). Art therapy treatment outcome studies could guide future research in this area and help define the particular aspects of art therapy programs which are most helpful to patients and their families.

References

Bender, B. (1995) 'Are asthmatic children educationally handicapped?' *School Psychology Quarterly 10*, 4, 274–291.

Bosssert, E. and Martinson, I.M. (1990) 'Kinetic family drawings – revised: a method of determining the impact of cancer on the family as perceived by the child with cancer.' *Journal of Pediatric Nursing 5*, 3, 204–213.

Burns, R.C. and Kaufman, S.H. (1972) *Actions, Styles, and Symbols in Kinetic Family Drawings (K-F-D): An Interpretive Manual.* New York: Brunner/Mazel.

Creer, T.L. and Bender, D.G. (1995) 'Recent trends in asthma research.' In A.J. Goreczzny (ed) *Handbook of Health and Rehabilitation Psychology.* New York: Plenum Press.

Creer, T.L., Stein, R.E.K., Rappaport, L. and Lewis, C. (1992) 'Behavioral consequences of illness. Childhood asthma as a model.' *Pediatrics 90*, 5, Part 2, 805–815.

Gabriels, R. (1997) 'Children's Illness Drawings and Asthma Symptom Awareness. Unpublished Doctoral Dissertation. Denver: University of Denver.

Gabriels, R.G. (1988) 'Art therapy assessment of coping styles in severe asthmatics.' *Art Therapy: Journal of the American Art Therapy Association 5*, 2, 59–68.

Hammer, E.F. (1980) *The Clinical Application of Projective Drawings* (6th edition). Springfield. IL: Charles C. Thomas.

Juniper, E.F., Guyatt, G.H., Feeny, D.H., Ferrie, P.J., Griffith, L.E. and Townsend, M. (1996) 'Measuring quality of life in children with asthma.' *Quality of Life Research 5*, 35–46.

Lehrer, P.M., Isenberg, S. and Hochron, S.M. (1993) 'Asthma and emotion: a review.' *Journal of Asthma 30*, 1, 5–21.

LeSon, S. and Gershwin, M.E. (1995) 'Risk factors for asthmatic patients requiring intubation: a comprehensive review.' *Allergology and Immunopathology 23*, 5, 235–247.

Lowenfeld, V. and Brittain, W. (1982) *Creative and Mental Growth.* New York: McMillan.

Miles, A., Sawyer, M. and Kennedy, D. (1995) 'A preliminary study of factors that influence children's sense of competence to manage their asthma.' *Journal of Asthma 32*, 6, 437–444.

Milgrom, H. and Bender, B. (1997) 'Nonadherence with the asthma regimen.' *Pediatric Asthma, Allergy and Immunology 11*, 1, 3–8.

Patterson, J.M., and Garwick, A.W. (1994) 'The impact of chronic illness on families: a family systems perspective.' *Annals of Behavioral Medicine 16*, 2, 131–142.

Quinn, C.M. (1988) 'Children's asthma: new approaches, new understandings.' *Annals of Allergy 60*, 283–292.

Rollins, J.H. (November 1990) 'The arts: helping children cope with hospitalization.' *NSNA/IMPRINT*, 79–80.

Silverglade, L., Tosi, D.J., Wise, P.S. and D' Costa, A. (1994) 'Irrational beliefs and emotionality in adolescents with and without bronchial asthma.' *Journal of General Psychology 121*, 3, 199–207.

Todd, W.E. (1995) 'New mindsets in asthma: interventions and disease management.' *Journal of Care Management 1*, 1, 2–7.

Wamboldt, M.Z. and Levin, L. (1995) 'Utility of multifamily psychoeducational groups for medically ill children and adolescents.' *Family Systems Medicine 13*, 2, 151–161.

Wamboldt, M.Z., Weintraub, P., Krafchick, D., Berce, N. and Wamboldt, F.S. (1995) 'Links between past parental trauma and the medical and psychological outcome of asthmatic children: a theoretical model.' *Family Systems Medicine 13*, 2, 129–149.

Weiss, S.T. (1994) 'The origins of childhood asthma.' *Monaldi Archives of Chest Disease 49*, 2, 154–158.

Hide and Seek

The Art of Living With HIV/AIDS

Emily Piccirillo

After years of controversy, it is definite that HIV (Human Immune Deficiency Virus) is the cause of AIDS (Acquired Immune Deficiency Syndrome). And although the initial hysteria about this epidemic may have subsided, it will never be a tidy topic. Many medical, social, psychological, legal and ethical issues are far from resolved. Unique major characteristics of HIV/AIDS will always distinguish it from most other illnesses.

From a purely biomedical perspective, AIDS is categorized as a syndrome, characterized by a broad, fluctuating spectrum of symptoms as opposed to a fixed set that follows a single predictable course. Fortunately, tremendous progress has been made in understanding and treating the medical aspects of HIV/AIDS. Now classified as a chronic illness, it is no longer perceived as an immediate death sentence, especially for those with early diagnosis and access to the cutting-edge antiretroviral and combination therapies (Beaudin and Chambre 1996). Still, its course varies wildly, with protracted periods of vague and nonspecific problems, often referenced at death as 'AIDS-related complications'. While the Centers for Disease Control (CDC) has established strict criteria for the diagnosis of AIDS, the list of qualifying clinical conditions has undergone many revisions in order to keep up with the changing definition of the disease.

HIV is contagious and its primary adult modes of transmission are sensation-seeking behaviors – unprotected sex and intravenous drug use – that tend to carry strong personal and political stigmas. Despite some crossover into the white middle-class heterosexual population, the virus continues to disproportionately affect drug users and gay/bisexual men. As a social disease, its impact extends well beyond viral infection and society's

pejorative perceptions often have been more contagious than the illness itself.

Women are contracting HIV at an alarming rate. Statistically they have tended to be the sexual partners of drug addicts or bisexual men, or are intravenous drug users themselves. However, with increasing frequency, they are unable to identify such contact (Stein 1998). The vast majority of infected children contract it during pregnancy, delivery, or breastfeeding and currently, about one quarter of the children of mothers with HIV/AIDS are born seropositive. This figure is predicted to continue to decline with the effectiveness of prenatal antiretroviral treatment as prophylaxis against transmission (Boland and Oleske 1995).

As of this writing, nearly 8000 cases of pediatric AIDS had been reported to the CDC (Centers for Disease Control 1997). With AIDS as a leading cause of death of parents of school age children, a tremendous number of these children eventually become orphans (Forsyth 1995). It has been predicted that unless the epidemic changes dramatically, by the year 2000 there will be as many as 125,000 American children living without their parents because of AIDS (Levine and Stein 1994).

While the geography of AIDS is spreading steadily into rural areas, it is crucial to underscore that the demographics of AIDS' youngest victims are still weighed heavily towards urban children of color and of poverty. Already challenged by their unstable circumstances, HIV/AIDS further weakens their fragile worlds. Some will suffer additionally with HIV as a consequence of incest or sexual abuse (Anderson 1995). HIV/AIDS affects the entire extended family, consisting of an often crisis and crime-ridden, undereducated extended family system, including single parents and multiple partners, each adding complexity to the child's situation.

Lastly, HIV/AIDS has a multigenerational impact. Seldom is only one member of a family infected, so children living with AIDS (CLWAs) come to experience HIV/AIDS in all of its different stages, eventually witnessing a series of early deaths (Ward-Wimmer 1997). For example, in one family there might be an HIV- infant, an apparently healthy 11-year-old, but who has not been tested because the mother cannot face the possibility of her child's infection, an HIV+ 2-year-old and 4-year-old (born after their mother tested positive and before she started taking medication). The four youngsters may have three different fathers with varying serostatuses, life situations, and relationships to the family. Aunts, uncles, cousins, grandparents, and significant neighbors may be HIV+ as well. The

consequences of these types of circumstances are often both catastrophic and long-lasting, burdening children with experiences of chaos, chronic loss, and anticipatory, complicated, and unresolved grief (Elia 1997).

From this biopsychosocial perspective, it is easy to imagine how a child living with HIV/AIDS must struggle to get the proper attention and understanding they need when they do not feel well. In many situations there may be no one available to notice or provide the needed care, due to their own illness. As a result, these children often end up feeling extremely isolated, even when they live in a house full of people.

The CLWAs described in this chapter are seen at Pediatric AIDS/HIV Care, Inc. in Washington DC. This is a non-profit organization created in 1987 as a respite care center, open afternoons and evenings to serve approximately 150 HIV/AIDS affected children ages 3 to 18 years and their families. As a safe refuge with consistent routines and rules, it provides a homelike space in which to share therapeutic and recreational activities, companionship, and evening meals. However, most of the children's caregivers have chosen not to disclose their status or their children's, and the subject of HIV/AIDS is sensitively handled in order to abide by these wishes, while still supporting the children's needs to explore their situations. The staff, mostly volunteer, monitor the overall welfare of the children. I conduct a weekly art therapy group, with individual sessions funded by the Family Ties Project, a program that specializes in permanency planning for families living with HIV/AIDS.

Impact of HIV/AIDS on physical and psychosocial areas

Physical

Children living with HIV/AIDS fall into two categories: *infected* (HIV+) or *uninfected* (HIV-, but with seropositive family members). Both groups, however, are referred to as *affected.*

Infected children have a higher mortality than adults with the virus. The most common indicators of AIDS in children are: Pneumocystis carinii pneumonia, lymphoid interstitial pneumonia, lymphoma, skin and bacterial infections, wasting syndrome, failure to thrive, Candidiasis of esophagus, and HIV encephalopathy (Andiman 1995). Other infected children also have anemia or unexplained fevers. Children born with HIV fall into two distinctive patterns: 'rapid-progressors' who die in infancy, and those who have the potential to live at least into their second decade. Sooner or later, all

HIV+ children will have to contend with the stress of needing frequent clinic visits, hospital stays, IVs and medications. However, with improved drug therapies their life expectancies are improving dramatically.

Because HIV is blood-borne, it circulates throughout the body, invading and damaging organ systems, particularly targeting the central nervous and respiratory systems. Neurological complications can manifest in developmental delays, thought disorder, distractibility, impaired motor and language skills, and memory loss (Brouwers *et al.* 1995). Without proper evaluation, they can be mistaken for other problems. For example, a child may stop following through with a simple task like getting dressed in the morning; this could be interpreted as oppositional behavior rather than the progressive encephalopathy it might indicate (Hanna and Mintz 1995).

As immunodeficiency advances, all areas of functioning can be threatened. Due to maternal substance abuse or poor prenatal care, many affected children (even if they are HIV-) have cognitive as well as physical disabilities (i.e. fetal alcohol syndrome). The chronic trauma that characterizes their stressful lives can also manifest in a wide range of psychosomatic reactions (Herman 1997), adding to the clinical picture for both infected and uninfected children.

Psychosocial

The psychosocial issues in the lives of CLWAs are astounding. Due to the high risk environments into which most affected children are born, it is virtually impossible to differentiate the psychosocial stressors and symptoms directly attributable to the presence of HIV/AIDS from the sequelae of a disruptive home environment. For many children, the virus just means additional turbulence and trauma, with the threat and crisis of death increased.

Many become both uniquely vulnerable and deceptively resilient to their circumstances. Some have never known a routine; others have been responsible for maintaining it within their families. In general, CLWAs may demonstrate one of two tendencies – they are either needy, labile, impulsive, easily overwhelmed and inclined to act out, or they are pseudomature, depressive, blunted, and counterdependent. Some vacillate markedly between the two.

On first impression, many HIV+ children look and act like normal kids, laughing, playing, fighting, moving, and talking freely. Even symptomatic children generally interact easily with others. However, health care providers

report a high incidence of post-traumatic stress disorder (PTSD) in affected children, similar to symptoms found in war veterans and child abuse victims (Apfel and Telingator 1995). Many have never established a baseline state of internal stasis for use when in distress. Because of the prolonged and pervasive nature of this syndrome, dissociation, vigilance, hyperarousal, irritability, and numbing are common symptoms.

Many CLWAs fear rejection or punishment and are eager to cooperate so as not to upset the therapist, mirroring their responses to parents and family members. Others will put caregivers and therapists through many rigorous tests of trust and reliability, already having been disappointed too many times by adults. Some children may react with entitlement, or with constant complaints while taking pleasure in watching others act out their feelings of helplessness and frustration.

Because death produces highly individual responses and depends on developmental factors, youngsters need careful attention and patience as they cope and grieve. Since children's cognitive capacities determine their ability to process their experiences, caution must be paid to the age-appropriateness of information given. Knowledge of and respect for developmental limits is key to working with CLWAs, as well as an allowance for regression due to stress.

There are a number of distinctive psychosocial implications which may be present in CLWAs :

SILENCE AND SECRECY
HIV/AIDS is surrounded by a code of *silence* and *secrecy*, with the issue of disclosure to children being a central concern (Tasker 1992). HIV+ parents tend to hide both their diagnosis and their children's, usually in a legitimate effort to protect them from abuse, ostracism, and discrimination. At times it is also due to denial, or their own need to first process its significance, or to comply with prohibitions in the family. Some prefer to avoid the difficult questions that might follow about how the illness was contracted.

Many caregivers worry that if the child is told the truth they will then inadvertently disclose their status, often citing the young age as the reason, or that the demands of keeping the secret will cause greater distress (Lipson 1993). The child who is informed or who has heard the word 'AIDS' mentioned is an exception; some are told about the opportunistic infections, but the word 'AIDS' usually remains unspoken. While it is not named, many recognize signs of illness, so there is usually a sense of 'knowing'.

This process of disclosure resembles the dynamics of the game of 'hide and seek'. However, just as the territory becomes more familiar during the game, it also becomes more difficult to conceal the fact of HIV/AIDS from the children. As sickness becomes more apparent, or the child advances in age, caregivers may decide to share accurate information openly and honestly, as well as their realistic fear of social repercussions (McCue 1994).

SHAME AND GUILT

HIV/AIDS taps the human reflex to either assign or accept responsibility when something goes wrong. This reactivity has crippling consequences for children living with it as they grapple with the question 'why?' Due to the mystery and etiology of HIV/AIDS, many affected children unwittingly inherit society's judgment of their parents' histories, whether it is bluntly laid out before them or not.

Since children naturally tend to think problems are their fault and that their suffering is punishment, HIV infects CLWAs with large doses of *shame* and *guilt*. As they try to solve the riddles of HIV/AIDS, the torment is reinforced if they overhear harmful remarks such as: 'She got what she deserved', referring to their mother's condition. Unless they receive corrective intervention, CLWAs internalize this negativity, damaging their self-worth. For healthy affected children living on after the loss of a family member, survivor guilt is common, as well as feelings of relief, regret, and even suicide.

UNCERTAINTY

Uncertainty is central to all aspects of HIV's impact on children. The ambiguous disease process involves unpredictable symptoms and treatments, many experimental. But there are also many practical concerns that cause tremendous uncertainty for CLWAs, such as where they will be sleeping tonight. As a result of the illness, devoted parents frequently lack the energy and well-being necessary to care for their children; schoolwork and hygiene are adversely affected. Other parents continue self-destructive lifestyles that keep them entirely absent. Deprivation is common, contrasted with sudden, unexplained and even extravagant displays of generosity, often by well-intentioned strangers and charities.

ATTACHMENT AND BOUNDARY ISSUES

Not many children who have a major illness also run the risk of losing both parents to it. *Attachment* and *boundary issues* loom large for CLWAs, characterized by ambivalent and jealous feelings. This is especially true when a mother gives up custody of her children because she can no longer attend to their daily needs, but does not provide a clear explanation for her absence, resulting in feelings of abandonment. For example, one 6-year-old HIV+ female client who has lived in five foster families since birth, yet still visits her mother who is in the final stages of AIDS, routinely asks me if I am a member of her family and looks to me as a maternal figure to meet her dependency needs.

In response to their disrupted lives, elaborate fantasies, superstitions and myths arise spontaneously. Some children become phobic, compulsive, or bizarre, typically in response to misperceptions and in a desperate effort to magically control their world. Some become psychologically disorganized, exhibiting what might be defined as psychotic features. In addition, HIV+ children must also bear the emotional and functional side-effects of medications and secondary conditions, such as dementia and seizures. These further interfere with their abilities to draw accurate conclusions about their lives and attachments.

Intervention and Treatment Planning

Before discussing the specific use of art therapy as an intervention with CLWAs, it is important to highlight the special skills that are advisable for health care providers in their work with HIV/AIDS affected families.

KNOWLEDGE OF HIV/AIDS AND ITS SEQUELAE

Any therapist working with CLWAs must be well-educated in the disease process, its manifestations, treatments, and implications. Changes in a child's behavior, physical or psychosocial status often happen suddenly and subtly, so such knowledge facilitates a swift response. Still, due to the complexity of care, it is essential to establish a community of professional contacts for advice and referrals to meet the demands of comprehensive care. The therapist must have access to a wide range of resources in order to quickly gather information on the syndrome and related services, since part of the professional's role is as patient educator and advocate. In addition to knowledge of HIV/AIDS, knowledge of addictions and recovery and their

impact on parenting is important and beneficial to the therapeutic process (Havens, Mellins and Pilowski 1996).

KNOWLEDGE OF DEATH AND BEREAVEMENT

Knowledge of the developmental stages of children's understanding of death and bereavement guides the therapist in counseling the entire family about the dying process (Grollman 1995). All children need to be supported and nurtured in formulating their spirituality in their own terms (Coles 1990). Many children facing serious illness feel a necessity to form answers for what happens both before and after death, as well as deciding for themselves about the place of God, the Devil, heaven, hell, reincarnation, angels and ghosts in their existential scheme of things (Fitzgerald 1992). This sensitive task requires open-mindedness in caregivers and health care providers so as to avoid imposing uninvited views on these deeper levels of their lives (Conforti 1997).

Since HIV/AIDS work involves both trauma and grief work, it is necessary for each health professional to have attended to one's own related personal experiences and losses and to be aware of how they influence the services provided (Elia 1997). The theme of abandonment is strong in the lives of people confronted daily by mortality, so it is vital for health care professionals to anticipate their own absences or vacations; treatment should not be entered into without an expectation of sustaining contact, and formal termination requires thorough attention.

CULTURAL COMPETENCE

A comprehensive awareness of diverse heritages, races, religions, lifestyles and socioeconomic groups, is essential to working with families living with HIV/AIDS (Groce 1995). This includes an appreciation of differing attitudes about doctors and therapists. Since sensitivity to these patterns and habits primarily comes with experience, awkward moments are unavoidable. For example, in one Latino family there might be multiple people called 'Poppy' (i.e. older brother, uncle, grandfather, and father – even the child himself), so it is wise to clarify who is being referenced in order to avoid confusion.

Mourning rituals vary greatly among cultures, so it is crucial to understand and respect these customs and values, as well as the emotional timing for dealing with losses (McGoldrick, Hines, Lee and Preto 1986). While cultural patterns exist, still, it is important not to slip into stereotyped

responses, remembering that each individual is unique and may be searching for answers from outside of their realm of experience (Boyd-Franklin, Aleman, Jean-Gilles, and Lewis 1995).

SELF-KNOWLEDGE

Understanding the personal reasons and motivations for working with CLWAs will help greatly when feelings of vulnerability, futility, fear and anger inevitably arise (Winiarski 1991). The extreme instability and chronic trauma in affected families requires multiple approaches by health care providers in order to attend to signs of potential counter-transference, overload, resistance, withdrawal, and burnout (Barret 1997).

HIV/AIDS revises the therapeutic stance, putting the therapist through personal changes and requiring shared experiences that challenge traditional roles, in other words, hospital and home visits and memorial services (Eversole 1997). It is essential to remember that all contact must facilitate growth and empowerment, and not be based on an impulse to indulge the client or one's own rescue fantasies. It is also helpful to keep in regular contact with case managers to share responsibilities and just to commiserate. Personal counseling and peer supervision provide safety valves for the release of emotions and the processing of problems that come with this work.

TOLERANCE FOR FRUSTRATION

Multiple obstacles make treatment of CLWAs frustrating for therapists. Many of the caregivers in the families have limited education, job skills, experience with medical, and psychosocial care. This is compounded by the 'bureaucratic run around' that HIV + persons and their caregivers face in order to get their many needs met (Paige and Johnson 1997). Therapy is difficult to initiate because energy is focused on navigating the system in order to attend to practical matters such as securing funds to pay rent and utilities.

Once engaged, therapy is difficult to sustain due to transportation problems and sudden crises, (i.e. the mother's need for hospitalization). The location and hours of therapy must be convenient, with improved attendance if the primary caregiver can gain personally from the session (i.e. the children's therapy provides a chance to spend time alone with her/his partner). Since the mother's outlook directly correlates to the child's outcome, it is vital to pay close attention to her well-being and coordinating family art therapy as indicated (Forehand et al. 1997).

Unique benefits of art therapy with CLWAs

Art therapy has the comprehensive capacity to provide for the five central needs of children living with HIV/AIDS: mastery, communication, enjoyment, belonging, and legacy.

Mastery

The experiential nature of art therapy helps children to organize and transform chaos, encouraging the development of inner resources and adaptive coping strategies. The very core of the art therapy process involves 'doing and undoing' which directly counteracts feelings of helplessness. Art externalizes problems and makes them available as concrete material for the therapeutic process. Experiences that involve consequential thinking in which causal relationships can be observed and influenced to satisfaction are both convincing and corrective for CLWAs.

The proficiency that comes from the repeated handling of an art material teaches about its expressive potential, its limits and its risks as the child tries to shape results. This development of problem-solving skills translates into a capacity to make productive choices, to anticipate complications, and to respond with confidence. From a command of the art process comes a generalized sense of security and a realistic appreciation of the extent of any single person's control over events.

Many CLWAs have restricted access to positive creative experiences, in part due to their illness or crisis-ridden households, their low socioeconomic status, and limited art exposure in school. Therefore, there must be a strong educational component in art therapy to help these youngsters grasp the techniques necessary to effectively use the media for expression.

For example, before joining Pediatric Care, some children had never touched clay, an ordinary experience in most public schools. Figure 6.1 was created by such a child, an 8-year-old boy with advanced AIDS. Despite multiple physical complications due to the virus, he was eager for his first adventure with clay. Every step was a monumental effort, hampered by gross and fine motor problems and visual/spatial impairments, but his enthusiasm compensated well for these difficulties. While he was unable to draw on the clay slab to his own satisfaction, barely scribbling like a toddler (there is a sun over the taller flower and a self-portrait of his face between the stems), he demonstrated a remarkable cleverness with found objects as tools for making his 'Sunflower Garden'. He was able to erase parts he wanted to change with

Figure 6.1 Clay piece by 8-year-old boy with advanced AIDS

a swipe of his thumb or by camouflaging them with layers of textures. He experienced the clay as a piece of the earth, talking as if his plants were springing to life before his eyes.

Mastery can be encouraged by providing structure through the thoughtful organization of space and supplies, simple demonstrations, and task segmentation. Multiple and distinct steps in art activities can sustain children's involvement and reduce frustration. Care must be given to introduce materials and processes that are not too complicated or sophisticated. If the art therapist appears very expert, the children are inclined to be more intimidated than reassured. They will either resort to copying the therapist, predict their own failure and/or self-sabotage, or request assistance with every step.

When the art process does not go as planned, these children may deny that a problem exists, become agitated, or force closure out of fear of an impending disaster. Even in the best therapeutic exchanges, the children's efforts can quickly go awry during the art process resulting in discouragement. After acknowledging these feelings as a natural part of life, the art therapist can then model how to maintain, review, and adjust the vision, and how to capitalize on 'mistakes'.

Ultimately, innovating from the unexpected and experimenting with new behaviors give rise to increased predictability, fluency, and originality. The children come to see the value of persistence and taking calculated risks, of developing trust in their native abilities to make sense of the world, and of influencing their own circumstances.

Communication

When words fail or are forbidden, art can still send the message by accommodating the overwhelming impact of HIV/AIDS. Through visual language, affected children can give form to perplexing thoughts and feelings. The imagery of CLWAs is filled with contradiction, probably a result of the mixed information they have collected about their lives. For those responding to family and societal pressures to keep the secret, they can both have their silence and break it too. Art makes their guarded internal worlds accessible through an encoded vocabulary that does not betray their caregivers. Their artworks are constructive expressions of strong feelings, especially despair, confusion, stress, anger, shame, guilt, fear, envy, hurt, grief, betrayal, revenge, relief, love, hope, and healing.

Figure 6.2 was created by a bright 12-year-old HIV+ child while visiting her mother in a nursing home where she was dying of AIDS. I offered her art materials to use as she waited for her mother who was being treated. First, she carefully drew a dog, adding the tree behind it. I learned later that this child was dealing with her own incontinence, evidenced by the anxious markings over the dog's hind end. As she drew the girl (at first without arms) she became distressed, describing the threat that the vicious animal posed.

Engaging in a dialogue with me, she determined that she wanted to make it safe for the girl to play, despite the dog's proximity. Finally, she put a collar on the dog, chaining it to the tree. She decided that while the figure was still vulnerable, she could accept the arrangement, therein indirectly expressing her own struggle to come to terms with her troubling reality. She then gave the girl arms and a jump rope (which doubles as an additional visual barrier). As an explicit metaphor for the virus as a predator with prey, the destructive potential of the dog has been restrained, permitting the child to take part in life's simple pleasures. She found a way to assert her wish for power over her own fate. Through art, all of this was explored and communicated without the mention of HIV/AIDS.

Many CLWAs instinctively use disguised elements like masks and multiple layers of imagery, but are no longer completely invisible when

Figure 6.2 Drawing by a bright 12-year-old HIV+ child

communicated through art. For some, their artwork divulges the reality of tragic secondary consequences of HIV/AIDS in their lives, such as sexual exploitation and physical abuse suffered at the hands of temporary guardians.

In response to the children's cautiousness, the therapist can ease fears and anxieties about communicating through art by wondering aloud and demonstrating the benefits of being open and honest, thereby modeling healthy functioning. The children are encouraged to use art therapy to relax and reveal themselves at their own pace.

Enjoyment

The 'fun' involved in art making is a wonderful part of its appeal, especially for children who are confronted with chronic worries. Spontaneous play focuses on the 'here and now' and while engaged in it, the virus vanishes. This reparative power resonates well beyond the moment, diverting attention away from pressing problems. For symptomatic children, their options for taking pleasure in their bodies diminish over time; art can remain a viable one

when other physical outlets are lost. Some activities can take on an interactive game-like quality (Vos Wezeman 1994).

To assist children in learning how to enjoy themselves in art, the therapist can model how to laugh at oneself or to be amused by the surprises that occur when making art. Most children take pleasure in the immediate gratification and soothing comfort of smearing, mixing, poking, and squeezing without the intention of producing anything, while others take delight in the serious work of making art. Some resort to repetitive behaviors as they re-enact traumatic moments without realizing it. For them, play has much deeper meanings and requires the deft assistance of competent professionals in order to address their issues and help to work them through trauma (Herman 1997).

In order to know enjoyment in art making, it is important that children feel secure enough to risk play and spontaneous expression. Playful activities counteract constriction and anxiety by simply providing ordinary opportunities to be happy and to have positive experiences. Figure 6.3

Figure 6.3 Finger painting: 'My dancing Sister'

entitled 'My Dancing Sister' was created by an exuberant 4-year-old HIV+ boy who engaged in the messiness of finger painting without hesitation. His joyful expression celebrates the strong bond he has with his older sister who helps care for him.

Belonging

The social aspect of art creation and display builds acceptance, establishing and normalizing common themes while highlighting the individual. This has a profound value with a socially stigmatized condition like HIV/AIDS. The exchanges that art requires counteract isolation and teaches healthy interpersonal and self-care skills (Rubin 1984).

Cooperation and conflict are central to art making, both as the child struggles with the materials to achieve a satisfying product and as he or she negotiates with peers within a group. Group art therapy teaches the responsibility of the individual to the community and how each of us influences the fate of others. It defines the basics of boundaries, such as the personal space of each person's ball of clay, and the mutual domain of a sheet of mural paper.

By providing a comfortable context in which to interact, children are encouraged to speak up and reach out, sharing their ideas and opinions with a company of their peers. These alliances become invaluable to their well-being. Use of a big table is helpful because it encourages independent content and exploration, with plenty of materials to minimize fighting. Since CLWAs often feel deprived in their own homes, adequate resources are important. With the daily disruptions that HIV/AIDS brings, the children search for an enduring sense of belonging. They put a great deal of emphasis in their art on types of places to live, with many images of dream houses and castles, often with detailed explanations of the idealized worlds within. For those who shuffle between the homes of relations and friends, art allows them to map out a physical space, thereby addressing their disorientation.

One 11-year-old male client lost his entire immediate family within 18 months to AIDS – father, mother, and sister. He also had to give up his cat and two dogs, as well as the house in which he was raised. When asked to make an image of a favorite memory, he painted the house they had shared, adding the small paper heart to signify his mother's spirit leaving through her bedroom window (Figure 6.4). In order to begin to settle into his new home with his grandmother, stepgrandfather, and aunt and to reconfigure his notion of family, he needed to mourn the loss of his early childhood world.

Figure 6.4 'This was our house' by 11-year-old boy

The response of others to the children's art also helps them to feel they are connected to the greater community. Inevitably, adult viewers of this art see aspects of their own lives reflected in the imagery – consciousness is raised and compassion grows, reducing the alienation that characterizes this syndrome in the lives of children.

Legacy

Lastly, art becomes survival itself. By transcending time, art is permanent proof of one's existence. Through art, children can make their unique mark, cultivating their uniqueness and ensuring that they will be seen and remembered by others. For children who live in poverty this cannot be overstated, due to the obstacles that limit their opportunities for advancing themselves in society. As the creative process nurtures the life force, it compensates for losses, relieves doubts, and gives inspiration. It represents growth – beginning with nothing, conceiving possibilities, affirming the struggle, and culminating in creation.

Similarly, children can honor and preserve the memory of a parent or sibling they have lost to AIDS through the tangible presence of artwork, perhaps through a valentine or a memory box. Figure 6.5 represents a

Figure 6.5 Box by a 15-year-old girl commemorating her mother

15-year-old's wish to commemorate her mother in a very personal way. As the piece developed, the process took on the semblance of a private funeral service. Over half a dozen sessions, she patiently selected words clipped from magazines and composed them to spell out her thoughts and feelings on the cigar box. As she worked, she engaged in a life review, telling stories about her mother and showing me photographs she planned to store in it. The box's capacity to open and close held special appeal, allowing her to regulate what she shared publicly. This format also serves as a sort of poetic coffin, allowing her to freely interpret the meaning of her mother's passing while achieving some closure.

Conclusion

For children living with HIV/AIDS, the world is a confounding place. It is difficult for them to make sense of being in it, especially when the information their senses are gathering is being challenged by the answers being given to their questions. They are likely to experience the deaths of their mothers, their fathers, or other siblings and their own mortality may be in question. Without therapeutic intervention and support from the wider

community, these multiple significant losses and the concomitant traumas are likely to result in increasingly serious problems for the future growth and development of these children. These include unresolved grief, attachment disorders, post-traumatic stress, and chronic depression. The relationships they form can provide the assistance necessary to healing socially and emotionally, even if their bodies never recover (Herman 1997).

Art therapy is uniquely qualified as a response to the needs of CLWAs. The practice of making art is about taking both risks and precautions, seeking pleasure, and tolerating frustration, elements reflected in the experience of AIDS. The process of art making provides children with experiences which help them to plan for and adjust to the unexpected. For children who do not have the cognitive or emotional capacity or maturity to fully comprehend the implications of HIV/AIDS, art helps them in their search for order and meaning by helping them give form to their feelings.

For the therapist, the art process remains one of exchanges. I once said to a skeptical boy that we were on a mutual journey and that I believed together we could discover the way. He turned to me with conviction and instructed, 'Okay then, you can hold the compass, but I get the flashlight'. The pervasive presence of HIV/AIDS in affected children's lives can become much more manageable once they find such camaraderie and confidence. Ultimately, art therapy serves this goal well. It creates incentives to care about one's future, to instill a capacity for creating a positive vision, transforming suffering, and advancing understanding. The practical experience of making art generates the solid rewards of a commitment to self-determination. This has lifelong consequences for individuals confronted by such an awesome specter as HIV/AIDS in their formative years. And it gives them a chance to celebrate life despite it all.

References

Anderson, C. (1995) 'Childhood sexually transmitted diseases: one consequence of sexual abuse.' *Public Health Nursing 12*, 1, 41–46.

Andiman, W. (1995) 'Medical aspects of AIDS; what do children witness?' In S. Geballe, J. Gruendel and W. Andiman (eds) *Forgotten Children of the AIDS Epidemic*. New Haven: Yale University Press.

Apfel, R. and Telingator, C. (1995) 'What can we learn from children of war?' In S. Geballe, J. Gruendel and W. Andiman (eds) *Forgotten Children of the AIDS Epidemic*. New Haven: Yale University Press.

Barret, R. (1997) 'Countertransference issues in HIV-related psychotherapy.' In M. Winiarski (ed) *HIV Mental Health for the 21st Century*. New York: New York University Press.

Beaudin, C. and Chambre, S. (1996) 'HIV/AIDS as a chronic disease: emergence from the plague model.' *American Behavioral Scientist 39*, 6, 684–706.

Boland, M. and Oleske, J. (1995) 'The health care needs of infants and children: an epidemiological perspective.' In N. Boyd-Franklin, G. Steiner and M. Boland (eds) *Children, Families, and HIV/AIDS: Psychosocial and Therapeutic Issues*. New York: The Guilford Press.

Boyd-Franklin, N., Aleman, J., Jean-Gilles, M. and Lewis, S. (1995) 'Cultural sensitivity and competence.' In N. Boyd-Franklin, G. Steiner and M. Boland (eds) *Children, Families, and HIV/AIDS: Psychosocial and Therapeutic Issues*. New York: The Guilford Press.

Brouwers, P., Tudor-Williams, G., Decarli, C. and Moss, H. (1995) 'Relation between stage of disease and neurobehavioral measures in children with symptomatic HIV disease.' *AIDS 9*, 7, 713–720.

Centers For Disease Control and Prevention (1996) *HIV AIDS Surveillance Report 8*, 2, 13.

Coles, R. (1990) *The Spiritual Life of Children*. Boston, MA: Hougton Mifflin

Conforti, P. (1997) 'Spirituality.' In M. Winiarski (ed) *HIV Mental Health for the 21st Century*. New York: New York University Press.

Elia, N. (1997) 'Grief and loss in HIV/AIDS work.' In M. Winiarski (ed) *HIV Mental Health for the 21st Century*. New York: New York University Press.

Eversole, T. (1997) 'Psychotherapy and counselling: bending the frame.' In M. Winiarski (ed) *HIV Mental Health for the 21st Century*. New York: New York University Press.

Fitzgerald, H. (1992) *The Grieving Child: A Parent's Guide*. New York: Simon and Schuster.

Forehand, R., Armistead, L., Morse, E., Simon, P. and Clark, L. (1997) 'The family health project: an investigation of children whose mothers are HIV-infected.' *Psychology and AIDS Exchange 2*, 1, 3–12.

Forsyth, B. (1995) 'A pandemic out of control: the epidemiology of AIDS.' In S. Geballe, J. Gruendel and W. Andiman (eds) *Forgotten Children of the AIDS Epidemic*. New Haven: Yale University Press.

Groce, N. (1995) 'Children and AIDS in a multicultural perspective.' In S. Geballe, J. Gruendel and W. Andiman (eds) *Forgotten Children of the AIDS Epidemic*. New Haven: Yale University Press.

Grollman, E. (1995) *Bereaved Children and Teens: A Support Guide for Parents and Professionals*. Boston: Beacon Press.

Hanna, J. and Mintz, M. (1995) 'Neurological and neurodevelopmental functioning in pediatric HIV infection.' In N. Boyd-Franklin, G. Steiner and M.

Boland (eds) *Children, Families, and HIV/AIDS: Psychosocial and Therapeutic Issues.* New York: The Guilford Press.

Havens, J., Mellins, C. and Pilowski, D. (1996) 'Mental health issues in HIV-affected women and children.' *International Review of Psychiatry 8*, 2–3, 217–255.

Herman, J. (1997) *Trauma and Recovery.* New York: Basic Books.

Levine, C. and Stein, G. (1994) *Orphans of the HIV Epidemic: Unmet Needs in Six Cities.* New York: The Orphan Project.

Lipson, M. (1993) 'What do you say to a child with AIDS?' *Hastings Center Report.* March–April, 6–12.

McCue, K. (1994) *How to Help Children Through a Parent's Serious Illness.* New York: St. Martin's Griffin.

McGoldrick, M., Hines, P., Lee, E. and Preto, N. (1986) 'Mourning rituals: how culture shapes the experience of loss.' *Family Therapy Networker 10*, 6, 28–38.

Paige, C. and Johnson, M. (1997) 'Caregiver issues and AIDS orphans: perspectives from a social worker focus group.' *Journal of The National Medical Association 89*, 10, 684–688.

Rubin, J. (1984) *Child Art Therapy.* New York: Van Nostrand Reinhold.

Stein, T. (1998) *The Social Welfare of Women and Children with HIV and AIDS.* New York: Oxford University Press.

Tasker, M. (1992) *How Can I Tell You? Secrecy and Disclosure with Children When a Family Member Has AIDS.* Bethesda: Institute For Family-Centered Care.

Vos Wezeman, P. (1994) *Creating Compassion: Activities for Understanding HIV/AIDS.* Cleveland: The Pilgrim Press.

Ward-Wimmer, D. (1997) 'Working with and for children.' In M. Winiarski (ed) *HIV Mental Health for the 21st Century.* New York: New York University Press.

Winiarski, M. (1991) *AIDS-Related Psychotherapy.* New York: Pergamon Press.

Art Therapy on a Hospital Burn Unit

A Step Toward Healing and Recovery

Johanna Russell

This chapter describes how art therapy can benefit children who are hospitalized due to severe burns, outlines the psychological phases of their healing process, and discusses how art therapy can assist patients at each stage of the recovery process. Burn patients typically suffer psychological as well as physical trauma due to their burn experience. Two case studies illustrate the use of art therapy with pediatric burn patients to express their trauma and cope with their burn experience.

Introduction

Patients who are hospitalized due to severe burns suffer physical and psychological trauma (Choiniere *et al.* 1989; Stoddard, Chedekel and Shakun 1996). Burn wounds have been described as one of the most physically traumatic injuries and hospitalizations a person may experience (Baker *et al.* 1996). Additionally, the burn incident and injury itself may be terrifying. The person may experience loss of home, parents, siblings, pets, and/or possessions. Those persons who require hospitalization endure necessary and painful procedures such as daily dressing changes which involve cleaning of wounds and debridement of dead tissue, occupational and physical therapy to increase range of motion and stretch scar tissue, and numerous surgical procedures. For some, disfigurement and disabilities may occur from loss of body extremities such as fingers, hands, toes or feet. For all, scarring as a result of the burn injuries can lead to difficulties in accepting a change in body image and self-esteem.

Patients may have to return to the hospital numerous times for reconstructive surgery in order to release skin contractures which may form across joints. Burn injuries can be severe and the psychological ramifications must be addressed so that patients can successfully adjust and adapt to their burn experiences.

A multidisciplinary team approach

Burn units that utilize a 'burn team' approach recognize the need for multidisciplinary professionals who meet both the physical and the psychosocial needs of burn patients. The available literature highlights how important it is that the team include mental health professionals who are not directly involved in the physical care of the patient. Nicosia and Petro (1983) recommend a 'no needle' mental health professional should be available to attend to the emotional needs of the patient: 'This should be someone on whom the patient does not depend for direct medical care, and therefore to whom it is easier for the patient to express a range of feelings, including opposition and anger' (p.108).

Art therapy can be an important part in the multidisciplinary approach with burn patients. Through a variety of age and developmentally appropriate art materials such as oil pastels, felt tip pens, paints, drawing supplies, paper, clay, print making and mask making materials, the therapist can help foster patients' hopes and positive attitudes, as well as elicit their anxieties, respond to their fears, and pass on this information to other medical burn team staff. Appleton (1993) notes: 'The art therapist is an advocate for the patient and works with the treatment team. . .' (p.73). Baron (1989) states: 'Because the art therapist is accustomed to reading a symbolic language, he or she has the opportunity to cue into these messages and to play a central role in their understanding' (p.152).

Art therapy is beneficial to burn patients throughout their healing and recovery and is a valuable part of treatment in the patient's therapeutic support system. Baron declares: 'From a holistic perspective, the art work provides art therapists with a much deeper level of understanding and the possibility to participate more fully with clients in their healing process' (p.151). Mehaney (1990) in writing about the use of play therapy with a 3-year-old burn patient concurs with Levinson and Ousterhout (1980), who used art therapy with burn patients, saying: 'interventions to facilitate adaptation to burns, include the use of art. . .' (p.57).

Art therapy provides an action-oriented, external outlet for hospitalized children to cope with their trauma. Steward (1993) states there is research to suggest that the selection and use of coping strategies changes across the life cycle, with younger children employing more action-oriented, external coping strategies while older children, adolescents and adults increasingly employ cognitive and affective, internal strategies. Steward also notes that opportunities for young patients to use developmentally appropriate action strategies in the face of stress (escaping, running away, etc.) are sharply limited by the need to administer necessary, painful medical procedures. Action strategies are further restricted by the drain on children's physical energy and well-being. By manipulating developmentally appropriate art materials such as paints and clay, children can make use of their action-oriented means of coping.

Psychological phases in adaptation to burn injuries

Of particular value to any mental health professional working with burn patients is an understanding of the stages of recovery patients may experience in their process of adaptation and recovering from their injuries. Watkins *et al.* (1988) describe seven stages of response that adult burn patients typically experience. The seven stages include: survival anxiety; problem of pain; search for meaning; investment in recuperation; acceptance of losses; investment in rehabilitation; and reintegration of identity. Doctor (1993) claims these stages can be easily adapted to the pediatric patient as well. Children certainly have special needs, but 'all burn patients tend to follow a similar course' (Cresci 1982, p.475). Not all burn patients experience every stage, and some patients experience the stages in different sequences at varying times. For example, children may pass through a stage and may return to a stage later in their recovery. In working with burned children, I have found that these stages are descriptive of children's psychological adaptations and have incorporated them into this chapter to help describe the recovery process.

Art therapy and the psychological phases of recovery in burn patients

Stage 1: expressing survival anxiety

Survival anxiety is the initial stage (Watkins *et al.* 1988) and is a time when patients wonder if they will survive the burn injury. During this time the

therapist may encourage patients to communicate their concerns and anxieties about the injury. Cresci (1982) explains that burned children sometimes need help in clarifying their feelings: 'By telling a story about a favorite animal that is sick, or drawing a picture, children will reflect their feelings and concerns' (p.494).

Stage 2: problem of pain

Pain experienced during hospitalization, especially procedural pain during dressing changes, can be intense (Miller, Hickman and Lemasters 1992; Patterson 1995). Sheridan *et al.* (1997) warn that: 'Inadequate control of pain and anxiety will have adverse psychologic and physiologic effects' (p.458).

Art therapy is an excellent tool to help burn patients express and cope with pain and anxiety. McGrath and Vair (1984), in their study of the psychological aspects of pain for burned children observe: 'It is helpful to give children a way of expressing severity of pain. If children are given effective tools to express their pain and are listened to, they are more likely to be able to cope' (p.83). They suggest three strategies to reduce pain: '(1) enhancing predictability and control, (2) encouraging relaxation, and (3) using distraction' (p.17). Art therapy may be used to assist patients in pain management in each of these areas.

To enhance a patient's feeling of control, a patient can choose whether or not to do art work; an art activity is one of few interventions to which the patient can say 'no!' If a child does desire to participate in an art activity, he or she makes decisions about art materials and what to make. Art expression offers a sense of control: the child can decide what kind of mark or picture they want to draw or how they want to squeeze, pound, or mold clay. Lusebrink (1989) observes that art therapy 'enhances a client's sense of control and mastery through the physical manipulation of materials, reorganization of sensations and corresponding conscious thought processes' (p.2).

In order to specifically address pain and to encourage relaxation, imagery that is soothing to the patient can be imagined and then drawn. The artistic process itself facilitates reducing tension as the patient becomes involved in the art activity: 'When the patient is involved in manipulating art materials and creating, he or she is focused on the art work and, therefore, is distracted from his or her pain' (Klingman, Koenigsfeld and Markman 1987, p.164).

Stage 3: search for meaning

During this phase, the patient may need to retell the burn accident many times in an attempt to understand the question: 'why did this happen to me?' A child, for example, may be feeling too much anxiety to verbalize this concern, but may be able to express his or her fears through art work. It has been anecdotally noted that art therapy is 'a very effective outlet for expression and a basis for exploring the patient's concerns' (Roberts and Appleton 1989, p.63).

Stage 4: investment in recuperation

During this phase, patients move toward regaining autonomous functioning. As burn team members praise patients for small gains, the patients learn to focus on their abilities rather than their disabilities (Watkins *et al.* 1988). 'The burn team should reinforce the child's positive adaptation at every phase of recovery' (LeDoux *et al.* 1996, p.476). For patients to regain successful functioning it is important for them to focus on effective coping skills such as resiliency (Holaday and McPhearson 1997), hope and positive attitudes (Gilboa, Friedman and Tsur 1994), and successful outcome expectations (Blalock, Bunker and DeVellis 1994).

By manipulating art materials and creating a tangible art product, pediatric burn patients are able to focus on their accomplishments. Through art therapy, the therapist can encourage and praise children's attempts to participate in and create art.

Stage 5: acceptance of loss

The next phase of the burn patient's recovery begins when the patient starts to comprehend cognitively and emotionally the losses experienced as a result of the injury (Watkins *et al.*). Orr, Reznikoff, and Smith (1989) who studied body image, self-esteem, and depression in burn-injured adolescents and young adults explain: 'Patients with burns may experience inordinate personal losses, such as the death of parents, siblings, or pets and the destruction of possessions, in addition to the loss of bodily functions or limbs' (p.454). Scarring due to burns can also be devastating in terms of body image and self esteem. 'The disfigurement of burn patients often results in increased body image concerns and acute social readjustment difficulties' (Armstrong, Gay and Levy 1994, p.75).

Art expression allows patients to express losses and, thereby, assists in defining their losses and moving towards acceptance. Cameron, Juszczak, and Wallace (1984) used creative arts in a hospital setting to help children cope with altered body image and learned that: '...creative arts can be helpful as a preventative, therapeutic and assessment technique for helping children with their body image. It is a way of allowing children to deal with potentially difficult issues at a safe distance and of providing opportunities for making choices and feeling in control' (p.108). They note that: 'Carefully selected expressive activities provide children with the opportunity to deal with their body image during hospitalization and thus help foster reintegration and acceptance' (p.112).

Stages 6 and 7: investment in rehabilitation and reintegration of identity

During these two stages patients learn to regain as much of their pre-burn level of independent functioning as possible. As patients experience success in accomplishing even simple tasks, they feel a sense of accomplishment and gain self confidence. However, patients may discover they are unable to resume some functions and, as a result, may feel sadness, hurt, frustration, anger, and anxiety. They may have to recognize their losses, accept them, and move towards recovery and rehabilitation.

Through art expression, pediatric burn patients can express their fears and concerns and work through their anxieties and frustrations. Patients may also determine and express goals through their artwork, which can provide the therapist with additional information about their status and thereby facilitate their rehabilitation.

Case examples

Mary

Mary was eight years old at the time an aerosol can exploded next to a wood stove in her home. She was the only one at home at the time of the explosion which caused her and her home to catch on fire. She suffered 80 per cent total body surface area burns, with 65 per cent full thickness burns to her arms, torso, legs and neck, and 15 per cent partial thickness burns to her face and posterior torso. Initially, the risk of Mary's death was high due to the high percentage of her body that was burned. Her initial hospitalization was of five months duration during which she had numerous surgeries. She would need to return to the hospital for reconstructive surgery many times.

Mary was three months post-burn injury when I joined the burn team and began working with her. At this time she was still undergoing numerous surgeries for skin grafting, experiencing painful, but very necessary procedures such as dressing changes, and learning to move and manipulate her limbs again through often painful physical therapy.

I worked with Mary for the next two months of her hospital stay and during numerous returns to the hospital for reconstructive surgery over the next two and a half years. From the psychiatric consultation notes in her medical record charts, I noted that she initially expressed fears of mortality, the loss of her kittens in the fire, and the possibility of her deformed appearance. Through art therapy, she expressed her concerns, losses, joys, and accomplishments as she adjusted to the phases of her burn experience.

Acrylic paints were the first art medium Mary tried. Her hands were still bandaged, yet she had enough dexterity to slip the paint brush in between her thumb and fingers with my help. She could then move her hand with the paint brush across the paper. She could make bright colors flow onto the paper without need to apply pressure which would have been difficult and painful for her to do. Most importantly, she was able to do the activity herself

Figure 7.1 Mary's first painting after her burn accident

and see the outcome of her endeavors. Painting was initially successful and continued to be Mary's favorite art medium.

Figure 7.1 is Mary's first painting after her burn accident. She discovered that she could manipulate the paint brush and control the color, shapes, and lines within the picture. It seemed important to her at this time to be able to create something bright and colorful, using bright red for the flowers and brilliant yellow for the butterfly with red and blue spots. Through her choice of a butterfly, a symbol of transformation, Mary may also have been unconsciously acknowledging that she was experiencing a transformation in adjusting to her burn injury. I praised her efforts and hung her picture on the wall of her hospital room which she could proudly show to family, friends, and hospital staff when they entered her room. Through art activities Mary had control over her art materials; also it was relaxing and it was a distraction – all helpful in reducing pain.

After completing several other paintings during her hospital stay, Mary painted the picture in Figure 7.2. It is a green fish swimming in a blue sea. When she finished painting it she exclaimed: 'That is the best I have ever painted!' This was a very important moment for Mary because her comment implied that there was something she could do better now than before the fire and her injuries. Mary was attempting to regain her autonomous functioning which Watkins *et al.* describe in the stage of investment in recuperation. The artwork was a tangible product in which she could take pride.

Figure 7.3 is an image Mary created by using the bandages from her fingers which she saved and painted. She originated the idea of painting her bandages. When I suggested she mount them on poster board, she did and labeled it: 'My colorful spinning wheel.' Mary transformed her bandages which were used for painful dressing changes and injuries into a colorful, playful object. Through art expression she was gaining control over her bandages, which in turn helped her control and diminish her pain (see Table 7.1 for more information about art making with medical materials).

Nine months elapsed from the time of Mary's discharge to our next session in the hospital. During this session she painted a light blue figure with yellow hair and eyes extending out of its head (Figure 7.4). Two lavender hearts float nearby. Mary told me she wanted to paint a monster and proceeded to paint this picture. It is my speculation that this may be a self-portrait, depicting Mary's feelings about herself. Her monster appears to be a friendly, feminine monster with eyes that are out of its body. The

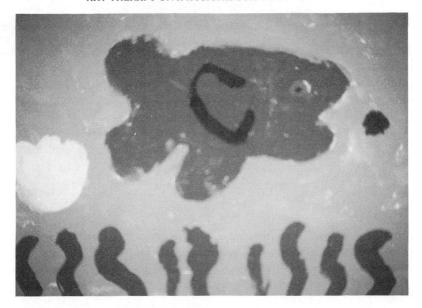

Figure 7.2 Painting of a green fish swimming in a blue sea

Figure 7.3 'My colorful spinning wheel', an image from bandages

7.1 Medical materials collage

Age
5 years through adolescence

Objectives
Exploration and manipulation of medical materials and implements; catalyst for identifying and discussing experiences and feelings associated with the materials and implements.

Materials
Medical materials and implements such as gauze pads, bandages, plaster gauze, IV tubing, paper cups, or any other flat or relatively flat materials; piece of cardboard to serve as surface for collage; glue; scissors; paint (optional).

Task
Assemble the materials and objects for the child to choose from. The child is then asked to arrange the materials and objects on the cardboard and to glue them in place. After the piece is dry, the child may also paint the project. The therapist may encourage the child to talk about the finished piece and to answer any questions, confusion, or concerns the child has about medical materials and implement.

lavender hearts, which are her favorite color, communicate friendliness and love. Her monster does not appear to have a neck, which is very similar to Mary's appearance at this time until she could have reconstructive surgery to reform her neck.

Mary's monster (and Mary herself) may be very aware and seeing, and may want others to see her friendliness and not her body which may appear monster like. Using the metaphor of the friendly monster may have been her way of expressing feelings which were too painful or threatening to verbalize. Mary was attempting to accept her body image which was an appropriate response for her as a burn patient and was expressing a normal concern for her adjustment process with her world of friends, family, and school.

Six months later, when Mary returned to the hospital for another reconstructive surgery, she created Figure 7.5, which she entitled 'Different'. The art medium here is a print making project which she had looked forward to trying for several hospitalizations. Mary decided the subject matter and while she drew, she said she did not like the clown who smiled all the time because he laughs and jokes when the other clown is sad. She then wrote 'Different' above the clown's head.

Another nine months followed and Mary returned for yet another surgery. She told me at this time that she and her family might be moving to another state. She painted a picture and spontaneously dictated to me the following poem:

Lost things

> I lost my jumping jacks.
> I used to have a pretty little teddy, but I lost it too!
> My Mom broke her wine glass but then couldn't find it.
> My older brother has stinky sneakers, but we guess the dog drug them off.
> At school I had a hole in my pocket – I lost all my money for pop cycles.
> My baby sister took my comb and hid it away.
> And while we watched an old movie, my Dad lost his cup.
> While I was painting this picture for the poem, I lost my paint brush.
> I met this THING – he says he knows all about it.

The possibility of moving appears to have prompted Mary to re-evaluate her losses. She was returning to the phase in her adjustment process of redefining and accepting her losses. She includes all members of her family, as if indicting the 'problems' of daily living that occurred in their lives. Mary's 'Thing' is a green, friendly looking monster (that is similar to her other monster in Figure 7.4). The 'Thing' seems to understand and takes life as it comes.

One month later, Mary was back. She created a painting during the afternoon while she was waiting to go to surgery. It was an image of a 'blue bird' who she said was sad and that the background was someplace where no one had ever been before. She was feeling very anxious about her upcoming surgery that day and told me that being busy with art helped her feel less

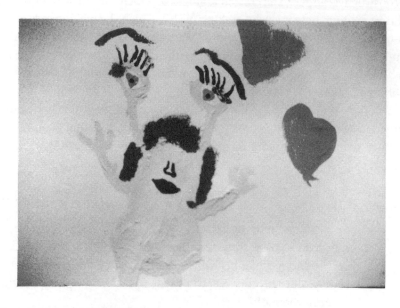

Figure 7.4 Mary's painting of a 'monster'

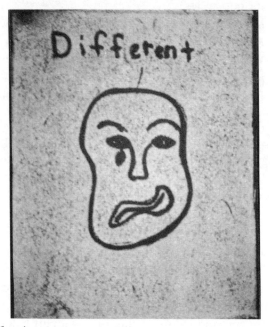

Figure 7.5 'Different'

anxious. The art gave her a way to express her anxiety as well as providing an activity she could engage in while waiting.

Art therapy assisted Mary in processing her inner concerns through the various psychological phases of her burn trauma. Art making was a positive, expressive activity where she had control over the medium and could take pride in the resulting art products. Art expression was also a diversion from pain and anxieties due to hospital procedures and surgeries. Through her artwork, Mary could express concerns about her body image due to scarring and deformities caused by her burns. She was also dealing with the losses she had suffered and portrayed these feelings through her art. Moreover, whenever she came back to the hospital for surgery, she could look forward to seeing me and having our time together, as well as creating art. Art therapy provided a tangible, positive medium through which Mary could express her joys, fears and anxieties and thereby assisted her in her healing process.

Tina

Tina was a four-and-a-half-year-old female who was admitted to the burn unit with burns on her buttocks, genitalia, legs and feet. Her injuries appeared to have characteristics similar to burns due to forced immersion in hot water and appeared to be several days old. Bruises also were evident on the patient's body. She smelled foul, had a severe case of head lice, appeared frightened, and was malnourished.

Tina's mother, a 20-year-old single parent with two other children aged one and six, first brought her daughter into an outpatient clinic for diarrhea whereupon the patient was transferred to the burn unit. Child abuse was immediately suspected due to the type of injury, the delay in bringing the patient for medical care, the bruises evident on her body, and the mother's accounting of how the burn happened, which was inconsistent with the type of burn injury. When the child was admitted to the hospital, Child Protective Services was notified, and Tina was removed from the custody of the mother.

The first day the patient was admitted to the hospital and settled in her hospital room, I introduced myself to her. Since she was very frightened, tired and hungry, I helped feed her ice cream at her nurse's suggestion. I then read to her from a children's book in which she took an interest. I felt she did not have the energy to do art this first day, but I still wanted to introduce myself and interact with her in a supportive, non-threatening manner.

At our second session, which was two days later, Tina appeared less frightened. When I offered her a drawing pad and crayons to use, she chose a

Figure 7.6 Drawing by Tina

Figure 7.7 Drawing by Tina

pink-purple crayon and started spontaneously drawing members of her family (Figure 7.6). While she drew, she talked quietly about each person. She started with a picture of her mother with a smile on her face and then drew her dad looking sad.

As Tina drew the figures, she talked about the behavior of different family members, such as one family member pulling out his hair. Tina said the small figure in the lower, left hand side of her picture, was 'too little to get hit'. The circle shapes beside each figure, she said, were cookies which her mom and dad made. However, she said that if she ate the cookies, she would throw up. Tina explained that the letters BA at the top of her picture meant 'I love you', which she wanted to tell her mom. However, Tina became angry at this point and said she did not know how to write 'I love you' because no one had taught her.

At this session, Tina was expressing many thoughts and feelings. For example, she was probably expressing survival anxiety (Stage 1); in Tina's case, her anxiety seemed to be primarily because of her abusive family environment. She appeared to have angry, conflicting feelings about her mother and father which she indicated by saying she would throw up the home-baked cookies and being angry at not knowing about love. She did not complain of her pain, which is often typical of children suffering from abuse.

Through her drawing and verbal dialogue, Tina could express her situation and her feelings of anger and sadness. When she was drawing, she seemed to give herself permission to talk about aspects of her abuse. I listened carefully to her and supported her feelings that it was not right to get pushed and hit, and that she had a right to be angry.

After she finished her first drawing, she drew a second picture (Figure 7.7). She first drew rain at the top of the page and later drew her mother's house and said the wind was blowing as she made large, back and forth strokes across the page. She then covered her mother's house with color, which she said was frost on the windows. She drew other ovals which represented other houses, such as her aunt's, which she also covered with color. Tina talked quietly as she drew with large sweeping strokes of color and communicated her story.

Tina appeared to be beginning to work through her 'search for meaning' (Stage 3). However, at this point she did not disclose how her burn accident happened, which made it difficult for her to resolve this stage. She expressed her anxiety by drawing wind, and then covered it up by drawing frost on the

windows so one cannot see in or out. During later sessions with Tina, I learned that her mother had told her not to tell what happened, which is again typical in abusive situations.

After this session, I charted the significant details of our interaction in her medical record chart. I also talked with the social worker handling this case and communicated to her what I had learned. The social worker could then make any necessary further reports.

Our third session was five days after the second session. Tina had received skin grafting several days prior in surgery. Her head had been shaved, which is a normal procedure when using this area as a donor site for skin to graft onto the burned areas of her body. She was quiet and withdrawn compared to the talkative and spontaneous manner during the previous drawing session. However, she told me she wanted to draw, and I offered her crayons. Tina drew one house which she said was her mommy's house. She then put her head down on her table, saying that she was hungry, but when lunch came she ate very little.

After lunch I showed her some hearts since it was close to Valentine's Day and during the second session she told me she wanted to draw a heart. She glued the hearts onto the paper, but remained subdued and quiet during this activity.

Tina's mother came into the room during this time, but Tina showed little response or reaction to her mother. She continued gluing hearts onto the paper. After about 30 minutes of very little interaction between the two, her mother said she was going to the cafeteria for awhile and left the room. Her mother did not return again that day. When her mom first left the room, Tina cried and wanted her mother to return. After a few minutes, Tina stopped crying and I offered her poster paints. Tina proceeded to paint her entire piece of paper red. This was the only time I saw Tina use entirely red paint. She appeared to be absorbed in her painting and talked very little during this time. The painting seemed to give her an outlet to express in paint that which she could not verbalize.

Our fourth art therapy session was four days later. I offered Tina the paints again because I knew she had enjoyed using the paints and had been expressive in her choice of color. During this session, she used all the colors and appeared to be excited and happily engrossed in mixing colors to discover new colors while she painted with large, circular strokes. After about 45 minutes of painting, she said she was finished and wanted to draw.

While Tina drew a large face, she said, 'My daddy whips me, and I don't like it.' She further said he hit her with a belt and that's how her feet got hurt. Since I knew that her feet were burned, I realized there was an inconsistency in her story and that she was not telling everything. She said her mom did not want her to tell anyone, and she did not want me to tell her mom that she had told me. She then said she was finished drawing. I listened to Tina, validated her feelings, and told her that it was not right to be hit and that she was right in telling me.

Through painting at the beginning of the session and then drawing, Tina seemed to become more confident and, as a result, was able to begin to express more about her abuse. In addition, she seemed to be continuing to work through the psychological phase of adjustment of 'searching for meaning' and beginning to be able to tell her story. By painting and drawing, Tina was able to express her emotions, to reveal aspects of her abusive home environment, and to tell secrets of her abuse which her mother had told her not to tell.

It was determined that Tina would be placed with a medical foster mother when discharged from the hospital. When I saw Tina for our fifth session, a few days before discharge, she was withdrawn and quiet. She appropriately seemed to be anxious about going to a new home and leaving the now familiar hospital surroundings and staff. She did not want to talk, paint, or draw. I then sat down next to her, put my arm around her, and read her a book. She leaned up against me and appeared to like being comforted.

The last time I saw Tina during hospitalization, a foster mother was at the hospital to take her home. Tina was frightened, crying, and did not want to leave the familiarity of the hospital and go to a new home. The foster mother was appropriately sincere and caring in the situation. I helped them pack Tina's belongings, supported her anxious feelings, transported her to the car, and said good-bye to her.

Conclusion

In conclusion, art therapy can play an important role in burn patients' recovery process. Since some patients, especially children, can express themselves better through non-verbal modalities, there is a need for art therapy to assist them in working through their trauma and psychological phases of adjustment. Art therapy provides an action-oriented, external outlet for hospitalized children to cope with their trauma. When children

manipulate developmentally appropriate art mediums, they make use of these action-oriented means of coping.

By drawing, painting, pounding clay, and other creative activities, children can express their emotions about their burn experience. During hospitalization, their participation in art allows them a distraction from their pain, offers them predictability and control, and provides them with a pleasurable, relaxing part of their day. They can look forward to seeing a therapist with whom they have built a relationship of rapport and trust, who provides the opportunity for creative activities, and who is not a part of painful but necessary medical procedures.

As burn survivors progress toward reintegration of their body image and adjusting to accomplishing tasks or being unable to resume all of their pre-burn functioning, art therapy can be an outlet for expressing their frustrations, anger, sadness and/or successes and joy. Art can help burn survivors recognize their losses and gains as well as assist them in determining new goals. Their art work serves as a permanent record of their thoughts and feelings and is a tangible product in which they can take pride and see their accomplishments. Art therapy provides a unique means of assisting, supporting and enabling these patients to cope with their burn experiences.

References

Armstrong, F.D., Gay, C.L. and Levy, J.D. (1994) 'Acute reactions.' In K.J. Tarnowski (ed) *Behavioral Aspects of Pediatric Burns.* New York: Plenum Press.

Appleton, V.E. (1993) 'An art therapy protocol for the medical trauma setting.' *Art Therapy: Journal of the American Art Therapy Association, 10,* 2, 71–77.

Baker, R., Jones, S., Sanders, C., Sadinski, C., Martin-Duffy, K., Berchin, H. and Valentine, S. (1996) 'Degree of burn, location of burn, and length of hospital stay as predictors of psychosocial status and physical functioning.' *Journal of Burn Care and Rehabilitation 17,* 4, 327–333.

Baron, P.F. (1989) 'Fighting cancer with images.' In H. Wadeson and J. Durkin (eds) *Advances in Art Therapy.* New York: John Wiley.

Blalock, S.J., Bunker, B.J. and DeVellis, R.F. (1994) 'Psychological distress among survivors of burn injury: the role of outcome expectations and perceptions of importance.' *Journal of Burn Care and Rehabilitation 15,* 5, 421–427.

Cameron, C.O., Juszczak, L. and Wallace, N. (1984) 'Using creative arts to help children cope with altered body image.' *Child Health Care 12,* 108–112.

Choiniere, M., Melzack, R., Rondeau, J., Girard, N. and Paquin, M. (1989) 'The pain of burns: characteristics and correlates.' *Journal of Trauma 29*, 11, 1531–1539.

Cresci, J.V. (1982) 'Emotional care of the hospitalized thermally injured.' In R.P. Hummel (ed) *Clinical Burn Therapy: A Management and Prevention Guide.* Boston: John Wright and Sons.

Doctor, M.E. (1993) 'History of psychosocial care.' *Journal of Burn Care and Rehabilitation, 14*, 267–271.

Gilboa, D., Friedman, M., and Tsur, H. (1994) 'The burn as a continuous traumatic stress: implications for emotional treatment during hospitalization.' *Journal of Burn Care and Rehabilitation 15*, 1, 86–91.

Holaday, M. and McPhearson, R. (1997) 'Resilience and severe burns.' *Journal of Counseling and Development 75*, May–June, 346–356.

Klingman, A., Koenigsfeld, E. and Markman, D. (1987) 'Art activity with children following a disaster: a preventive-oriented crisis intervention modality.' *The Arts In Psychotherapy 14*, 153–166.

LeDoux, J., Meyer, W., Blakeney, P. and Herndon, D. (1996) 'Positive self-regard as a coping mechanism for pediatric burn survivors.' *Journal of Burn Care and Rehabilitation 17*, 5, 472–476.

Levinson, P. and Ousterhout, D.K. (1980) 'Art and play therapy with pediatric burn patients.' *Journal of Burn Care and Rehabilitation 1*, 42–46.

Lusebrink, V.B. (1989) 'Art therapy and imagery in verbal therapy: a comparison of therapeutic characteristics.' *American Journal of Art Therapy 28*, 2–3.

Mehaney, M.B. (1990) 'Restoration of play in a severely burned three-year-old child.' *Journal of Burn Care and Rehabilitation 11*, 57–63.

McGrath, P.J. and Vair, C. (1984) 'Psychological aspects of pain management of the burned child.' *Child Health Care 13*, 15–19.

Meyer, W., Blakeney, P., LeDoux, J. and Herndon, D. (1995) 'Diminished adaptive behaviors among pediatric survivors of burns.' *Journal of Burn Care and Rehabilitation 16*, 5, 511–518.

Miller, A.C., Hickman, L.C. and Lemasters, G.K. (1992) 'A distraction technique for control of burn pain.' *Journal of Burn Care and Rehabilitation 13*, 5, 576–580.

Nicosia, J.E. and Petro, J.A. (1983) *Manual of Burn Care.* New York: Raven Press Books.

Orr, D.A., Reznikoff, J. and Smith, G.M. (1989) 'Body image, self-esteem, and depression in burn-injured adolescents and young adults.' *Journal of Burn Care and Rehabilitation 10*, 454–461.

Patterson, D.R. (1995) 'Non-opioid – based approaches to burn pain.' *Journal of Burn Care and Rehabilitation 16*, 3, 372–376.

Roberts, D. and Appleton V. (1989) 'Psychosocial care of burn-injured patients.' *Plastic Surgical Nursing 9*, 62–65.

Sheridan, R., Hinson, M., Nackel, A., Blaquiere, M., Daley, W., Querzoli, B., Spezzafaro, J., Lybarger, P., Martyn, J., Szyfelbein, S. and Tompkins, R. (1997) 'Development of a pediatric burn pain and anxiety management program.' *Journal of Burn Care and Rehabilitation 18*, 5, 455–459.

Steward, M.S. (1993). 'Children's memory of medical procedures: "He didn't touch me and it didn't hurt!"' In C.A. Nelson (ed) *Minnesota Symposium on Child Psychology: Memory and Affect in Development.* Hillsdale, NJ: Lawrence Erlbaum.

Stoddard, F.J., Chedekel, D.S. and Shakun, L. (1996) 'Dreams and nightmares of burned children.' In D. Barrett (ed) *Trauma and Dreams.* Cambridge, Massachusetts and London, England: Harvard University Press.

Watkins, P.N., Cook, E.L., May, S.R. and Ehleben, C.M. (1988) 'Psychological stages in adaptation following burn injury: a method for facilitating psychological recovery of burn victims.' *Journal of Burn Care and Rehabilitation 9*, 376–384.

Comparisons of Pain Perceptions Between Children with Arthritis and Their Caregivers

Jennifer Barton

Juvenile rheumatoid arthritis (JRA), the fifth most common chronic disease of childhood (Lovell and Walco 1989), affects approximately 71,000 children in the United States (Arthritis Foundation 1987) and is similar to the rheumatoid arthritis (RA) which affects adults. It is an autoimmune disease in which the immune system malfunctions and attacks the lubricating synovial lining within the joints of the body. Inflammation results from this attack, bringing with it the commonly seen symptoms of swelling, redness, loss of motion, and – most notably – pain in the joints. Joint cartilage may weaken and ultimately be destroyed.

The child with active JRA of any form is typically in a lot of pain. Pain, therefore, is one symptom of disease activity which a child can feel and communicate to others. Children with JRA experience a variety of types and levels of intensity of pain, but often do not have the ability to articulate their specific experience of pain. Because physiological pain can be considered a subclinical (not visibly apparent) symptom of disease activity, one must rely on the indicators of a person's subjective reactions to that pain experience. In children who are unable to communicate their pain verbally, pain behaviors (moans, limping, inactivity) become important. For this reason, physicians often rely on the primary caregiver to provide the specifics in regards to the history and the experience of the pain. It is therefore important to have as accurate as possible a description of children's pain from the primary caregivers.

How can a young child effectively communicate the pain to the primary caregiver, typically the mother? Furthermore, if the primary caregiver is relying on his or her own perceptions of the child's pain when advocating for the child during doctor visits, just how reliable are these perceptions? Are the caregiver's perceptions of the child's pain similar to the child's own perceptions of his or her pain?

Because young children enjoy working with art and they are often able to communicate through art more easily than they can communicate through words, it seems natural to use art therapy as a component in treatment of JRA, particularly in the understanding of children's and caregivers' perceptions of pain. The study described in this chapter compares how children with juvenile rheumatoid arthritis draw their pain with how their primary caregivers draw the children's pain. The purpose of this descriptive study is to assess and compare the perceptions of JRA pain through the use of drawing, both with children with JRA and their caregivers, in the hope that the caregivers can improve their role as the child's advocate and that art expression can assist children in explaining their pain to their caregivers.

Pain and arthritis

Pain and functional disability are considered the central dimensions of a patient's experience with rheumatic disease, such as JRA (Brown *et al.* 1984; Fries, Spitz and Young 1982). In his report on the undertreatment of pain in children, Schechter (1989) lists the following definition of pain: 'an unpleasant sensory and emotional experience connected with actual or potential tissue damage, or described in terms of such damage' (p.781). He suggests that 'pain is always subjective. Each individual learns the application of the word through experiences related to injury in early life' (p.781).

Among the many causes of the pain of arthritis is inflammation of the joints, signalling damage to the joint tissues. Inflammation is a reaction of the body that causes redness, swelling, pain, and loss of motion in the affected area and is the major physical problem in the most severe forms of arthritis (The Arthritis Foundation and The American College of Rheumatology 1993). Inflammation is a normal function in which the immune system protects the body from disease. However, in the development of inflammatory arthritic diseases, such as rheumatoid arthritis, the normal protective process goes awry. Lymphocytes, or white blood cells, lose their ability to distinguish between antigens (foreign toxins or enzymes) and

healthy tissue and attack and destroy the synovial lining around the joints. This process results in swelling, tenderness, and pain.

Other contributors to the pain of arthritis include muscle strain caused by overworked muscles attempting to protect the joints from painful movements, and/or fatigue (Arthritis Foundation 1991). Stress and depression can exacerbate the pain experience.

The course of JRA tends to vary from child to child and symptoms can and do change often. Treatment generally includes anti-inflammatory medication and balanced programs of rest and exercise in order to relieve pain, reduce inflammation, stop or slow down joint destruction and improve function, and increase patient well-being (Arthritis Foundation and The American College of Rheumatology 1993). A team of health care professionals from different disciplines – including pediatric rheumatologists, physical therapists, occupational therapists, nurses, psychologists, orthopedic surgeons, and/or social workers – is usually involved in the treatment.

Ross and Ross (1988) describe three distinct experiences of pain related to JRA. The first is arthritic pain, described as 'a dull ache' or 'dull constant pain'. Children with JRA in their study tended to view this pain as an annoyance because medication was ineffective in controlling their discomfort. The second pain experience results from overexertion and is a more intense version of 'arthritic pain'. The third and most severe pain experience is the spontaneous flare-up, which is so severe that medical attention is required.

Psychosocial influences on children's concepts of pain

Children's pain is influenced not only by the physical trauma that they experience but also by psychosocial aspects, such as their cognitive development, memory of previous pain, and fear, culture, attitudes and interactions with family, peers, and professionals (McGrath and McAlpine 1993). In their long-term study of 75 children with JRA between the ages of 7 and 17, Beales and co-workers (Beales, Holt and Keen 1983) conducted interviews consisting of descriptions by children of their arthritis and its effect on their bodies, followed by the subjects drawing and describing pictures of their own joints and describing and explaining each type of therapy and its purpose. As the authors anticipated, a definite difference could be found in the children's beliefs about their JRA. The younger group interpreted arthritis in a very concrete manner, in terms of pain and swelling,

while older children were capable of more abstract, realistic interpretations of their disease. The authors believe that this study demonstrates that children do require different types of explanation of the disease process at different ages, depending on that child's level of cognitive development.

Gaffney and Dunne (1986) state that: 'children's drawings are proving to be a valuable source of information about pain' (p.115). The authors relate findings from a study of children's visual perceptions of pain (Scott, cited in Gaffney and Dunne 1986) which found 'a greater readiness to attribute color and shape to different types of pain in younger children in the preoperational stage of cognitive development' (p.106).

Color symbolism in child's pain renderings

It has been observed that color may be related to physical sensations and conditions. Birren (1961) describes Babbitt's theories written in the late 1800's on the therapeutic primary colors. To Babbitt, red was 'the center of heat…a thermal or heat-producing color' (p.55). Birren notes that the color red was prescribed for paralysis, physical exhaustion, and chronic rheumatism and that yellow and orange stimulated the nerves.

Birren also describes Hessey's theories of color, with the red end of the color spectrum as inflammatory, the blue end as cooling. According to Hessey (cited in Birren 1961), blue contracts arteries and is beneficial to 'various forms of inflammation' (p.60), green lowers the blood pressure, is sedating and hypnotic, orange is a stimulant, increasing the blood pressure slightly and 'enlivening the emotions' (p.60), yellow is a mental stimulant, and red is 'too strong' (e.g. extremely stimulating, p.61).

The use of colors by children to communicate the intensity of pain has also been investigated. Red is reported as the color most frequently chosen by children to represent pain (Savedra, Gibbons, Tesler, Ward and Wegner 1982; Scott 1987). In a study of recurrent migraine headaches and chronic musculoskeletal pain, children were asked to draw themselves when in pain using eight colored markers. Red and black were most frequently chosen by the children in their drawings, with no significant differences found for age or sex (Unruh, McGrath, Cunningham and Humphreys 1983). Red was chosen most frequently (52% of the sample) to represent severe pain by children with chronic musculoskeletal pain in JRA, with purple representing moderate pain most frequently, orange representing mild pain most often, and yellow representing no pain most frequently (Varni, Thompson and Hanson 1987).

Parent's versus child's perception of child's pain

Barr (cited in McGrath and Craig 1989) has noted that questions regarding the child's pain are addressed exclusively to the parents and that the child's own viewpoint frequently is not ascertained. In their study of pediatricians' views of the child's role in the pediatric interview, Mendelsohn, Quinn, and McNabb (1993) found that pediatricians sampled reported that, while they routinely play with or talk to infants up to 15 months of age and toddlers up to 3 years of age, they use these children's parents as the sole source of history information. As the age of the child patient advances, more reliance is placed on the child for the history. This general tendency to ignore the pediatric patient and to rely on the parent, however well informed, deprives the clinician of the child's understanding of the pain and report of the symptoms.

Most clinicians rely almost exclusively on the mother's reports of the child's behavior; however, this can be problematic in some cases. Eiser *et al.* (1992) state that: 'certainly, mothers' reports may often be the most viable means of collecting data about a child, but judgments are likely to be influenced by certain factors' (p.263), such as depression, neurotic symptoms, and marital dissatisfaction.

In a study by Ennett *et al.* (1991) comparing children's and mothers' reports of the child's adjustment to JRA, modest correlations were found between children and mothers in their assessments of the child's perceived competence in several domains, and in their perceptions of how JRA is experienced by children and families. However, there were significant differences in the magnitude of impact which the children and mothers reported. For example, children and mothers differed significantly in their perceptions of the day-to-day experience of JRA and in the burden of the disease on the family.

Severity of JRA assessed by the child was found to be significantly milder than the parent's assessment and that of the physician (Vandvik and Eckblad 1990). However, the children's present pain correlated significantly with their own assessment and their parents' assessment of disease severity. No correlation was found at any time in the study between the child's present pain and disease severity as rated by the physician. In addition, there was no significant correlation between disease severity assessed by the mother and physician in the total sample.

Study subjects

The subjects in this study were 30 boys and girls diagnosed with JRA by a pediatric rheumatologist and 30 primary caregivers, typically the child's parent. The children who participated in the study showed an even distribution of ages from 5 to 14 years, with slightly more children being between the ages of 9 and 10. Seventy per cent of the children in the sample are female, 30 per cent male. Eighty-three per cent are Caucasian, 10 per cent African-American, and 7 per cent of other racial ethnicities. The primary caregivers, both male and female, ranged in age from approximately 25 to 48 years. All subjects were volunteers who have been involved to some extent in diagnosis and/or treatment at either the University of Wisconsin Hospital in Madison, Wisconsin, or the Children's Hospital of the King's Daughters in Norfolk, Virginia.

The children in this study had all been previously diagnosed with one of the three main forms of juvenile rheumatoid arthritis. The particular course of the disease for each child at the time of the study was not necessary to take into account, because the objective was to obtain general findings for children at any and all stages of JRA. In general, the children in the study appeared to be minimally incapacitated physically by their illness. Out of the 30 children, only one relied on an assisting ambulatory device.

The primary caregiver in this study was defined as the person who typically holds a central role in the care of the child. This was always the legal custodian and the person who brings the child in for treatment, typically the mother. When asked if the caregivers felt that they are able to give accurate reports of the child's pain (including location and severity), the majority (90 %) indicated that they were confident in their ability. Seventy-three per cent of the adults indicated that they tend to notice a certain emotional and/or physical state in the child that tells them the child is about to experience pain.

Method

Two tasks were used in this study: Body Outline Forms (BOF) and Magnified Pain Drawing (MPD). The BOFs are pre-drawn generic outlines of both the front and back of a child's body which are used to assess the subjects' perceptions of the size, location, and color of the pain within the body. They were designed by this investigator for use in the study; similar body outlines have been utilized by Varni and Thompson (1985) and Eland (1981). These designs serve, perhaps, as independent verification of the suitability of these

methods, as this investigator was unaware that such methods already existed at the time this study was initiated.

The MPD is a projective technique developed by this author to assess an individual's internal unconscious representation of pain, either in himself/ herself, or in others. The idea of drawing a magnified image (MPD) of the pain associated with JRA appears to be a novel one, although this researcher is aware of others, notably art therapists, who utilize such an approach with other medical populations (Councill 1993).

In general, this investigator felt that it was important to focus on the parent's and child's perceptions of the color, size, and location of the pain. The BOF measures the size and location, as well as the color(s), of the pain sites. The MPD was devised to measure the color(s), the size, and overall quality of the pain.

The instrument used to rate the drawings collected for this study is the self-designed Pain Assessment Index (PAIn). This rating scale provided a list of specific characteristics to identify and/or specific measurements to make in both the child's and caregiver's BOF and MPD. The similarity in drawing characteristics between caregiver and child drawings, such as a similar location, size, or color for the pain, was assumed to indicate a similar pain perception between caregiver and child. Conversely, a discordance in drawing characteristics, such as completely different placement of the pain within the body, or a soft pink hue versus an abrasive red hue, was considered as suggestive of a dissimilar pain perception between subjects.

In this particular study, the primary caregiver and child were seen separately. The primary caregiver was given the directions in the same format as was subsequently given to the child. It was emphasized to the caregivers that to avoid biasing the data in any way, they would not be allowed to be in the same room as the child during the child's participation in the study. However, as a comfort, they were welcome to sit in an adjoining room to look on and/or listen after finishing their part of the study.

Each participant was asked to complete the BOF drawing, indicating the overall location and size of the child's pain, using any or all of ten assorted color markers. Each subject was asked to mark wherever the pain was located, be that on the front and/or back of the body. The caregiver's and child's pain sites on these outline forms were later compared to each other in terms of area, location, number, color, and consistency of style, utilizing the PAIn rating scale.

8.1 Body Outline Form

Age range
5 through 14 years and their caregivers

Objective
To evaluate subjects' perceptions of the size, location, and color of pain within the body.

Materials
Body Outline Form; ten assorted colors of markers.

Task
In separate sessions, each subject is asked to mark wherever the pain was located. The exact instructions include the following statement: 'Do not worry about how well you are drawing. There is no right or wrong way to draw this. Try to draw the pain exactly where you feel it hurts inside you. Also, I'd like you to try to draw the pain how you think it feels in you: what color(s), what shape(s), and/or texture(s) it might be.' Caregivers, of course, would be asked to draw their children's pain sites, as they perceive them.

The subjects were also each asked to complete the MPD, providing a close-up, symbolic depiction of the pain, utilizing any of the ten markers. Each was asked to visualize the child's general pain from the JRA and then draw that image in a magnified form.

Again, the self-designed PAIn rating scale was used to rate frequency counts of size, color, form, and line quality in these caregiver and child MPDs.

Study results and discussion

Analysis of Concordance of Number of Pain Sites in BOF

A marginally significant finding involves the greater amount of total median number of pain sites in the BOF drawings of the caregivers (4.5) than of the children (2.5). This result could imply that caregivers may have had a

8.2 Magnified Pain Drawing

Age range
5 through 14 years and their caregivers

Objective
To assess an individual's internal unconscious representation of pain, either in himself/herself or in others.

Materials
Paper and ten assorted colored markers.

Task
In separate sessions the child and caregiver are asked to use the materials to provide a close-up depiction of the pain, using any colors they wish. Specific instructions include: 'I would like you to try to pretend that you can see your pain right now as it feels inside your body. You may close your eyes if you would like. Try to imagine what the pain looks like, what color or colors it is, what shape or shapes it is, what size it is. Try to picture what it sounds like if you could hear it, feels like if you could touch it, looks like if you could see it. There is no good or bad way to see the pain. It is how you view your pain, and only you can see it that way... Now I would like you to open your eyes if they were closed. Please try to remember how your pain looked, sounded, and felt. I'd like you to draw on the paper what you saw, the pain. Try your best to draw exactly what you saw – drawing the same colors, sizes, shapes, of the pain – but try to draw it really big on the paper, so that if a person couldn't see very well and he or she saw your drawing, he or she could see everything you drew very easily, because it would be big and close-up.'

tendency to exaggerate the extent of the child's pain through depiction of a greater total number of pain sites.

Analysis of concordance of color usage within the MPD and BOF

A comparison of the number of colors used (without regard to prevalence) for caregivers and for children was made with a paired t-test. For the BOF drawing, caregivers had a mean of $1.73 \pm .94$ colors used, compared to 2.17

± 1.58 for children. For the MPD, caregivers had a mean of 2.83 ± 1.51 colors used, compared to 2.97 ± 2.06 for children.

For the BOF drawing, there were 10 over 30 (33%) caregiver-child agreements on the most prevalent color used, which was the color red. There was only one other agreement between caregiver and child, and this was for the color orange as the fourth most prevalent color used. No other agreements between caregiver and child in the order of prevalence for any other color occurred. The remaining colors were used more or less in the same quantity except that only one caregiver used the color pink.

Red was the most prevalent color used in the MPD, with 8 over 30 (27%) caregiver-child agreements. Pink was the second most prevalent color used by children, but was the least used by caregivers. Use of the remaining colors was evenly distributed.

Analysis of concordance of imagery shape in MPD

When comparing the caregiver and child data by paired t-tests, it is interesting that caregivers were rated significantly higher on the amount of realism and perseveration in their MPD images than the children, and that the children were rated as having more closed forms (i.e. circles) in their MPD drawings than the caregivers.

Visual impressions of degree of discordance/concordance among images

There are some interesting characteristics within the two sets of drawings which were not picked up by the rating instruments. These results suggest a degree of similarity between the perceptions of caregiver and child. Besides the overall prevalence of warmer colors in the BOF and MPD drawings of most subjects, many of the subject pairs appeared to use similar quantities of red and other warmer colors of orange and yellow in their drawings. Such observations are supported by the analysis of color prevalence for the BOF drawings and analysis of color agreement in the MPD drawings.

However, even in those instances when one subject utilized the less frequently chosen colors, such as purple and green, the other subject likewise tended to choose those colors for his or her drawings. This was most apparent in the BOF drawings, where the majority of subjects tended to choose the warmer colors. In the MPD drawings, many subjects appeared to utilize a broader color spectrum.

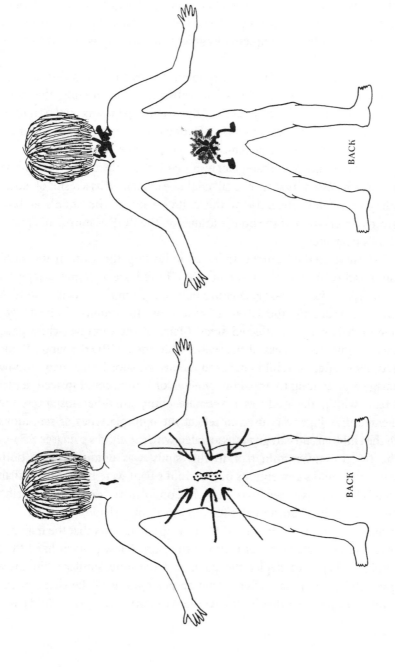

Figure 8.1 Caregiver's BOF (left) and child's BOF (right)

In a few cases, it was noted that the caregiver and child appeared to be in exact agreement as to the general size, number, and location of the child's JRA pain in the BOF (see Figure 8.1; the caregiver's drawings is to the left and child's is to the right). This tended to occur most often with the older children (the 12- to 14-year-olds). In a couple of instances, the caregiver and child appeared to be in complete disagreement in their indications of the pain.

Of significance, but not necessarily identified by the rating instruments, was the fact that some caregivers had difficulty remembering the exact location of the affected limb(s), specifically, whether pain was on the right or left side of the child's body. For example, one caregiver commented during the study that she could not remember which knee was painful for her daughter. In most cases, the caregiver eventually chose the correct side of the body. Nevertheless, difficulty in recall could be explained as a result of either the caregiver's faulty memory of the child's pain or the child's and/or caregiver's observation of the body outlines on the BOF as mirror-images of the child's pain sites.

A few subjects used unique styles of indicating the pain in the BOF drawings rather than coloring-in of the affected areas. Some caregivers depicted rays of warm color emanating outwards from the affected joints. A few children, especially the 12- to 14-year-olds, drew monster-like images (see Figure 8.2) over the affected areas. Many of the caregiver-child pairs depicted fragmented images of the pain within their MPD drawings. Some subjects, most often the children, asked the investigator if they had to draw one image representing their pain in general, or if they could instead depict each pain within the body as a separate entity. In other instances, the fragmented drawings were used to reflect the multiple types of sensations which the children and caregivers associated with the child's pain (see 8.3).

The first caregiver-child pair in this study was unique in that both caregiver and child's perceptions of the child's pain were highly dissimilar. Their MPD drawings appear to be complete opposites of each other, sharing virtually no similar characteristics (color choice, size, shape) (see 8.4).

Focusing on form within the MPD drawings, it appears that the majority of the subjects depicted circular forms of the pain. A few pairs utilized their own unique shapes to depict the pain, and uncanny similarity in these caregiver-child forms may reflect common perceptions of the shape of the child's affected joint or other bodily region. With other caregiver-child pairs,

the overall similarity in form can be seen in the size, placement of color, and perseverative line quality of the magnified pain images.

Lastly, the caregivers in particular tended to depict fire imagery when visualizing their child's pain in the MPD. Only two children depicted fire imagery for their own drawings.

Cognitive and developmental influences

Cognitive and developmental influences must be taken into consideration when discussing the style and content of the drawings collected in this study. The caregivers, more cognitively and developmentally advanced, are able to depict more realistic images than young children who are still in scribbling or schematic stages of expression, and are often drawing circles (Gardner 1980).

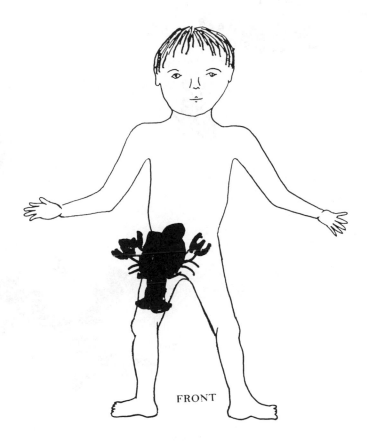

Figure 8.2 BOF from 12- to 14-year-old group

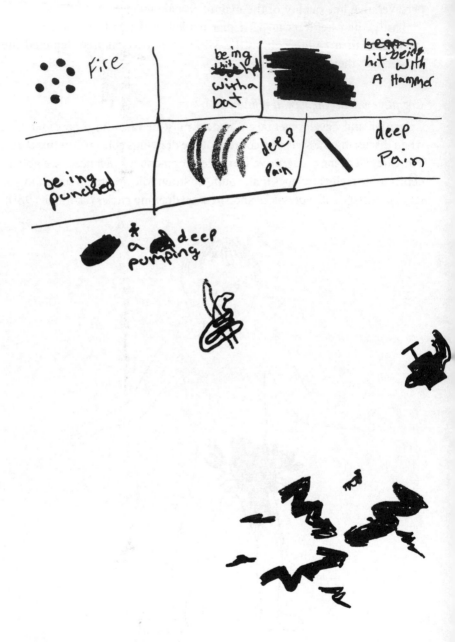

Figure 8.3 Fragmented drawings

The greater amount of circular forms in the children's drawings could also be related to development. Children's art expression begins with scribbles, then progresses to radials and other circular forms at around age two or three (Gardner 1980). It may be possible that the older one gets developmentally, the further away one's images move from circular forms. A second reason for the children's greater amount of circular forms is that, based on the development of children's artwork, the inclusion of circular shapes implies regression. It has been shown that children under stress, including the disruption of a chronic illness, appear to regress in functioning. When in pain, children may regress to earlier types of expression, in this case drawing circular forms.

Developmental factors may have influenced some of the children's responses to the MPD task in this study. Considering that 5 and 6-year-old children are thought to be just beginning to develop symbols in drawings and that they have difficulty with abstract concepts, it is then not surprising to find that the youngest children in the study appeared to have difficulty comprehending the directive for the MPD. Notably, these children

Figure 8.4 Example of dissimilar MPDs

approached the MPD directive with confusion and a playful curiosity with the art media; their resultant images consisted of tiny disconnected lines and/or circles. It cannot be definitively stated whether or not the youngest children comprehended the directive, and/or if they were able to realistically depict what they were envisioning in their minds. Nevertheless, the ramifications of such an observation are significant, for they imply that one might need to further adapt the MPD task for the younger children or consider omitting it altogether.

Children's color use in MPD and BOF

When analyzing the children's color prevalence in terms of their cognitive-developmental level, it was found that only one of the six children in the 5- to 6-year-old group utilized red as the most prevalent color in the BOF drawing, while the majority of the 7- to 10-year-olds and 11- to 14-year-olds utilized red predominantly in both their BOF and MPD drawings. Furthermore, grey was used predominantly in the drawings of the 5- to 6-year-old group, but was used only once in the drawings of the two older groups. The fact that the older children utilized more red could imply that color choice and identification with pain appear to relate to the child's cognitive abilities. The younger children may have associated pain with colors which are unpleasant to themselves (i.e. gray), with the older children tending to utilize colors as symbolic representations of the pain and its associations with blood (i.e. red).

Additional observations

The majority of child subjects stated that they were not experiencing pain at the time of the study. For some, their last reported JRA pain experience occurred as long as two years ago. In such instances, both caregiver and child were depicting their perceptions of the pain experience as recalled from their memory. These subjects' perceptions may be dissimilar simply because of the fallibility of memory. The difficulties inherent in visually depicting memories from prior pain experiences may very well be supported by this investigator's observation that many of the caregivers evidenced difficulty remembering the correct afflicted limb (e.g. left versus right knee). An improvement would be to use the instrument in the active phase of the pain for all the subjects tested.

Recommendations for future study

Recommendations for future studies pertaining to the topic of the pain perceptions of caregivers and children with JRA include analyzing and comparing the perceptions of child, caregiver, and physician. In this way, one could compare the perceptions of the three most important persons in the scope of the child's experience with the disease.

An additional recommendation for further study involves a longitudinal study, tracking the pain perceptions of children with JRA throughout a year or more. This could compare the perceptions from children experiencing pain at the time of the study to those same children's perceptions after a week, month, and so on. It would also be interesting to compare these findings with those of the caregiver and physician, studied at similar intervals.

A third and final recommendation for future study involves researching the accuracy and reliability of the caregiver as advocate for the child with JRA. Interviews using the BOF and MPD could be staged with the caregiver and child separately, while they were waiting to go into a doctor's appointment. The interviewer would enter the examining room with the child, caregiver, and physician, and record what the caregiver tells the physician and how the child reacts and/or behaves, with the goal of comparing responses.

Conclusion

Art and imagery in the diagnosis and treatment of JRA currently remains an untapped resource. However, this author expects many benefits from the utilization of such a resource. Spontaneously, as well as by directive, very young children are often able to communicate visually more effectively than verbally. It is felt that the child's visual depictions of JRA pain is an accurate and virtually effortless mode of communication of that child's pain experience.

As a result of this study, this investigator concludes that a fair amount of similar pain perceptions occur, more so than initially assumed. It seems more than coincidental that the caregiver and child utilized similar colors, shapes, and other characteristics in their depictions of the child's pain.

This study also indicated that these types of drawing tasks are useful in understanding how caregivers perceive and recall their children's pain. In indicating the exact location of the pain, many of the caregivers had marked

difficulty in trying to remember the correct affected limb or other area (i.e. left versus right) on the child's body. In a few cases, the two subjects indicated the pain sites on opposite limbs. In other cases, the caregiver's and child's perceptions of the location of the pain did not match at all. This can be important information to the clinician or therapist working with the parent and child to enhance treatment as well as their mutual understanding of the child's condition.

In conclusion, this author strongly believes that future utilization of the Body Outline Forms and Magnified Pain Drawing during the course of treatment of the child with juvenile rheumatoid arthritis would aid in the communication of the child's pain experience to the treatment team, notably caregiver and physician. Moreover, the employment of caregiver-and-child art therapy, as a means of improving the accuracy of the caregiver's perceptions of the child's pain, would no doubt be beneficial for all chronically ill populations. Art expression could be utilized as an intervention to aid the caregiver in developing more realistic, accurate perceptions of the child's perceptions of pain and experience of disease, and might help to provide more effective, accurate treatment of the child's pain.

References

Arthritis Foundation (1987) *Arthritis in Children.* Atlanta, GA: Arthritis Foundation.

Arthritis Foundation (1991) *Coping with Pain.* Atlanta, GA: Arthritis Foundation.

Arthritis Foundation and The American College of Rheumatology (1993) *Rheumatoid Arthritis.* Atlanta, GA: Arthritis Foundation.

Beales, J.G., Holt, P.J.L. and Keen, J.H. (1983) 'Children with juvenile chronic arthritis: their beliefs about their illness and therapy.' *Annals of the Rheumatic Diseases, 42,* 481- 490.

Beales, J.G., Keen, J.H. and Holt, P.J.L. (1983) 'The child's perception of the disease and the experience of pain in juvenile chronic arthritis.' *Journal of Rheumatology, 10,* 61–65.

Birren, F. (1961) *Color Psychology and Color Therapy.* Secaucus, NJ: Citadel Press.

Brown, J.H., Kazis, L.E., Spitz, P.W., Gertman, P., Fries, J. and Meenan, R.F. (1984) 'The dimensions of health outcomes: cross-validated examination of health status measurement.' *American Journal of Public Health, 74,* 159–161.

Councill, T. (1993) 'Art therapy with pediatric cancer patients: helping normal children cope with abnormal circumstances.' *Art Therapy: Journal of the American Art Therapy Association, 10,* 2, 78–87.

Eiser, C., Havermans, T., Pancer, M. and Eiser, J.R. (1992). 'Adjustment to chronic disease in relation to age and gender: mothers' and fathers' reports of their children's behavior.' *Journal of Pediatric Psychology, 17,* 261–275.

Eland, J. (1981). 'Minimizing pain associated with prekindergarten intramuscular injections.' *Issues of Comprehensive Pediatric Nursing, 5,* 361–372.

Ennett, S.T., DeVellis, B.M., Earp, J.A., Kredich, D., Warren, R.W. and Wilhelm, C.L. (1991) 'Disease experience and psychosocial adjustment in children with juvenile rheumatoid arthritis: children versus mothers' reports.' *Journal of Pediatric Psychology, 16,* 557–568.

Fries, J.F., Spitz, P. and Young, D.Y. (1982) 'The dimensions of health outcomes: the Health Assessment Questionnaire, disability and pain scales.' *Journal of Rheumatology, 9,* 788–793.

Gaffney, A. and Dunne, E.A. (1986) 'Developmental aspects of children's definitions of pain.' *Pain, 26,* 105–117.

Gardner, H. (1980) 'Children's art: the age of creativity.' *Psychology Today, 13,* 84–96.

Hodges, K. (1987) 'Assessing children with a clinical research interview. The child assessment schedule.' In R.J. Prinz (ed) *Advances in Behavioral Assessment of Children and Families.* Greenwich, CT: JAI Press.

Lovell, D.J. and Walco, G.A. (1989) 'Pain associated with juvenile rheumatoid arthritis.' *Pediatric Clinics of North America, 36,* 1015–1027.

McGrath, P.J. and Craig, K.D. (1989) 'Developmental and psychological factors in children's pain.' *Pediatric Clinics of North America, 36,* 823–836.

McGrath, P.J. and McAlpine, L. (1993) 'Psychologic perspectives on pediatric pain.' *Journal of Pediatrics, 122* (Suppl. 83), S2–S8.

Mendelsohn, J., Quinn, M.T. and McNabb, W.L. (1993) 'Practising pediatricians' views of the child's role in the pediatric interview.' *Academic Medicine, 68,* 90.

Ross, D.M. and Ross, S.A. (1988). 'Assessment of pediatric pain: an overview.' *Issues in Comprehensive Pediatric Nursing, 11,* 73–91.

Savedra, M.C., Gibbons, P., Tesler, M., Ward, J. and Wegner, C. (1982) 'How do children describe pain? A tentative assessment.' *Pain, 14,* 95–104.

Schechter, N.L. (1989) 'An undertreatment of pain in children: an overview.' *Pediatric Clinics of North America, 36,* 781–795.

Scott, R. (1987) '"It hurts red." A preliminary study of children's perception of pain.' *Perceptual Motor Skills, 47,* 787–791.

Unruh, A., McGrath, P., Cunningham, S.J. and Humphreys, P. (1983) Children's drawing of their pain.' *Pain, 17,* 385–392.

Vandvik, I.H. and Eckblad, G. (1990) 'Relationship between pain, disease severity, and psychosocial function in patients with juvenile chronic arthritis (JCA).' *Scandinavian Journal of Rheumatology, 19,* 295–302.

Varni, J.W. and Thompson, K.L. (1985) 'The Varni/Thompson Pediatric Pain Questionnaire.' Unpublished manuscript.

Varni, J.W., Thompson, K.L. and Hanson, V. (1987) 'The Varni/Thompson Pediatric Pain Questionnaire I. Chronic muscoloskeletal pain in juvenile rheumatoid arthritis.' *Pain, 28*, 27–38.

CHAPTER 9

Understanding Somatic and Spiritual Aspects of Children's Art Expressions

Cathy A. Malchiodi

Anyone who works with children in medical settings, particularly children with serious illnesses, traumatic injuries, or life-threatening conditions, is not only concerned with their psychosocial status, but also how somatic illnesses or conditions are experienced and expressed by young patients. In cases where children's lives are threatened, therapists also face their questions about death and dying, and in some cases, spiritual issues and religious beliefs about God, heaven, and what happens after death. As demonstrated throughout this book, art often serves as a way to express that which is not spoken about illness, particularly fears and concerns about being sick or disabled as well as why one is ill and what will happen if one dies.

This chapter explores two areas of children's art expressions (somatic and spiritual) not as thoroughly researched as other aspects of children's art expressions such as developmental and emotional influences. Looking at children's art expressions through a somatic and/or spiritual lens can be particularly meaningful when working with children who are experiencing life-threatening illnesses, coping with grief, or dying. The term *somatic* is defined as of or relating to the physical body, distinct from the mind or the environment. Somatic aspects of children and their drawings may include characteristics which express or depict physical impairments or disabilities and acute or chronic physical illnesses. In the case of the latter, art expressions may reflect children's experiences with life-threatening illnesses or conditions such as cancer, heart or kidney problems, surgery or invasive medical treatments, or serious traumatic injuries from accidents or abuse.

Spiritual aspects of children's drawings refer to content or characteristics that reflect children's experiences of God or intangible entities such as angels, religious figures, or ghosts and the supernatural, and experiences associated with church or religion. The term *transpersonal* is sometimes used in place of the word spiritual and is a term that has been used to describe phenomena beyond the personality and across cultures; it literally means 'beyond the self'. At other times the word 'religious' is used to connote the spiritual aspects, however, religion is actually only one expression of spirituality. For the purpose of this chapter, the term spiritual is used in order to encompass not only religious beliefs, but also perceptions and experiences which relate to that which is beyond the self (Malchiodi 1998).

Somatic and spiritual aspects: thinking in context

My own thinking about children's art expressions, including those of pediatric patients, comes in part from a phenomenological view (Betensky 1995) which underscores the importance of context in understanding art expressions. Phenomenology is the study of events in their own right rather than from preconceived causes. What is important about looking at children's drawings with a phenomenological eye is the emphasis on an openness to a variety of meanings, the context in which they were created, and children's ways of viewing the world. It is a way of understanding children's expressive work from many perspectives, allowing the therapist to work with children to construct meanings from more than one vantage point and to develop a more integral view of children's art expressions. Materials, environment, attitudes about art making, intention, previous art experiences, sociocultural influences, and the therapeutic alliance are a few of the influences which affect how and what children create in art.

In my own work with children's art expressions from a phenomenological approach, the initial step involves taking a stance of 'not knowing'. This is very similar to the foundation of social constructivism which sees the therapist's role in work with people as a co-creator, rather than expert advisor. By seeing children as the experts on their own experiences, an openness to new information and discoveries naturally evolves. Although art expressions may share some recognizable commonalities in form, content, and style; taking a stance of not knowing, allows children's experiences of creating and making art expressions to be respected as individual and to have a variety of meanings. This becomes particularly important in working with pediatric patients who need the opportunity to express personal meanings

for their experiences and to convey relevant issues related to physical illness and hospitalization and, at times, spiritual concerns.

Taking a stance of not knowing also reduces the chance that the therapist will misunderstand or possibly miss important information, not only about pediatric patients' psychological health, but also their physical and spiritual well-being. This approach naturally provides the opportunity to acknowledge many different aspects of growth which are linked to art expression, including cognitive abilities, emotional development, interpersonal skills, and developmental maturity, and in my experience, somatic and spiritual aspects. This multiplicity of meaning provides the therapist with material for developing and deepening the therapeutic relationship while also honoring the unique experiences of the child client. Although it may be difficult to truly understand all levels of meaning in children's expressive work, it is important to allow for the possibility of multi-meaning and multiple perspectives.

A phenomenological approach also allows the therapist to comprehend children's drawings from an integral orientation rather than a limited viewpoint. Many therapists unfortunately learn to rely on one or two theories in their thinking about clients, or resort to 'cookbook' approaches to categorizing elements in children's art from lists of characteristics. In my own training as an art therapist I was originally taught to look at children's art expressions from developmental and emotional (mostly psychoanalytic) aspects. In my consequent work as a medical art therapist I became aware of how a child's experience of hospitalization, physical illness, injury, or impairment, and medical interventions such as surgery, chemotherapy, radiation, or dialysis forms an important context for how children's art expressions are understood.

Art expression as narrative with pediatric patients

One of the most powerful qualities of art making for pediatric patients is its potential as a form of personal narrative. In addition to a phenomenological approach, my work with this population is guided by the belief that art expression provides children with the potential to tell stories, convey metaphors, and present world views, both through what is present in the image itself and through their own responses to their images. The narrative qualities of children's art expressions and children's interest in narrating them offer the therapist a way of understanding meaning from the child's perspective. A narrative, by definition, is a story or a recounting of past

events, or a history, statement, report, account, description, or chronicle. By narrative qualities, I mean the ability of children's art expressions to present their impressions of their inner worlds, responses to their environments, and individual stories both through a developmentally appropriate form of communication (i.e. art) and through talking with the therapist about the content of their art expressions (Malchiodi 1998).

In recent years, therapists have come to view narratives as an important part of their work with clients, using clients' descriptions and stories about their lives, concerns, and world views to help them externalize problems (White and Epston 1990). Narrative therapies have become increasingly popular in work with both children and their families (Freeman, Epston and Lobovits 1997), emphasizing regard for children's unique language, problem-solving resources, and perspectives. While the goal of narrative therapy is to help to separate the problem from the individual through written narratives, I believe that art expression serves a similar narrative function for children by externalizing their experiences, thoughts, and feelings through visual images.

Like the narrative therapy approach, offering art to physically ill children not only validates what they are experiencing and feeling, but also to helps them to put some distance between themselves and their problems by making these problems (illness, trauma, hospitalization, pain, and impairment) tangible and visible. It is important in any therapeutic interaction with a child to begin to establish that the problem is the problem, and that the child is not the problem, to paraphrase a well-known adage of narrative therapy (White and Epston 1990). In my experience, art as therapy in most circumstances helps a great deal in establishing that the problem, whether it be a difficult feeling, behavior, or situation is separate from the self, by putting it out in tangible form.

A therapist using narrative approaches with pediatric patients may rely upon verbal story-telling to allow them to share information about the content of their drawings, and with most children, this is helpful and necessary feedback about the meaning of their art expressions. However, it is also easy to see that drawings themselves are an age-appropriate and effective form of narrative with children. Children do not have adult capabilities to verbally articulate their emotions, perceptions, or beliefs, and often prefer to convey ideas in ways other than talking. Many have noted the limits of using only verbal approaches with children (Axline 1969; Case and Dalley 1990; Gil 1991; Malchiodi 1990, 1997), highlighting the need for non-verbal

forms of communication along with traditional talk-therapy. The combination of both art and children's verbal descriptions provides therapists with an integrative means of understanding pediatric patients. Art expressions themselves not only allow narratives to naturally emerge, but permit the therapist to use these visual narratives as a way to interact with their patients and can serve as a catalyst for communication of thoughts and concerns about physical illness, injury, or impairment, medical intervention, or questions about what happens if one dies.

Trauma and its impact on children's art expressions

When considering the somatic and spiritual aspects of art expressions of physically ill children, it is first important to consider the impact of physical and psychological trauma on this population. Trauma, both to the psyche and the body, is inevitably a part of children's experiences with illness, hospitalization, and medical intervention and is a line of demarcation distinguishing a time of relative safety from a time of distress, fear, anxiety, and other feelings associated with experiencing the trauma. Therefore, what is known about how traumatized children express themselves in art and play is salient to working with pediatric populations, particularly those children who experience injury, invasive medical treatment, or severe physical abuse which may lead to hospitalization.

Art is well suited as a modality for self-expression with children in trauma because it may be easier for them to use visual modes of communication before being able to talk about trauma (Malchiodi 1990, 1997; Stronach-Buschel 1990). Therapists generally agree that children use art expression to express trauma and associated feelings of grief, mourning and loss and often explore and master trauma through play activity or artistic expression (Terr 1981, 1990; Malchiodi 1990, 1997). Art may also serve as a way to integrate parts of the identity that are temporarily lost or confused when trauma such as illness, injury, or impairment is experienced.

As previously described, art also serves as a way to externalize the problematic feelings traumatized children have, and provides the therapist with visual clues to help children see their illnesses as illnesses, and to help them separate themselves from the illness. For the pediatric patient in particular, art serves an important function of not only exploration of thoughts and feelings about illness, but also for reframing beliefs about the cause of illness or injury.

Responses to physical and psychological trauma through play or art expression are individual and depend on how a child perceives and reacts to trauma, age, developmental level, amount of support from others (e.g. family, friends, or others), and the type and extent (acute or chronic) of trauma experienced. For example, a hospitalized child may feel that it may feel dangerous to depict feelings about what has happened, especially if a trauma has involved physical or sexual abuse, a situation that could repeat itself if the art reveals a family secret. Personal styles of expression of trauma also will have an effect on the content of the art expression. Some children may wish or even be compelled to express themselves through art or play shortly after a traumatic experience while others may take longer to feel safe to communicate their feelings. Some children may express traumatic events in fully-formed images, expressing the terror of their experiences in great detail, while others may convey events or perceptions through sparse renderings, giving as few details as possible. It is consistently important to remember that it is a difficult task for a child to take a pencil or crayon and depict a traumatic memory and often one that many children do not initiate spontaneously for reasons of fear, personal safety, secrecy, or denial.

There are some characteristics of children's art expression and art making which appear to reflect the effects of trauma. However, within children's art in general, there is a wide range of expression due to developmental, environmental, and personal capacity for art making. Therefore, the following characteristics are by no means a definitive list of indications of trauma, but simply a guideline to alert therapists to how children commonly express trauma through art.

Some traumatized children may limit use of color or developmentally appropriate details in their art expression, particularly in drawings (Malchiodi 1990, 1997). Colors may be limited to predominately black or red and within pediatric populations; this use of specific colors may also relate to somatic influences (see section on color and somatic aspects later in this chapter). Because the use of color is strongly related to development, it is always important to consider how children normally use color in their art expressions before making any assumptions. Very young children, for example, are subjective in their use of color so it is difficult to unilaterally apply ideas about color meaning with them.

Initial responses to trauma may include simplistic art expressions, some of which may resemble stereotyped cartoons or doodles (Terr 1981, 1990; Malchiodi 1990, 1997). This lack of content, detail, and color is not

surprising for several reasons. First, traumatized children may be withdrawn or frightened, or may be disassociated from life around them. Physical debilitation due to the trauma of illness or medical intervention depression may take its toll, leaving children little energy or tolerance for art expression, or causing them to be withdrawn and uninterested in sharing much about their feelings. When a child is psychologically as well as physically exhausted, the robustness of the expression is often affected: the child simply does not have the internal resources to represent feelings and experiences on paper.

Repetition is often present in both the structural elements and the art behaviors of children who have experienced trauma. Children may repeat images related to the trauma they have experienced, or may repeat themes of rescue (such as the police, paramedics, or firemen coming); or violence and destructive acts (aimed at a perceived aggressor or perpetrator) through their art and play activities. For example, an eight-year-old boy on a pediatric burn unit repeated a drawing of his house where he was burned in a fire in the family kitchen. His narratives about the house drawings were always the same: his father was in the house when the fire started and they both would die in a fire, explosion, or other disaster from which escape is impossible. The drawings often became unrecognizable because of the maze of lines that evolved along with his stories of being burned by flames and anxiety about dying within his home.

My interaction with the boy during his hospitalization involved helping him to develop themes of safety through art and play and resolution of his fears about being in his house for fear of being burned again. Repetition of art or play are an important part of the curative process of medical art therapy, in that it allows the child to gain a symbolic power over the trauma through repeating an image and with the therapist's help, eventually mastering the traumatic event. Although a specific story may be repeated through art or play activity as described in the previous case, traumatized children may also repeat a drawing of a simple image or shape, or engage in repetitious mark-making or staccato movements of pencil or crayon on paper. In this sense art may be used as a way to self-soothe as well as symbolically master traumatic experiences.

What children understand about their bodies and illness

In thinking about children's art expression from a somatic aspect, it is also necessary to understand the impact of development on what children

understand about their bodies. Children naturally learn more about their bodies as they get older, and learn about the inner workings of the body sequentially. They also may understand more about their bodies than is included in their figure drawings. For example, when very young children are asked about their tadpole images (rudimentary figures with a circular head and legs and arms coming directly from the head), they are often able to identify details (such as the stomach) which are not obviously apparent in their drawings (Golomb 1990). There is also some evidence that children with serious illnesses such as heart disease, cystic fibrosis, or diabetes may understand more about their bodies than children who do not have serious health problems. Because they have serious conditions, these children may have been sensitized to learning about aspects of their bodies relating to their conditions (Eiser 1985).

Children's concepts of what they believe about illness may also be reflected in their art expressions. Banks (1990) conducted a study of how children ages 3 to 15 years perceive health and sickness, how colds happen, what germs are, and how medicine works to remedy illness with children. A drawing task was used to evaluate children's understanding of 'germs' and three age groupings were created (3 to 5 years, 7 to 8 years, and 9 to 12 years) for the purpose of the study. Not surprisingly, developmental influences were evident in each age level. The children in the 3 to 5 years age group drew forms that contained scribbles or rudimentary figures, images that would be expected from very young children. Many of the older children in this group (five-year-olds) drew forms which they categorized as 'monsters', human or animal-like faces or shapes that had non-human characteristics such as horns, spikes, or large, pointed teeth. Monsters appeared in the drawings of the children ages 7 to 8 years, but more frequently they contained images which looked like cells of some sort, demonstrating the children's growing knowledge of biology and health concepts. In the oldest group, ages 9 to 12 years, a large majority of the drawings of germs were of cells of one type or another. The drawings along with the children's verbal interviews, provide evidence that children's concepts of illness go from external (monsters) to internal (actual disease-causing cells in the body) and their images of these external and internal causes change with age and exposure to information on how one becomes sick.

Bank's study underscores the importance of using art expression in therapy with pediatric patients as a way of understanding their impressions of illness, concepts of how illnesses are caused, and reflections of feelings

about being sick. For example, many children feel guilty about their illnesses, thinking that they did something bad in order to get sick or were punished by someone or something outside of themselves. This is particularly true of young children who naturally see illness as a 'monster', but older children may also perceive illness from a similar perspective. I recently worked with a nine-year-old boy with terminal bone cancer who struggled with the question of why he was stricken with what is a horribly painful disease. He stated on several occasions that the devil was punishing him for 'bad things he did' by giving him bone cancer. During his hospitalization he drew a series of images depicting a devil torturing a cat on the operating table. In part, his drawings related the intense physical pain the boy experienced as a result of bone cancer as well as some of the medical procedures used to treat his cancer, such as radiation and surgery. A second important theme is also involved, one of punishment involving tortuous pain which was specifically inflicted because he was 'bad'.

As mentioned by many of the authors throughout this book, art expression can be useful in helping children rehearse medical procedures to ameliorate pain or illness and, as a result, alter beliefs about illness and treatment. For example, if a child requires surgery, the therapist may help the child express issues and feelings about the medical procedure through drawings. In the case of the boy who depicted his medical intervention as a form of torture, I was able to start a conversation with him about his treatment and to help him find ways to adjust to the medical procedures he found painful and frightening. When children have concerns about the source, treatment, or outcome of their pain or symptoms, art activities which invite children to express their pain or symptoms can be helpful in understanding any questions, concerns, or fears that they may have. Body image drawings (like the ones described by Barton in Chapter 8) are one of many art activities which can be particularly helpful in identifying and clarifying feelings about illness or impairment. I often give children a blank body image to color with markers, colored pencils, or crayons, asking them to show me where symptoms are located and where any worry, fear, anger, sadness, or other emotions are located in their bodies; art therapists and other mental health professionals have developed tasks similar to this one in recent years (Gregory 1990; Steele, Ginns-Gruenberg and Lemerand 1995). At the very least, children are able to begin to identify and express where symptoms and feelings are felt in their bodies (head, tummy, heart) and how they are experienced (as an ache, a burning, a queasy feeling).

Health care providers have developed similar strategies for understanding how children perceive and describe illness and symptoms such as pain or discomfort. In a study of children's headaches (Lewis *et al.* 1996), when asked to 'draw a picture of how you feel when you have a headache', most children drew images which portrayed their symptoms, helping medical personnel to determine the classification of their headache (migraine, tension-vascular or other types). In many cases, children were able to communicate their specific symptoms more effectively through drawings than through words alone. For example, the quality of pain experienced was often differentiated through drawings: the children with migraines depicted images of pounding or hammering or throbbing, while those children with tension headaches included vices or belts around their heads in their human figure drawings. Although the sample of children studied was small, the trends in findings show promise in aiding understanding of children's somatic complaints through drawings as an adjunct to medical diagnosis.

Theories about somatic aspects of illness in art expression

There are relatively few authors who have explored the topic of somatic conditions expressed in children's drawings. Lowenfeld (1947), well-known for his theory of artistic development, was one of the first to note the expression of physical impairments in children's drawings of human figures. He noted that repeated exaggeration or distortions of the same body part or area of the figure by children with physical problems might indicate an 'abnormality' within the body. For example, a child who experienced paralysis on one side of the body might reflect it through a shorter leg or arm on one side of a self-portrait. A child with a broken arm may also emphasize it through detail, either by enlarging it or accentuating it with color within the drawing. Art therapist Donald Uhlin (1979), like Lowenfeld, noted that physically impaired children may portray aspects of their conditions in their art expressions. He believed that at least part of this portrayal involves responses to impairments as well as the impairment itself. In other words, children react in a variety of ways to physical impairments, and these reactions present themselves in their drawings in very personal ways.

Although children may accentuate a particular feature in figure drawings to express a physical condition, it is also important to remember that children may exaggerate aspects of their art expressions for other reasons. In looking at drawings the therapist should be aware that any distortion may have either developmental or emotional origins, or may simply be the result of the

creative or artistic license of the child. Also, in cases of physical impairment, the therapist often knows in advance that a particular child has a physical condition or disability and it is easier to make connections about it through the child's drawings.

Drawings are thought to provide therapists with information on children's perceptions of pain or symptoms that are difficult to express through words, reactions to medical interventions, surgery, or drug treatment, and possibly trends in health, recovery, or physical deterioration (Malchiodi 1993). Susan Bach (1966, 1975, 1990) is known for her research into how seriously ill children use art to express somatic conditions. Her seminal book, *Life Paints Its Own Span* (1990), presents her principles of deciphering physically ill children's art expressions. Bach, a Jungian analyst, became interested in the spontaneous artwork of children and began investigating the use of painting as a way to understand emotional conflict. She realized the potential for understanding children from a multi-dimensional perspective, including physical aspects, noting that: 'not only the mental and psychological state was reflected but also the condition of the body' (1990, p.8) and that: '...free paintings may reflect specific physical illnesses in typical colors, shapes, motifs, etc. They can show present acute states and point back to past traumatic events. Often ahead of recognized symptoms, they may indicate the future development of an illness, even asymptomatic processes, which, at the time, cannot be diagnosed' (1975, p.87).

Bach collected hundreds of pieces of spontaneous art from children in hospitals, comparing it to the course of their illnesses and outcomes. As a result of her research she identified characteristics of pictures which she believes can predict the outcome or treatment, and confirm or deny the presence of symptoms and problems. Her findings are in harmony with many popular theories of the link between the body and the mind, a worthy area of investigation for any clinician working with medical patients. One of Bach's most intriguing theories is a method she developed known as quadrant analysis. She divided children's paintings and drawing into four equal parts – upper left, upper right, lower left, and lower right. Bach observed that:

> objects in the upper right quadrant may point to the situation in the 'here and now'. On the other hand, objects, paths, etc., moving within or towards the lower left quadrant have consistently been observed as 'downhill' trends, towards darkness and the unknown. A movement from the right, across the centre and into the upper left quadrant, where the

sun is last seen and furthest to the west, we have found in the pictures of children and adults whose illness takes them slowly out of life… Objects in the lower right quadrant often indicate the potential future or the recent somatic state…' (1990, p.39)

Although Bach's work remained focused on art expressions as diagnostic tools rather than for their inherent therapeutic value, she did provide a major contribution in the area of understanding children's art expressions from a somatic perspective.

Later Greg Furth (1981, 1988), who became aware of Bach's research, also observed that somatic conditions may be communicated by children in spontaneous drawings weeks or months before an illness was actually diagnosed. Like Bach, Furth notes that drawings may contain content that predicts physical deterioration, recovery, and prognosis. Furth's work with what he calls 'impromptu drawings' emphasizes too that many aspects of a child's experience may be present in an art expression, and that it is important to not only pay attention to developmental and emotional aspects, but also to the possibility of somatic conditions appearing in art expressions.

Bach's system of analysis and the art of a young man with cancer

Using Bach's quadrant analysis, Tracy Councill (author of Chapter 4 on medical art therapy with pediatric cancer patients) offers two works by a young man named Eugene who was diagnosed with acute myeloid leukemia at the age of 19 and was to eventually die of the disease. An intelligent and serious young man, Eugene became ill during his freshman year of college; malignancies categorized as childhood cancers may be diagnosed even in young adults. Eugene's cancer diagnosis was to change his career direction. He was an astronomy major before his illness and eventually changed colleges and majored in psychology when he was well enough to resume his studies. He attributed the change to being challenged by his illness to choose a career path that suited him rather than one that fulfilled his father's dreams for him. Eugene used art therapy as a way of passing long hours in the clinic waiting room. He painted both at home and in the clinic, often carrying pieces back and forth to discuss them with Councill who was his art therapist at the time.

One of the first pictures Eugene painted in art therapy, only a few weeks after his cancer diagnosis (Figure 9.1), is chillingly titled 'The Unwanted

Departure'. The picture is very dark and dramatic, featuring a central face painted in shades of green and red which is shouting and shaking a stark white fist. The left side of the canvas shows the arm of a grey-clothed figure, beckoning the central figure with a bright orange hand. This small canvas, about which the artist said very little, seems to be a compelling depiction of the confrontation between the young patient and the possibility of death. The orange hand (of death) beckons hauntingly from the lower left quadrant, that of darkness and the unknown. The white hand (the patient's own) is in the lower right quadrant, that of the recent somatic state. Ironically, the word leukemia means white blood, referring to the body's characteristic over-production of white blood cells.

Figure 9.1 'The Unwanted Departure', painting by Eugene

Another of Eugene's paintings (Figure 9.2), done while he was in remission before his cancer's fatal recurrence, is also a study in dramatic contrasts. A blue-faced figure stares from behind a tree, placed near the center of the canvas. The figure's yellow-orange left hand grasps the tree. His right, in shades of fiery red, is turned palm outward in the lower left quadrant, pushing the viewer away. A grove of trees sprouts from the top of the figure's head, enveloping the upper left quadrant and spreading to the upper right. A sunset sky, in graduated shades of yellow, orange, red, brown, and blue fill the background behind the trees. Eugene related this painting to his struggle with self-disclosure about his cancer diagnosis: should he tell friends and potential employers about his illness, now in remission, and would they reject him if they knew? He struggled with this very real question, and yet the menacing mood of the painting alludes to even more profound concerns. Viewed through the lens of Bach's quadrant theory, the painting seems to foreshadow the fatal outcome of his illness. The eye is drawn immediately to the upper left quadrant, where trees grow out of the central figure's head, as the red hand futilely pushes away the inevitable.

Figure 9.2 Painting by Eugene

Color and somatic aspects of children's art expressions

Eugene's paintings present imagery in which color, as Councill notes, was an important characteristic of Eugene's paintings. For example, she observes his use of white which could be related on some level to his leukemia. Bach (1990) felt that colors in children's art expressions may have specific connotations, but she also emphasized the importance of intensity of colors used in a drawing or painting. The term intensity refers to the vividness of color, its relative brightness or strength. For example, pink is a less intense color than bright red. With regard to children's drawings, although the color green may be related to growth or healing, whether the child used dark green or light green in their artwork may be more important when considering overall health or prognosis. A predominant use of dark green by a child in an art expression, according to Bach's research, would be more likely to be indicative of health or recovery, while light green may indicate that the child was physically weakened or, in some cases, coming back to health after medical treatment. In other words, any color may have various implications, depending on how it is used by the child in a drawing or painting.

Art therapists have noted connections between color and somatic aspects in their work with pediatric patients. Perkins (1977) conducted a pilot study comparing drawings of children ages 3 to 12 years who had life-threatening illnesses with those of healthy children. Perkins found that the drawings of the life-threatened children, the majority with cancer and a poor prognosis, contained specific color choices, symbols, and composition which she believed were indicative of an awareness of impending death. In Perkins' study, the color black was used consistently by the children with serious illness and she explains that: 'The black areas identified in the various pictures were generally consistent with negative affect in the children. Black was used to represent, among other things, a faceless nightmare creature, a cave, a vise, a spreading shadow, and a darkened house' (1977, p.9).

The color red was used by both Perkins' control group (healthy children) and the life-threatened children, but the ill children used it more extensively and their association to it was most often related to blood. Others have noted that red may be a possible indication of somatic conditions and is used more frequently by children who are physically ill. Bach (1990) observed that red may be related to burning sensations, pain, or tumors, and observed unusual uses of the color red by children with leukemia or other blood diseases. Levinson (1986), in her work with children who have been severely burned, believed that red and black were used to represent intense pain and trauma. In

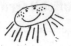

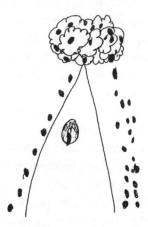

Figure 9.3 6-year-old girl's drawing
Source: Malchiodi 1998

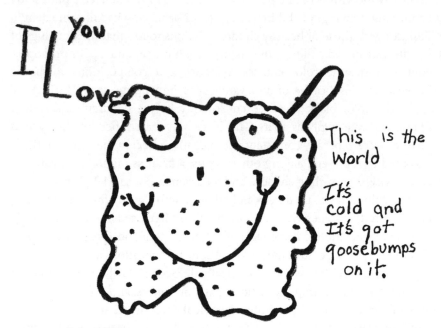

Figure 9.4 'The World'
Source: Malchiodi 1998

her clinical work with pediatric patients hospitalized for burns, if given the opportunity to paint a doll, they invariably paint it with red or black on the areas of the body in which they themselves have been burned.

In my experience in working with children with leukemia, I have found that the color red seems to play a prominent role in their drawings. For example, a six-year-old girl recently hospitalized for treatment of her leukemia repetitiously drew a red sun freckled with red dots and an apple tree losing a great many red fruits (Figure 9.3). A seven-year-old boy drew a face he referred to as 'the world' and covered it with red dots he called 'bumps' (Figure 9.4). In his case, the red dots on the world may have had a prognostic element; two days later his face and arms were covered with small red hemorrhages, a characteristic of leukemia. Many leukemic children's drawings seem to include an unusual use of red markings, dots or jabs, and as Perkins (1977) noted, frequent spontaneous depiction of fruit trees such as apple trees, often losing their red fruits.

Spiritual aspects of seriously ill children's drawings

Spiritual aspects of children's art expressions have received relatively little attention for several possible reasons. Freud, whose work influenced the practice of psychiatry and psychology for most of this century, was not favorable to the subject of spirituality in his writings. Jung, in contrast, was more receptive to the concept of spirituality than Freud, but insisted that spiritual experiences were part of the second half of life, not childhood. In recent years, the idea that spiritual aspects are important to therapy has gained increasing acceptance, although many therapists still hesitate to include or recognize these issues in their work with children. Some do not believe that children are capable of spirituality in any form, observing that Piaget's period of formal operations must be reached before spirituality is possible (1959). Up until adolescence it is thought that children's thinking about death is concrete and is largely influenced by the religious beliefs of their families. Other therapists may simply be uncomfortable with the topic of spirituality because they have not sorted through their own beliefs and do not feel that they can or should relate to children in this way. In addition, because Freud and Jung have had a broad influence on psychology, psychiatry, and particularly art therapy, spirituality in children and how they express spiritual issues through art has not been fully explored.

In work with medical populations it is my personal bias to incorporate spirituality, spiritual beliefs, and religion in my understanding of and

therapeutic interactions with children, particularly in terms of the integral perspective described earlier in this chapter. While children's art expressions, which include religious or spiritual themes, could be understood from an emotional and developmental standpoint, it can be important to look at them through a slightly different lens. The art of children who are facing life-threatening illness described in the remainder of this chapter is particularly important to consider in terms of spiritual issues. Although any child may express ideas or perceptions that relate to spirituality or religious beliefs, these circumstances seem particularly relevant to spiritual aspects of drawings, possibly because the crisis of death naturally brings a child face to face with questions about God, religion, and what happens when life ends. When a therapist considers how children express these issues through art, a more integral focus which includes individual, sociological and cultural influences is naturally brought into treatment.

One of few health care professionals who has studied children's expressions of spirituality is physician and psychiatrist, Robert Coles (1990). His extensive work with children and his explorations of children's 'spiritual lives' through both verbal interviews and drawings, has renewed interest and curiosity in understanding children's perceptions and expressions of spiritual experiences. Although some question still exists as to whether children actually have spiritual experiences in the same sense that adults do, Coles' observations provide documentation that children do think about and experience spiritual matters, particularly in the form of religious beliefs and ideas about God, heaven, the devil, and angels, and the spiritual world of ghosts and the supernatural. Over the course of his research Coles interviewed more than 500 children about their spiritual lives through conversation and drawings, concluding that children, not unlike adults, asked and considered many of the same questions that adults ask about spiritual issues.

Kubler-Ross's (1983) therapeutic work with dying children has contributed to the knowledge of children's spirituality, based on years of work with dying people. She notes that children as young as age three or four can talk about their dying, are aware of impending death, and frequently use symbolic means such as drawing to convey their experiences. Spiritual aspects of children's art expressions can encompass many things including religious symbols, images of spirits, ghosts, or representations of a deceased person. Both Coles and Kubler-Ross underscore the importance of

supporting and creating a safe environment for children to convey their ideas about God and other spiritual entities, religion, and death, if only to allow them to explore through art expressions questions that they may have about life.

Children's expressions of terminal illness, death and dying

Serious or terminal illnesses bring an experience of profound trauma to children, including confrontation with the process of dying. Children may not be able to express their feelings and needs through words alone, but may be able to relate unexpressed fears, questions, or anxieties through art expression. Seriously ill children, in particular, need help in sorting out what is happening to them not only on a physical level (e.g. surgery, body changes, or effects of drugs), but also what is occurring on deeper, often more existential levels. They often have questions about spiritual matters such as God, heaven, or angels, and may explore ideas of what will happen to them when they die through art activity.

Before adolescence, children are believed to go through specific stages of development of concepts about death and dying. For example, three to five-year-olds do not understand that death is final, seeing it as reversible and as a form of separation while older children (five through nine years) see death as the result of cause and effect and may see it as a consequence of doing something bad or evil. By age nine or ten, children may be able to comprehend death as being irreversible and an inevitable outcome of life, and understand that it is the result of illness or other circumstances that affect body function (Wass 1984).

Others, like Kubler-Ross (1983), are convinced that even very young children perceive and understand a great deal about death and dying, and that children have similar spiritual questions about death as adults do. Kubler-Ross believes that children have an 'inner knowledge of death', particularly through symbolic representations such as dreams and art expressions. Her observation underscores the idea that therapeutic work with life-threatened or terminally ill children demand that their expressive work be understood from a different perspective and that the therapist view children and their art expressions beyond strictly emotional and developmental aspects. In particular, children's inner confrontation with unfinished business, struggles and questions about leaving life, and acceptance of the process of dying can be conveyed through creative activities such as art expression.

Specific forms, colors, and content in the art expressions of life-threatened or dying children may provide some basis for recognizing and understanding spiritual aspects. Bach (1966, 1975, 1990), who believed that both body and soul were expressed through art, noted a particular configuration of elements that may appear in the drawings of children close to death. She observed that children begin to direct attention in their expressive work to the upper left hand section of the paper, perhaps including a road or pathway leading to that area. According to Bach, this area of the paper represents the movement of the sun to the west at the end of the day, and for dying children, may represent leaving life. Bach felt that the upper left hand portion or quadrant of a drawing or painting held special significance in relation to spiritual issues and children's experiences of death and dying. Perkins (1977) in her work with terminally or life-threatened children also noted the appearance of a sun in the upper left hand corner of their drawings more than in those of healthy children.

Other elements have been noted in dying children's drawings that could be related to spiritual or transpersonal aspects of their experiences. For example, both Bach (1966) and Perkins (1977) observed the inclusion of a window in the eaves of house drawings by dying children. Bach refers to this as a 'soul window', a small, often round window placed on roof or eaves of the house drawing. In Swiss folklore, the soul window is thought to be the place through which the recently deceased person leaves a house. Although there is no similar story in the United States, Perkins (1977) reports life-threatened children also included such windows in their house drawings. Perkins (1977) noted the appearance of snakes in drawings of life-threatened children, observing that they may connote transformation as well as the threat of serious danger to the self.

Aside from composition and content in children's drawings, many children will also consciously express spiritual beliefs, including religious practices and concepts, through their art. For example, children may depict religious activities such as prayer, finding comfort in practices which they have been taught as part their family's religion. Other children may draw a dead relative as an angel or in heaven, while very young children may fear that the ghost of a deceased person will come back or appear in their bedrooms. A four-year-old boy who was hospitalized for minor surgery confided to me that he had wished that his younger brother would die, and subsequently, when his brother did die, it caused him to become guilty and fearful. He consistently included an image of his brother as a ghost hovering

around the boy's home and over the church the boy's family attended. Children sometimes believe that wishing for something bad to happen to a person has magically caused a death and in the boy's case, also influenced him to believe that his surgery was a punishment for his wish. When children express such beliefs through art, they often come in the form of ghosts or demons and are particularly important to recognize and acknowledge. As discussed in the section on somatic aspects expressed in drawings, some children see their illness as a punishment, feeling disciplined by God or the devil for doing something bad in the past.

Other questions about death children may visually explore through their art expressions include: 'Where do I or other people go when they die? Can I see my family when I am in heaven? Do dead people ever come back?' It is obvious that the therapist should not have any particular religious stance in responding to these questions, but should be unbiased in allowing children explore these concerns. Children will generally develop answers that match their cultural and family belief system.

Coles (1990) provides an important rationale for respecting and recognizing the spiritual aspects of children's drawings, observing that 'children try to understand not only what is happening to them, but why; in doing that, they call upon the religious life they have experienced, the spiritual values they have received, as well as other sources of potential explanation' (p.100). Resiliency, discussed in Chapter 1, is strongly linked to children's sense of spirituality, among other characteristics (Center for Children with Chronic Illness and Disability 1996). While it may not be necessary to have a strong sense of religious or spiritual beliefs, it is still a powerful personal characteristic that therapists may become aware of through children's art expressions. When working with children who are struggling with illness or bereavement, recognizing and supporting these beliefs if they appear in drawings could, at the very least, be an important factor associated with helping children cope with life-threatening physical conditions or to understand and assimilate a loved one's death.

Although images in the drawings of dying children may hold special significance related to their experiences, many of these same elements are common in healthy children's art expressions and as with most images, it is difficult to universally categorize them into one area of meaning. What is particularly important, however, is to take a nonjudgmental stance, allowing children to feel accepted for sharing through art what is often sensitive

material, and to explore with them questions they may have about death and dying through the narratives about their images.

Spiritual issues that dying children may express through art may be difficult for therapists, but must be recognized and supported. Bach has some important advice for therapists working with children who are seriously or terminally ill, noting:

> After all our endeavors to see the child's or parent's side, I feel very strongly that we need to look at those who surround the patient, including ourselves, and to assess our stamina and ability to stand the strain of what might be seen and realised in such a picture... This calls for considerable awareness of the difficulty of the work we are doing in studying seriously ill children's painting; it is important to learn how to feel with the child without becoming identified with his or her particular situation. (1990, p.147)

Bach underscores the powerful impact that children's art expressions, particularly those from children who are sick or dying, can have on helping professionals. Children's drawings of their struggles with illness may reflect profound pain and suffering, declining health, and the process of dying; issues which are very difficult to confront, but are important ones to address in therapeutic work with children with physical illness.

Conclusion

Health care professionals who work with children who are seriously ill or confronted with death will inevitably be confronted by both somatic and spiritual elements present in their art expressions. Noting the contributions of Bach and her work with dying children, Furth (1981) supports the notion that physical and spiritual aspects are inevitably connected, observing that that both body and spirit 'act conjointly to serve the life and health of the individual...we should find this link expressed in the undirected, impromptu drawings of children' (p.67–67), particularly the drawings of children who are seriously ill or dying. In this sense, art expressions are a way to help health care professionals more fully understand life-threatened children, to allow them to communicate their experiences of serious illness and confrontation with death, and to be able to help these children 'restore harmony between body and soul' (Furth 1981, p.69).

References

Axline, V. (1969) *Play Therapy*. New York: Ballatine.

Bach, S. (1966) 'Spontaneous paintings of severely ill patients.' *Acta Psychosomatica,* 8, 1–66.

Bach, S. (1975) 'Spontaneous pictures of leukemic children as an expression of the total personality, mind and body.' *Acta Paedopsychiatica, 41,* 3, 86–104.

Bach, S. (1990) *Life Paints Its Own Span.* Einsiedeln, Switzerland: Daimon Verlag.

Banks, E. (1990) 'Concepts of health and sickness of pre-school and school-aged children.' *Children's Health Care, 19,* 1, 43–48.

Betensky, M. (1995) *What Do You See? Phenomenology of Therapeutic Art Expression.* London: Jessica Kingsley.

Case, C. and Dalley, T. (1990) (eds) *Working with Children in Art Therapy.* New York: Tavistock/Routledge.

Center for Children with Chronic Illness and Disability (1996) 'Factors associated with risk and resiliency.' *Children's and Youth's Health Issues, 4,* 1, 6–7.

Coles, R. (1990) *The Spiritual Life of Children.* Boston, MA: Houghton Mifflin.

Eiser, C. (1985) *The Psychology of Childhood Illness.* New York: Springer-Verlag.

Freeman, J., Epston, D. and Lobovits, D. (1997) *Playful Approaches to Serious Problems: Narrative Therapy with Children and Their Families.* New York: Norton.

Furth, G. (1981) 'The use of drawings made at significant times in one's life.' In E. Kubler-Ross (ed) *Living with Death and Dying.* New York: Macmillan.

Furth, G. (1988) *The Secret World of Drawings.* Boston: Sigo Press.

Gil, E. (1991) *The Healing Power of Play.* New York: Guilford.

Golomb, C. (1990) *The Child's Creation of a Pictorial World.* Berkeley, CA: University of California.

Gregory, P. (1990) *Body Map of Feelings.* Lethbridge, Alberta: Family and Community Development Program.

Kubler-Ross, E. (1983) *On Children and Death.* New York: Macmillan.

Lewis, D. W., Middlebrook, M., Mehallick, L., Rauch, T. M., Deline, C. and Thomas, E. (1996) 'Pediatric headaches: what do children want?' *Headache, 36* 4, 224–230.

Levinson, P. (1986) 'Identification of child abuse in the art and play products of pediatric burn patients.' *Art Therapy: Journal of the American Art Therapy Association, 3,* 2, 61–66.

Lowenfeld, V. (1947) *Creative and Mental Growth.* New York: MacMillan.

Malchiodi, C. (1990) *Breaking the Silence: Art Therapy with Children from Violent Homes.* New York: Brunner/Mazel.

Malchiodi, C. (1993) 'Introduction to special issue: art and medicine'. *Art Therapy: Journal of the American Art Therapy Association, 10,* 2, 66–69.

Malchiodi, C. (1997) *Breaking the silence: Art therapy with children from violent homes* (2nd revised edition). New York: Brunner/Mazel.

Malchiodi, C. (1998) *Understanding Children's Drawings*. New York: The Guilford Press.

Piaget, J. (1959) *Judgment and Reasoning in the Child.* Patterson, NJ: Littlefield, Adams.

Perkins, C. (1977) 'The art of life-threatened children: a preliminary study.' In R. Shoemaker and S. Gonick-Barris (eds) *Creativity and the Art Therapist's Identity: The Proceedings of the Seventh Annual Conference of the American Art Therapy Association.* Baltimore, MD: AATA.

Steele, B., Ginns-Gruenberg, D. and Lemerand, P. (1995) *I Feel Better Now! Leader's Guide.* Grosse Pointe Woods, MI: The Institute for Trauma and Loss in Children.

Stronach-Bushel, B. (1990) 'Trauma, children and art.' *American Journal of Art Therapy, 29,* 48–52.

Terr, L. (1981) 'Forbidden games: post-traumatic child's play.' *Journal of the American Academy of Child Psychiatry, 20,* 741–760.

Terr, L. (1990) *Too Scared to Cry.* New York: Basic Books.

Uhlin, D. (1979) *Art for Exceptional Children.* Dubuque, IA: William Brown Company.

Wass, H. (1984) 'Concepts of death: a development perspective.' In H. Wass and Corr (eds) *Childhood and Death.* Washington, DC: Hemisphere.

White, M. and Epston, D. (1990) *Narrative Means to Therapeutic Ends.* New York: W.W. Norton.

Resources

American Art Therapy Association (AATA)
1202 Allanson Road
Mundelein, IL60060
847/949-6064
web page: http://www.arttherapy.org; e-mail:arttherapy@ntr.net

Australian Art Therapy Association
PO Box 303
Glebe
New South Wales 2037

British Association of Art Therapists (BAAT)
1 Holford Road
London NW31AD

Child Life Council
11820 Parklawn Drive
Suite 202 Rockville, MD 20852-2529 301/881-7090

Dutch Association for the Creative Therapies (NVKT)
Fivelingo 253, 3524 BN
Utrecht
Netherlands

International Arts Medicine Association(IAMA)
714 Old Lancaster Road,
Bryn Mawr, PA 19010
610/525-3784
web page: http://members.aol.com/iamaorg

International Association for Art
Creativity and Therapy (IAACT)
Rumelinbachweg 20
Basel
Switzerland 4054

International Expressive Arts Therapy Association (IEATA)
PO Box 64126
SanFrancisco, CA 94164
415/522-8959

Japanese Art Therapy Association
3600 Handa-cho
Hamamatsu, University School of Medicine
Dept. of Psychiatry
Hamamatsu, Japan 431

Japanese Society for the Psychopathology of Expression
91 Benton-cho
Shinjuku-ko
Tokyo, Japan 162

Korean Art Therapy Association (KATA)
2288 Daemyung-dong
Taegu, 705-033, Republic of Korea

Association des Art-Thérapeutes du Quebec, Inc.
5764 Avenue Monkland
Bureau 301
Montreal
Quebec H4A 1E9

National Art Therapy Association of Canada
1561 Gloucester Road
London
Ontario N6G 2S5

Journals

Art Therapy

Journal of the American Art Therapy Association; available from the AATA, 1202 Allanson Road, Mundelein, IL 60060; 847/949-6064

American Journal of Art Therapy, Vermont College of Norwich University, Montpelier, VT 05602

The Arts in Psychotherapy (formerly *Art Psychotherapy*), Elsevier Science Inc., 660 White Plains Road, Tarrytown, NY 10591-5153

International Journal of Arts-Medicine, MMB Music, Inc., 3526 Washington Avenue, St. Louis, MO 63103; 800/543-3771

Web Sites

Arts for Health in the UK
http://www.artdes.mmu.ac.uk/arts4hth.htm
A national center for advice and information about using the arts in health care and links to other related sites.

Foundation for Hospital Art
http://www.hospitalart.com
A site devoted to painting hospital walls with the help of volunteers worldwide.

Contributors

Jennifer C. Barton, MS, is a graduate of the Art Therapy Program at Eastern Virginia Medical School and specializes in pediatric art therapy. Her research is based, in part, on her own experiences with rheumatoid arthritis and she is currently applying to medical school with the goal of working in the field of pediatric rheumatology.

Erika Cleveland, MA, ATR-BC, LMHC, is an art therapist and licensed mental health counselor who has extensive experience in short-term psychiatric work with medically ill children. She has also worked with older adults in a variety of settings and holds a certificate in Gerontology. She teaches art therapy at Lesley College and Emmanual College in Boston and is on the Editorial Board of *Art Therapy.* Erika is also a practicing artist and musician.

Tracy Councill, MA, ATR-BC, is an art therapist in Pediatric Oncology, Lombardi Cancer Center, Georgetown University Hospital, Washington, D.C. and is on the adjunct faculty of The George Washington University. She has written numerous articles on art therapy and pediatric oncology.

Carol Delue, MA, A.T.R., is an art therapist who specializes in working with children and adolescents and is a biofeedback therapist certified by the Biofeedback Certification Institute of America. In 1994, Carol won the Gladys Agell Award for Excellence in Research for her work with biofeedback and art therapy, demonstrating that drawing can be physiologically relaxing for children. She is currently completing a Marriage, Family and Child Counselor (MFCC) license in California.

Robin Gabriels, Psy.D., ATR, received her doctorate in clinical psychology from the University of Denver School of Professional Psychology and completed her postdoctoral training at the University of Colorado Health Sciences Center. She established and directed the art therapy program at the

National Jewish Center for Immunology and Respiratory Medicine, Denver, CO, and has given numerous lectures and presentations on art therapy approaches to the treatment of chronically ill children and families.

Johanna Russell, MS, ATR-BC, has been an art therapist at the University of California Davis Medical Center, Sacramento, California, for ten years, providing art therapy to hospitalized pediatric patients. She has been a frequent presenter on the topic of art therapy and traumatic burns at national and international conferences and psychiatric and pediatric grand rounds.

Emily Piccirillo, MA, ATR-BC, is an art therapist who has worked with people living with AIDS since 1988 and has authored several articles on the topic. She currently lives in Washington, DC, focusing on art therapy with homeless adults and children with or affected by AIDS, with women in recovery from substance abuse, and with children in special education programs.

Subject Index

Author Index